ACTING SUCCESSFUL

Using Performance Skills in Everyday Life

By Jillian Campana

The University of Montana

cognella®
academic publishing

Bassim Hamadeh, CEO and Publisher
Michael Simpson, Vice President of Acquisitions
Jamie Giganti, Managing Editor
Jess Busch, Graphic Design Supervisor
Mark Combes, Acquisitions Editor
Jessicsa Knott, Project Editor
Luiz Ferreira, Licensing Associate
Sean Adams, Interior Design

First published in the United States of America in 2015 by Cognella, Inc.
Trademark Notice: Product or corporate names may be trademarks or registered trademarks, and are used only for identification and explanation without intent to infringe.

Cover image copyright © by Terry Cyr. Reprinted with permission; © 2012 Depositphotos Inc./Wavebreakmedia.; © 2013 Depositphotos Inc./Tanor.

Printed in the United States of America

ISBN: 978-1-62661-703-2 (pbk)/ 978-1-62661-704-9 (br)

www.cognella.com 800-200-3908

CONTENTS

SECTION FOUR: REHEARSING FOR REALITY

INTRODUCTION

For more than twenty-five years I have been working with actors and non-actors alike to understand how the skills that actors learn and cultivate can be applied by everyone in their daily lives. I have worked with young children, college students, pre-adolescents, and the elderly. I have worked with individuals who were physically disabled, emotionally traumatized, or insecure, and also with people who were in positions of power, individuals who oozed confidence, and even others who were overbearing or oppressive. My experience teaching acting to actors and non-actors alike has led me to see the study of acting as a tool for developing specific life skills. My students have agreed that by embarking on this course of study, they have learned a great deal about society, the people who comprise it, and themselves. Armed with this information and a new skill set, my students have been able to modify the way they present themselves to the world so that the way they *want* to be perceived is indeed the way they *are* perceived. They have also strengthened their relationships and gained more energy. They have learned to articulate their goals clearly, and they have developed a confidence and appreciation for their individual identities and for the identity and plight of others.

This book is different from most acting books in that the focus is not on how to apply acting skills in auditions or on the stage or screen, but on how to apply acting skills in everyday situations. It is a compilation of the observations I have made as an acting teacher over the years, descriptions of concrete exercises that can be applied daily, and lessons that can be undertaken with groups. It can be read individually, used as a guide to facilitate group work, or used as a classroom text. It is organized into four sections, and although the first three are intended to be sequential, the fourth section can be used at any point, as it provides exercises and lessons that teach the specific skills. Sections 1 through 3 provide new information,

showcase moments in which acting and real life connect, and ask readers to reflect on their use of the skills taught and to set goals for the future. Personal anecdotes discussing the connection between acting and daily life take the form of interviews and are featured throughout the book highlighting individuals who have previously studied acting but who are now successful in careers outside of the performing arts. I switch back and forth with gender as I refer to the actor; at times he is a man, and at times she is a woman. There is consistency only in the individual skills and paragraphs, and this is to lend an equality to the descriptions. Finally, the term *actor*, as it has come to be known, now encompasses both males and females and thus I have adopted this singular term throughout the text to describe people of any gender.

My purpose in writing this book is to help the reader develop and then learn to use acting skills to find success, self-awareness, and clarity. By studying the principles and techniques of acting, both actors and non-actors can learn when and how to employ specific acting skills in key moments of their social and professional lives in order to enhance relationships, guide situational outcomes, express needs, and revitalize the way they feel about themselves.

section one

ACTING YOUR

BEST SELF

SEEING YOURSELF AS A PERFORMER

All the world's a stage,
And all the men and women merely players:
They have their exits and their entrances;
And one man in his time plays many parts,
His acts being seven ages.

—William Shakespeare, *As You Like It* (1599)

Most of us don't think of ourselves as performers or actors. We relegate those labels to people who are paid to entertain, are obvious extroverts, or demonstrate some type of artistic skills. But the truth is that we all perform on a daily basis. You are acting most of the time. Broadly defined, *acting* is simply the process of engaging in an action while possessing an awareness of your audience. Think about the times throughout your day when you are observed by one or more people while carrying out an act of any kind. If you appreciate this comprehensive term for acting, it is probably more difficult to find a time when you are *not* acting. It is precisely the moments when you are observed by other people that drive what perceptions and opinions are formed about you. Your actions in front of others shape the way people respond to you, what types of relationships you have, what events unfold, and how you feel about yourself. When you start to examine your actions and view them as performances, you will begin to see how they frame both your experiences and your identity.

The word *performance* sometimes carries with it an implication of falseness Some of us tend to think that in order to perform, we must either play a character distinct from ourselves or be amusing. But, in fact, definitions for the

term *perform* are varied but most commonly expressed in one of two ways: (1) to carry out, accomplish, or fulfill an action, task, or function; or (2) to do something in front of an audience, often in order to entertain it. By merging these two definitions, we can view a *performance* as any action that is carried out in front of an audience. In most instances you are being observed while you engage in your various tasks, and in many cases you are probably aware that you are being observed. In his book *Performance Studies: An Introduction*, Richard Schechner (2002) discusses the range of human actions that can be considered performances, from "ritual, play, sports, popular entertainments, the performing arts (theatre, dance, music), and everyday life performances to the enactment of social, professional, gender, race, and class roles, and onto healing (from shamanism to surgery), the media, and the internet" (2). With this definition in mind, you can appreciate that all of your public endeavors and actions are performances. And if your actions are performances, you can learn to apply acting skills to them. By using acting skills in everyday performances, you will direct your actions to produce your desired result, whether that is to get or keep the attention of your audience, to sway your audience, or to commit clearly to expressing an idea, need, or feeling. Consciously being aware of your actions, the way professional actors are, will help you find clarity in your articulations and expressions.

EXERCISE: Juggling

I often teach juggling as a component of a beginning acting course because it is unique skill that is fairly straightforward to learn. Most participants start out thinking they'll never be able to learn how to do it, but after an hour or two of practice find that they are able to keep three balls in the air for around thirty seconds. Juggling serves several purposes. (1) The very act of juggling is a wonderful metaphor for life. Most of us need to multitask in our daily lives. Whether we are good at it or not, we must juggle many things at once and not "drop the ball." The physical act of juggling allows us to practice concentrating on three things at once and to enjoy doing so. (2) In a group setting, the act of learning to juggle becomes a social one. People who already know how to juggle often help those who find the task difficult, and pairs and groups break off to talk and get to know each other while engaging in a physical task. Providing two or three thirty-minute sessions to juggle goes a long way in cultivating a group dynamic naturally without force or manipulation. (3) After a week of practice juggling I ask participants to stand up before the group and to try to juggle three balls ten times (each time a new ball lands in the hand counts as one time). Participants get several chances to succeed and then are offered another opportunity again the next week. When the participant stands up in front of the group, she is typically concentrating so intently on succeeding that she forgets about her audience and the fact that she is formally performing—and performing solo! This act frees the performer from feeling like they need to be funny or entertaining and relaxes the participant into performing in front a group. (Howcast.com offers a good video on learning to juggle: www.youtube.com/watch?v=kCt1bmSASCI.)

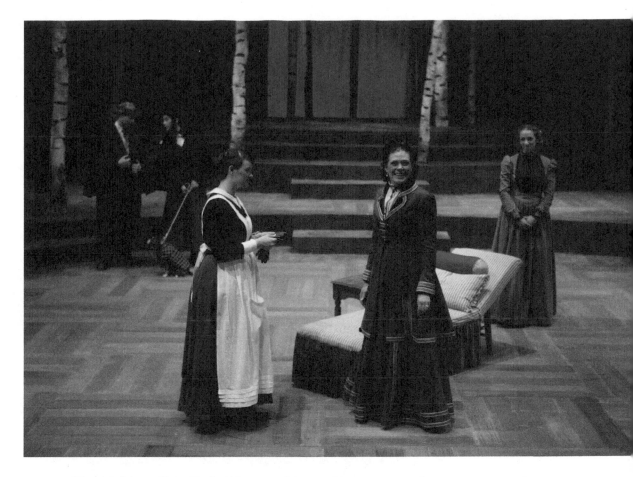

Fig. 1.1 (photo: Terry Cyr.)—What we might consider an overt performance: a scene from Anton Chekhov's play *The Cherry Orchard* produced at the University of Montana in 2013.

Typically we think of actors as those who are paid to perform in front of a theatre, film, or television audience, but let's open up that definition and look at the terms *acting, actor, character,* and *audience* in broader terms. *Acting* involves portraying a character in front of an audience. An *actor* is a person who takes part in the action before an audience. *Character* is the role the actor performs, and we consider an *audience* to be a group of people who have gathered together for the distinct purpose of watching a performance. But an audience can be as small as one or two people. And audiences can find themselves watching without having made any choice to watch. In this way an audience is simply a person or people who are observing another person perform an action of any sort. In other words, any time you are being watched, you have an audience. Character often defines someone who is part of the action in a story. But we are the main character in our own story. In theatre, television, and film we often think of a character as someone different and distinct from the actor playing that role, but that does not necessarily have to be the case, especially if we consider the multiple roles we play on a daily basis: student, friend, lover, employee or employer, parent, child, and on and on and on. In this sense our character is made up of the different roles we perform throughout the day, each with its own story, actions, and attributes. The term *acting* certainly can mean the performance of a character different and distinct from the self in front of a large group of people who have come for the express purpose of watching a fictional story, but it can also mean much more. Likewise, an actor in the broad sense of the word is anyone who performs a task in front of an observer.

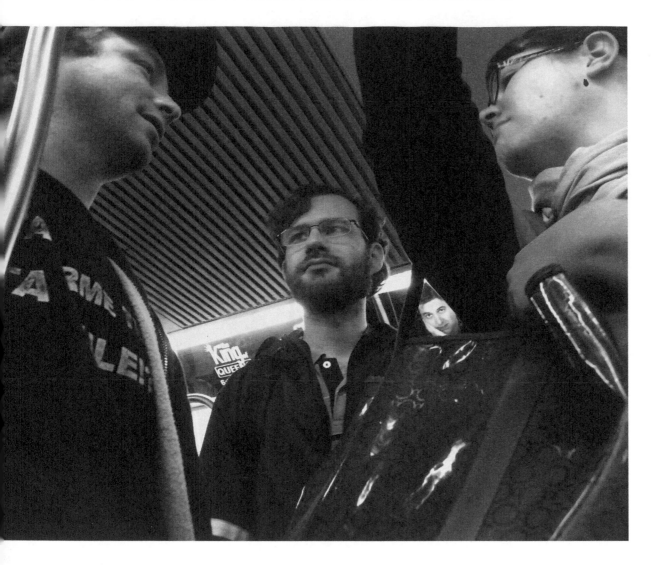

Fig. 1.2 What might be considered a more casual performance: observing and being observed on the New York City subway.

Think about how you naturally use your body and voice to attract or dissuade others. Even if you are not aware of it, your body language broadcasts your thoughts and feelings to others, and your voice communicates not just words but a subtext that lies underneath your language and is shared through how you speak. Verbal and nonverbal communication affects how you act and react to others and how they react to you. The more you understand how your body language and vocal choices influence others, the better you will communicate with them. When you cross your arms in front of your body, for example, no matter how comfortable this posture may feel to you, your audience is receiving the message that you are closed off. If you understand what your body language conveys and what your vocal tones and intonations sound like to others, you can make conscious changes in these areas that will guide your audience to become aware of you the way you want to be viewed. Just as an actor on the stage will depend on body language to communicate meaning to the audience, so can you in your everyday interactions. Think about your *actions*, the things you do and say, and your *reactions*, the things you do and say as responses to some form of stimulation. These are major indicators

of your values and your personality. Your actions and reactions inform others' opinions and dictate how other people relate to you. When you start to analyze your actions and reactions, you will also start to understand the actions and reactions of other people. By considering this behavior, you will naturally make connections between how you shape the perceptions of other people and how those perceptions in turn influence the way you feel about yourself. The way a character acts and reacts in a film demonstrates to the audience the kind of person he or she is, what he or she likes and dislikes and finds important and meaningful. An actor is aware of how his or her character's actions and reactions shape outcomes, and you too can shape results in your life by being more aware of your actions and reactions.

WORKSHEET: ACTIONS AND AUDIENCE

Take a moment to recall your day yesterday. Try to be as specific as possible and consider the entire day, from the moment you woke up to the moment you went to sleep. As you run through the events of the day, compile a list of as many public actions you performed as possible. Write out this list below by recording a description of your actions and of the audience who bore witness to your performance.

Examples:

ACTIONS PERFORMED	AUDIENCE
Attended at a meeting at work	The other people present at the meeting
Dealt with a parking ticket	The parking or city official
Went out to dinner	The host and server as well as the other people present

ACTIONS PERFORMED	AUDIENCE
Went to school	Teachers, other students
Went to Library	Math Instructor, Librarian, other students
Went to gym	Other members and gym staff
Went to work as a Host	Customers, managers, coworkers
Came home made dinner	Roomates

HOW YOU
PERFORM

Drama is life with the dull bits cut out.

—Alfred Hitchcock

Many people take part in performances that are overt and recognizable. Such performances can entertain audiences, make them think, or allow them to momentarily escape from reality and they usually provide an opportunity for the actor to explore and experiment. Reenacting stories, playing party games such as charades, taking part in a role-play, or impersonating another person are examples of performances that involve portraying a character distinct from the actor. Children engage in such performances often, where they temporarily assume another persona. Play, for example, is a natural part of childhood, but it is also a social function. Play theorist David Elkind (2007) discusses the necessity of play in the development of learning and quotes education theorist and psychologist Jean Piaget who once said, "Play is the answer to the question: how does anything new come about?" (3). Certainly play helps children rehearse for responsibilities and roles they may take on in later years, but even adults perform different characters in an effort to try out different personalities or engage in certain behaviors possibly denied to them in everyday life. Halloween or costume parties allow adults to assume characters other than themselves, and technology has made the act of performing a character distinct from oneself very common. Not just online role-playing games but even social media allow us to disguise our real selves and hide behind made-up characters.

There are other obvious moments when it is clear that a person is performing for an audience but in which the person is not assuming another identity outside of himself or herself. This is most typically seen when one or two people overtly seek to hold the attention of a group who has gathered for an express purpose of observing those people. The most apparent is when the performer has had an opportunity to prepare a presentation in advance and is literally on a stage of some sort. For example, when a person makes a speech, he or she has often rehearsed it and is following a written script with a specific intention. Eliot Eisner (1968) draws a clear parallel for us: "Teachers, like actors, attempt to communicate to groups of people in an audience-like situation, and while the ends of comedy and instruction differ markedly, both the actor and the teacher employ qualities to enhance communication; both must come through to the people with whom they work" (362). When teachers present new information, or when lawyers argue a case, they are also following a script, and although they are not attempting to play a character outside of themselves, they are attempting to keep the attention of their audience and cultivate an interest in, and an opinion about, the subject. When executives present a pitch or people interview for a job, they too are endeavoring to persuade their audience. Skyping, where the stage is a screen or monitor, is also a performance. Through Skype users can communicate in real time, often using a webcam, so that the actions, vocal quality, and physical movements are witnessed by the audience, and perhaps because of the relative newness of the technology and the closeness of the image, the Skype performance is likely to be somewhat organized by

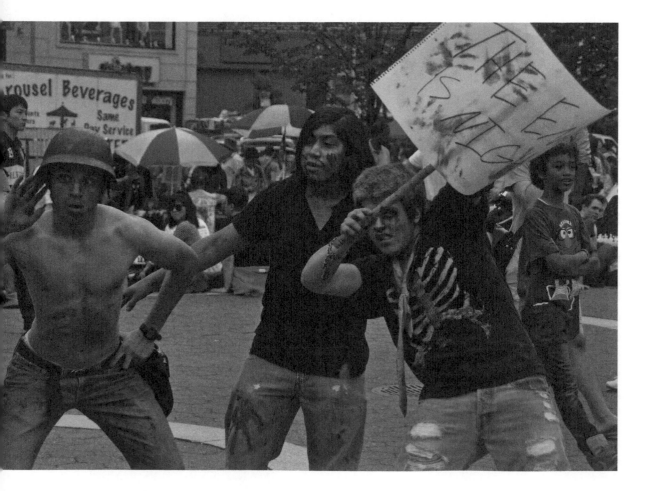

Fig. 1.3 A street performance in Union Square.

the actor. With all of these above instances, the common denominator is an acute awareness of the act of performing and observing. In these moments the stage, though small, is literal, and the actor is typically somewhat separate from the observers, who often constitute more than one or two people. There is a formality in such performances in that the performer holds the audience's attention for a specific and contained moment of time.

There are also less obvious performance moments. These are often moments when the boundaries between stage and audience are blurred, when both parties are less aware of the consequences of the performance, and when the actors are less in control of the length and span of the performance. These might include moments such as talking to a group of friends at a party, addressing a customer's or client's needs, telling a joke to another person, or answering a question in a class or meeting. For example, a person who yells to warn another of an imminent danger will use her voice to communicate far more than the words, "Watch out!" And there are even more subtle performative flashes so understated that at first they might seem insignificant. Such performances might involve audience members and actors who do not know each other. Possibly they are short moments involving no language or formal communication, or rather an observation of another person from a distance, but with a recognition on the behalf of the performer that he or she is being observed. Such moments are innumerable and

Fig. 1.4 A historical reenactment performance at a Living History event in the United Kingdom.

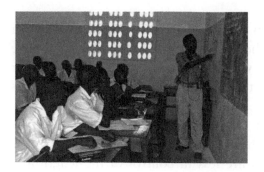

Fig. 1.5 The teacher is always a performer, even in a remote classroom in the Sierra Leone.

include all actions that are public, and thus potentially observable. People watching, or the act of covertly observing people and their interactions, can also be viewed as a performative event. The late social anthropologist Victor Turner wrote a great deal about what he came to call "social drama," which refers to all social relationships. "For the artist in me," he writes, "the drama revealed individual character, personal style, rhetorical skills, moral and aesthetic differences, and choices proffered and made" (Turner 1982, 9). What Turner was getting at in his work was that unless we are hermits, we are all constantly involved in a series of social dramas, small or large, overt or covert, which, when linked together, offer up a larger picture of a social identity or character.

We also perform through social media, in images, in video, and in online presentations. There are many extreme cases of people creating totally new identities to present through online chats and presentations. NFL player Manti Te'o, made *Sports Illustrated* headlines when he lead his college team, Notre Dame, to a 20-3 victory after learning of the death of his girlfriend from leukemia. The news that followed was even more sensational; it turned out that his girlfriend was fake and that he had been in a four-year relationship with a character created by a prankster with some technological savvy and imagination. Te'o had been communicating with, but never met, a woman whom he had "fallen for through Internet chats and long phone conversations" (*Sports Illustrated*/Associated Press 2013). Te'o, who was eventually apologized to by the culprit, is not the only person who has interacted with a false identity. For example, a recent Huffington Post article about Facebook revealed that company filings disclosed that 8.7 percent, or roughly 83 million of Facebook users are fake, meaning that thousands of us could be interacting with fictional characters on Facebook alone (Mosbergen 2012). In massively multiplayer online role-playing games (MMORPGs), people create avatars to interact with one another in a virtual world. These characters often end up having attributes the creators wish they had in real life. This type of acting, a way of experiencing an alter ego through role-play, is seen more and more because more than half of US adults now play online games and use social media to create, share, and exchange information with large virtual communities. Facebook, with more than one billion active users, has for many people become the best way to catch up with old friends. Many of us have "friends" on Facebook whom we have not seen or talked to in real life for years or possibly never even met in person. By creating a personal profile, sharing our lives and ideas via posts, "liking" pages, and communicating a history, we are executing a performance that is seen through the lens of our virtual audience, who form opinions about who we are, what we are doing in our lives, and what we value.

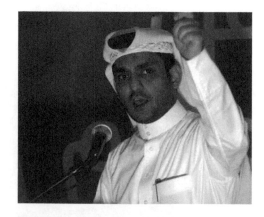

Fig. 1.6 Bahrani Mohamed Al Buflasa gives a speech as part of his bid to win parliamentary elections; like the actor, he uses his expressions, voice, and position to hold the audience's attention.

Fig. 1.7 Guests at a party in Sydney, Australia, perform for one another as they banter back and forth.

Finally, there are times when the actor is performing for himself or herself—moments when she may need to muster a hidden or rarely shown aspect of her personality for an added boost of confidence, a more demure attitude, or a more logical perspective. There are many shy people, for example, who demonstrate great expressiveness when the moment demands such behavior. Psychologist Dr. Paul Ekman has studied the connections between facial expressions and emotions for years to discover, among other things, that emotions are felt when a person mimics a corollary expression (Ekman and Friesen 2003). In this way our expressions communicate our emotions to other people but also to ourselves. Recently a study at the University of Cardiff in Wales found that people who could not frown because of cosmetic injections of Botox reported feeling happier than those who were able to frown daily. And, of course, there are also moments when a performer feels or thinks one way but must act completely different in order to accommodate the situation or audience. Each of us has moments when we must bite our tongue and perform a reaction that is contradictory to the way we think or feel. Expressing rage, for example, in a business setting is usually considered inappropriate, but, nonetheless, rage is often experienced in such a setting. In such a case the performer must act to conceal the emotion.

EXERCISE

Furrow your brow. Go ahead, really furrow it. Keep it tense, with your eyebrows pulled together. Now, tense your forehead and add a frown to your expression. Set your jaw so that it is tight and firm. Close your mouth to do so. Pull your shoulders forward and cross your arms tight across your chest. Hold this position for 1–2 minutes. How do you feel? What is your emotional state? If you were going to say something, what might it be? Continue to hold this pose and look around at your surroundings. Allow yourself to feel something about where you are and whom you are with. Now relax your entire body and try the opposite. Begin with a smile. Hold the smile, and go ahead and force yourself to laugh. Laugh at anything and for any reason. Open your mouth to laugh. Make your eyes smile. Raise your eyebrows at another person in a positive and flirtatious greeting. Hold your shoulders back and open and drop your arms so that they are at your sides. Unclench your fists and try to smile with your entire face—with your entire body. Hold this position. How do you feel now? How do you feel about yourself? How do you feel about your environment and the people in it?

In all of these cases, there exists some level of awareness that actions are being observed. Perhaps both performer and audience are acutely aware of the performance, such as when a lawyer argues a case in front of a jury. Perhaps only the audience is more aware of the performance, as in the case of people watching. Perhaps the performer is aware of her act, as she attempts to present herself with confidence when in actuality she is feeling very self-conscious. These varied examples serve to illustrate the large and small everyday moments in which you perform for someone or observe a performance by an actor. Within all of these examples there are ways in which performers communicate their self, their needs, their beliefs and ideas, and their feelings. All of these examples offer us situations in which we are acting or performing. But in addition to such scenarios, there are also multiple parts that we play in our lives.

Think about the different roles you play every day. You probably behave differently at work than you do around your family. You might dress differently depending on the situation or location, and you probably use different language depending on the company you are keeping. Every one of us assumes many different roles each day. You might be a dutiful employee all day at work and then return home to find yourself in charge of an entire household. One minute you might be a confidant to a friend in need, only to find yourself in the role of an aggressor later on in the day. In all of these instances you are probably performing your true self, but you are shifting your purpose and demeanor, however slight, to suit your own needs and the needs of your audience. Understanding the varied roles we play, whether it is the roles that have been assigned to us (family

Fig. 1.8 Social media provides an opportunity for us to perform for large and wide audiences.

member, neighbor, employee) or the roles that we create (clown, hero, victim, mascot, storyteller), helps us write our own scripts rather than letting them be written for us. Just as a character influences the story line of a film or play, so do the varied roles you play guide your life story.

When you realize how often you are being observed, and when you begin to understand the different roles you play in your daily life, and when you appreciate how large a part your body and voice play in the way you are perceived, you are thinking about yourself as an actor. And if you think about yourself as an actor, you can learn how to present yourself to your audience confidently, with self-assurance and expressiveness, and you can direct the ways in which you are being perceived. You can, in effect, elicit the types of reactions you desire. You can learn to use the basic skills actors gain through training to demonstrate and acquire confidence and poise. You will cultivate your imagination, empathy, and creativity. And you will coach your audience to see you as an important figure with important things to say and do.

Everywhere you look, famous people, local celebrities, and characters from your own life are acting. Famous actors, such as Will Smith, Angelina Jolie, Jake Gyllenhaal, and Queen Latifah, not only perform on the stage and screen; with the help of their publicists, makeup artists, and agents, they have crafted careful images of their public selves. They have chosen how they wish to be perceived, and they have taken pains to direct the attention of the world toward their assets. Local celebrities often gain the attention of the community by being seen doing things others might find unusual, interesting, wonderful, or strange. Like famous celebrities, local personalities also work to construct and uphold a persona that captures the attention of others. Finally, the people in your social circle, workplace, or home likewise perform small and large acts on a daily basis that guide the observations of others and shape the judgments you might make. If everyone around you is acting, it follows that you must be performing as well.

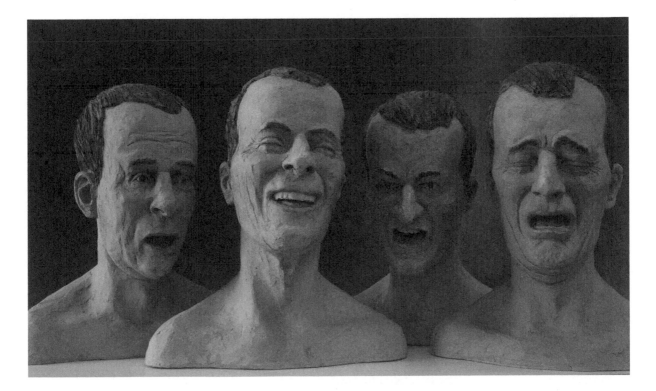

Fig. 1.9 Psychologist Paul Eckman tells us that there are seven emotions that offer clear facial expressions across cultures: anger, sadness, fear, surprise, disgust, contempt, and happiness.

INTERVIEW

Gillian Egan, a defense attorney at a private firm

My experience in theatre and acting definitely gave me confidence as a new lawyer. I may still have been a successful lawyer without them, but I was more confident about jumping into the courtroom because of the similarity between a court appearance and a performance in a play. Both involve a script, props, lines, projection, and blocking and costume—lawyers just call these things by different names. I've also benefited from my acting experience in high-pressure litigation situations outside the courtroom: negotiations, mediations, client meetings, and leading legal updates and classes for the public. As an actor, I've performed well under pressure—under the hot lights of the theatre, with an audience waiting to judge me. This experience has given me confidence "performing" as a lawyer.

Having an awareness of your body, an ability to control it, and an image of what you look like from the outside is as vital to winning a legal argument as it is to convincingly playing a role in a play. I once observed a senior lawyer in a criminal trial perform a "terribly blocked" questioning of his client. His client had been accused of stealing hundreds of thousands of dollars. This lawyer took a piece of paper from his desk, shuffled to the defendant, and asked with his back to the jury, "What is this?" The defendant said, "An unpaid AT&T bill." The attorney never displayed this item to the jury or explained its significance. The lawyer shuffled back to his desk, picked up another single piece of paper, and shuffled to the defendant. "What is this?" he asked. This was repeated fifteen times. The lawyer didn't project, didn't turn his body toward the jury, didn't make a show of holding up the bill, didn't use a highlighter to highlight the outstanding amount. He failed to use, display, and explain his prop in a meaningful way, didn't make eye contact with the jury, and ultimately lost at trial because the jury was so bored and his point was not made.

Actor memorization has immediate transference to the work of practicing law, even outside the courtroom. If I'm talking informally to opposing counsel on the phone and can't remember the key facts of my case, I could make a serious tactical blunder. If I'm deposing a plaintiff, it is possible that I have read several thousand pages of records in advance of the deposition. Good notes help keep me on task, but nothing can substitute for the good memory I cultivated as an actor. Years of focus on memorizing lines and remembering the details of the world of the play—in case I had to cover another actor's flubbed line or missed entrance—definitely have come in handy in my work now. In both theatre and the law you are put on display. You cannot hide your screw-ups. If you are not prepared, then there's no question you're going to fail spectacularly, and in front of a huge audience.

WORKSHEET: WHAT ROLES DO YOU PLAY?

William Shakespeare wrote in his play *Twelfth Night*, "One man in his time plays many parts." Halle Berry once spoke of the most important role she has ever played, saying, "Career is important, but nothing really supersedes my role as a mother" (www.biography.com). Facebook chief operating officer Sheryl Sandberg discussed the role women can play in the business world: "If more women were in leadership roles, we'll stop assuming they shouldn't be" (www.oprahmag.co.za). And former First Lady Eleanor Roosevelt spoke about her attitude of resistance: "I have spent many years of my life in opposition and I rather like the role" (Royall 2012, 2). What are the roles you play in your life? Consider the different types of roles you have played over time. Think about roles that are determined by your work or family, but also roles that exist in your social life. Finally, think about how emotions, relationships, and circumstances influence your roles. List the types of roles you have played, currently play, or hope to play in the future below. Name and describe the role and catalog your audience for the role as well.

Example:

ROLE: Parent

DESCRIPTION: I provide love, affection, order, and consistency. I keep my child safe and teach her responsibility, morals, and how to enjoy life.

AUDIENCE: The audience is my family, my daughter's friends and their families, her teachers, her coaches, and her teammates.

ROLE: _____

DESCRIPTION: _____

AUDIENCE: _____

ROLE: _____

DESCRIPTION: _____

AUDIENCE: _____

ROLE: _____

DESCRIPTION: _____

AUDIENCE: _____

ROLE: ——————————————————————————————————

DESCRIPTION: —————————————————————————————

AUDIENCE: —————————————————————————————————

ROLE: ——————————————————————————————————

DESCRIPTION: —————————————————————————————

AUDIENCE: —————————————————————————————————

ROLE: ——————————————————————————————————

DESCRIPTION: —————————————————————————————

AUDIENCE: —————————————————————————————————

ROLE: ——————————————————————————————————

DESCRIPTION: —————————————————————————————

AUDIENCE: —————————————————————————————————

A BRIEF HISTORY OF ACTING

I look down upon them from the stage, and behold the various emotions of pity, wonder, sternness, stamped upon their countenances when I am speaking.

—Plato, The Dialogues, "Ion" (approximately 380 BCE)

Ethnologists who study animal behavior know that that our primate ancestors engaged in mimesis, or imitation, in order to better their chances of survival. As anatomically modern humans, or *Homo sapiens*, we have been engaged in acting via storytelling for more than 120,000 years, and actors have been formally performing in front of audiences to share news and events, to enact creation myths, and to tell stories since then. The first known dramatic performance with actors who performed a story with distinct characters in front of an audience occurred around 2055 BCE in Abydos, Egypt, when priests performed a ritualized enactment of the death and resurrection of the Egyptian god Osiris. Historians estimate that this spectacle-filled passion play lasted from a few days to several weeks, with thousands of participants playing the god Osiris, his brother, Set, and their followers (Williams, 2010). Here we see a connection between acting and religion through reenactments of myths or religious tales, and performances such as this still continue to this day.

Much later, in the first half of the sixth century BCE, ancient Athenians honored the Greek god of wine, Dionysus, by performing group dances paired with songs called *dithyrambs*. Audiences gathered to witness and take part in the dithyrambs,

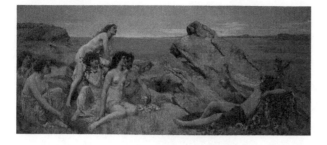

Fig. 1.10 Dionysus, the god of wine and theatre, as depicted by John Reinhard Weguelin in his 1888 painting *Bacchus and the Choir of Nymphs.*

and a formal performance emerged, with a story narration performed by a chorus and a chorus leader who spoke to one another. Around 560 BCE a playwright, Thespis, is credited with becoming the first known actor when he, as the leader of the chorus, impersonated a character different from himself. Soon after Thespis first wore a mask to represent another person, Athenian citizens began performing in large amphitheaters built specifically for playwriting competitions. With the success of such performances, the art of acting grew, and playwrights, who typically were the chorus leader, began performing several characters with the help of masks. When the playwright Aeschylus added a second actor to his plays, the profession of the actor became distinct from that of the poet. A third actor was added by the playwright Sophocles, and dialogue, over narration, became even more significant. Athenian theatre saw the development of the first actors' guild, Artists of Dionysus, and as a testament to the how important acting skills were, the actors who were considered more skillful gained prominence over others, and eventually the stronger actors had to be equally distributed between the various plays in the contests to lend fairness to the playwriting competitions. With ancient Greek theatre we see the connection between acting and democracy, which originated at the same time. Plays, playwrights, and actors drew attention to social issues, and all citizens participated in the festivals that brought social, political, religious, and educational issues to the community through theatre performances.

Of course, actors have seen their ups and downs. As Christianity spread across the West and people were asked to look to the church for spectacle, not the theatre, actors were reduced to the role of entertainers only. By the year 80 CE, in ancient Roman theatre, actors were typically slaves or low-ranking members of society. Denied citizenship, they were prohibited from certain rites and rituals unless they renounced their profession. This directive from Roman emperors was a common judgment for actors throughout Europe and lasted in some form for hundreds of years, through the Dark Ages and into Medieval Europe. Here we see the connection between acting and ridicule, where those who mimic and impersonate others in an attempt to reveal aspects of humanity are relegated to positions of scorn and derision.

At the same time that the Roman Empire was at its height, and continuing through to its eventual collapse, actors in the East were thriving. With the development of classical Indian theatre, actors continued to develop skills that concentrated on improving their performances. The *Natya Shastra*, a treatise on the performing arts written sometime between 200 BCE and 200 CE, most likely by the sage Bharata, directs actors on the art of *abhinaya*, or acting. Performers were

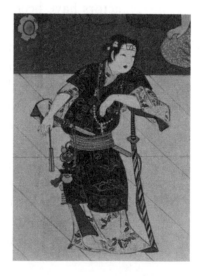

Fig. 1.11 Okuni, performing the role of a samurai, is credited with the first Kabuki performance.

instructed on how to use facial expressions to imitate the eight basic human emotions: love, mirth, terror, fury, disgust, amazement, sadness, and valor. In ancient Sanskrit dramas, and still to this day, Indian actors express *bhavas*, or emotional states, to allow the audience to feel the corresponding *rasas*, a word best translated as "that which is being tasted or enjoyed." The *Natya Shastra* also advises actors on *mudras*, or hand gestures, that communicate specific words. This highly codified system of notation takes body language to a new degree by offering actors and their audiences more than 470 hand gestures, each of which expresses specific information.

In Japan, a while later, a new acting style emerged when the Tokugawa shoguns closed off Japan to Western influences. In approximately 1603, a singer and dancer known as Okuni began to perform a new style of performance in Kyoto called *Kabuki*, best translated to mean "the art of singing and dancing" (Frederic 2002). Other women joined her, and soon a troupe of women, performing stories and portraying both male and female roles, was invited to the imperial palace. Kabuki's bawdy form grew popular, and other troupes formed. Performances grew more intriguing for some patrons, when the female actors were available as prostitutes after the performance, and possibly because of this, young male troupes began to compete with the women, and they too prostituted themselves. This connection between the art form and prostitution enraged the samurai rulers, and by 1629 women were banned from performing Kabuki. Twenty-five years later, young men were also banned from performing, leaving the art form to mature male performers, often in their middle age. Kabuki is incredibly popular in Japan today, and prostitution is no longer associated with the performers; in fact, today Kabuki actors, who are typically quite revered, are still all male, and the actors who are most famous are the men who perform the female, or *onnagata*, roles.

Around the same time, actors in England saw a brief rise in their status during the Elizabethan drama period, named after Queen Elizabeth I, who supported theatre and offered actors legal protection. William Shakespeare emerged as the top playwright in London, and partly because of his success, actors, though only males, were in demand again. Finally, several theatrical companies emerged, including the Lord Chamberlin's Men, the Queen's Men, and the Lord Admiral's Company, with consistent groups of actors hired to perform in all of the companies' plays. Run by a head actor-manager, these companies contained groups of leading actors who had a share in the business. Lead actors were hired for wages, and apprentices were young boys who played the female roles. Actors became well known, and audiences, both noble and common, gathered religiously to watch them perform. But, in 1642, only twenty-six years after Shakespeare's death, King Charles I was beheaded, leaving the government to the English Parliament under the leadership of Oliver Cromwell, who closed all London theatres. Because it was believed that theatre could incite immoral and illicit behaviors in audience members, actors were arrested if caught performing because it was assumed that ordinary people might be tempted to commit

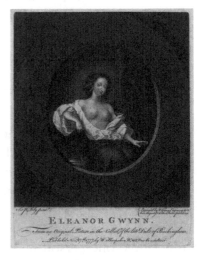

Fig. 1.12 A portrait of Nell Gwynn, celebrity actor and mistress of King Charles II.

crimes that they saw or heard about on the stage. In *The Player's Scourge*, published in late 1632, Puritan lawyer William Prynne wrote,

> Popular stage-playes are sinfull, heathenish, lewde, ungodly spectacles, and most pernicious corruptions; condemned in all ages, as intolerable mischiefes to churches, to republickes, to the manners, mindes, and soules of men. And that the profession of play-poets, of stage-players; together with the penning, acting, and frequenting of stage-playes, are unlawfull, infamous and misbeseeming Christians. (2)

After Cromwell's death, the throne was restored to the British monarchy, and in 1660 King Charles I's son, Charles II, was crowned king and returned to England from his exile in France. With the monarchy back in charge, and with a king who had been in residence at the French court and experienced the thriving French theatre firsthand, actors again took to the stage in England, and for the first time in western theatre, women were allowed to perform on the stage. Charles II became so enamored of one of the leading ladies, Nell Gwynn, that he took her as his formal mistress. Though the two children she bore him were not legitimized, the king granted one son, also named Charles, the title of Duke of St. Albans. Nell Gwynn was perhaps one of the first in a long line of well-known actors, and it was during this time in history that actors began to be seen as celebrities and the central focus of performances, a feature which still draws audiences to contemporary theatre, film, and television.

EXERCISE

> *Choose something that you enjoy doing and prepare a one-minute presentation to showcase your talent in front of a group. This can be a song, a dance, or a poem or piece of writing that you have written that you read aloud. It can be a lesson in cooking with a shared food, a sports demonstration, or a comedy routine you know. I've had students demonstrate how to cast a fly rod, do handstands or cartwheels, talk about a piece of visual art they have created, and demonstrate how they charm others. The goal is twofold: (1) to gain experience performing in front of a group; and (2) to recognize your talent and celebrate your skills.*

In modern times the connection between the daily acts people conduct and theatrical performances has been made. In 1959, sociologist Erving Goffman wrote his seminal book *The Presentation of Self in Everyday Life*, which demonstrated to the reader that in our social communications we often attempt to control or guide our interactions. Goffman tells us, "A 'performance' may be defined as all the activity of a given participant on a given occasion which serves to influence in any way any of the other participants" (15). Goffman points out that while one person may be controlling an interaction, another is simultaneously forming opinions or gaining information from the counterpart, and he uses the metaphor of performance to demonstrate how all of our actions are meant to give off or maintain particular impressions. Goffman studied the community of Shetland Island in the United Kingdom for

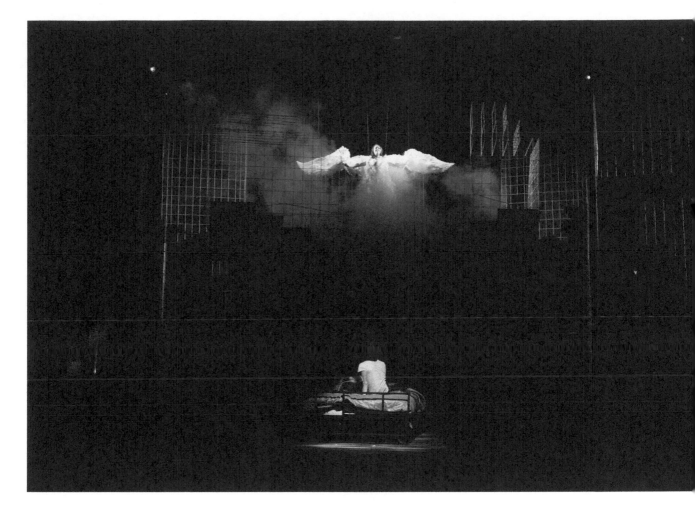

Fig. 1.13 (photo: Terry Cyr.)—The theatrical stage set for a contemporary performance of the play, *Angels in America,* directed by John DeBoer at the University of Montana. Photo by Terry Cyr.

more than one year to discover and prove that the only time when we can get rid of our roles and stop performing is when we are "backstage," his reference for private, alone time.

In 1971 Brazilian theatre practitioner Augusto Boal was kidnapped off a São Paulo street by the police of the military dictatorship, arrested, imprisoned, and tortured because his work with actors and non-actors was challenging notions of authority and oppression in the country. Boal had created a technique called "forum theatre," which dealt with social issues and sought to demand equality in the social and political system. Forum theatre generates a script based on an identifiable but unsolved community problem. The play is presented to an audience, discussed with audience feedback, and then presented again. During the many subsequent performances, audience members are allowed to call, "Stop!" come up onto the stage, and replace an actor in the play to enact different possibilities of dealing with the problem. Forum theatre was so effective in empowering oppressed communities that the Brazilian dictatorship found it to be threatening enough to halt it completely and by force.

This brief history presents us with a picture of the paradoxical nature of acting. Acting is a powerful tool, so powerful, in fact, that people have been drawn toward it even when public performances came with dire consequences. Clearly, humans have a need to perform, casually

and formally, as ourselves and as characters distinct from ourselves. So, what is it about this art form that so attracts us? And why does the practice of performing in front of an audience thrill and scare us at the same time? Acting is powerful because it cultivates broad abilities that can sway a community, a group, or an individual, whether it be the underprivileged whom Boal educated, the Puritans who feared the emotions portrayed on the stage, or the person you are talking to at a party who forms an opinion about you as he or she watches and listens to you share a thought.

WORKSHEET: WHAT MAKES A GOOD ACTOR?

List two of your favorite actors.

Will Ferrell

Bradley Cooper

Why do you like to watch them perform? What draws you to watch them? Locate specific moments of formal performance, such as their work in a film, and moments of public-social performance, such as being interviewed that you enjoy.

They're both funny. The comedy and action. Step brothers for W.F. and American Sniper for B.C. he brought a whole new bring to everyone

What, specifically is it that you like about these actors? Is it the types of characters they tend to perform? A quality or characteristic that they have? A style of performance that they are particularly good at?

Both can play comedy but cooper can do any genre

Do some research. Find out something new about one of these actors. Has that person always been this confident and talented?

Bradley cooper started out very small but easily took his Audience. W.F. has always been the way he is.

What qualities do these actors have that you also see in yourself?

comedy, seriousness, a sense of humor

BROAD
ABILITIES

Life's like a play; it's not the length, but the excellence of the acting that matters.

—Lucius Annaeus Seneca, from Seneca's Letters to Lucilius: Volume 1 (approximately 60-65 BCE)

The arts offer practitioners important life skills. We know that students who study the arts often see improved test scores in other subjects, and we are aware that participants also experience emotional growth, social development, intellectual growth, and the development of cognitive abilities (Baker 2012). Bill O'Brien, senior advisor for program innovation at the National Endowment for the Arts, reminds us that newer brain studies view the mind as a "holistic organ" that needs all areas to "work together to function at the highest level" (Reid 2012, 18). The arts teach us new ways to conceptualize ideas, frame questions, and discuss possible answers, and they help us imagine different strategies for ways to work through problem solving. Like all art forms, the study of acting cultivates numerous abilities in those who pursue the study. Actor training teaches us how to use our voices and bodies to communicate more expressively and effectively. It trains us to use and rely on our imagination and on our senses. And it helps us learn to improvise, empathize, and concentrate. The study of acting asks participants to carefully observe ourselves and others and to then analyze and reflect on our observations in an effort to learn more about humanity. It has often been said that the study of acting is the study of one's self. Perhaps because observation and reflection are at the heart of the art form, actors tend to possess abilities and insight that help them in the world off stage or camera.

INTERVIEW

Fabrizio Spada, a research scientist for a pharmaceutical company

Acting classes gave me huge confidence when going for job interviews because I knew I could engage, listen to, respond, and communicate with nearly any kind of audience. I work as a research scientist for a multinational pharmaceutical company, and my responsibilities include developing new pharmaceutical formulations, communicating and collaborating with team members and project teams, reporting to upper management, and planning and organizing work for laboratory technicians. Acting taught me how to "read" others and the environment, and this ability to read my workplace culture from day one has helped me figure out which colleagues I want to build collaborations with. During meetings and presentations, I manage to keep my colleagues engaged by making sure my voice is strong. My intonation changes depending on the emphasis I need to get across, and my enunciation is clear. Since my accent is different from that of my colleagues—I'm Italian and I work in Australia—I do not want it to get in the way of the information I need to share. Even when the meetings are teleconferences, everyone over the phone can always understand what I am saying and what I am trying to communicate.

The concentration skills that I have been able to develop because of acting classes has really allowed me to be mindful of the activity and objective I have in front of me, be it an experimental scientific activity, presenting results to the team, enjoying playtime with my family, or actively listening to the person in front of me. For me, listening is 110 percent of any job. The improvisational skills I have developed through acting have made me capable of letting go of my nerves and self-consciousness so that I can really concentrate on the connection I have to establish with my audience. Finding opportunities for humor during my presentations helps me "recharge" my focus and drop all tension, while making sure I can listen to, and quickly address, any unexpected questions without being distracted by unnecessary thoughts that are not related to the information I need to share. My character skills help me understand the point of view of the person I have in front of me. By looking for the motivations that drive the actions of the people I interact with, both in the workplace and in my social life, I have been able to analyze and resolve conflicts well.

The Ability to Confidently and Articulately Express Self

Actors develop a strong sense of self. Because they are constantly portraying others, they must learn to know and understand themselves. Acting asks participants to experiment with a variety of ways of being through performing different roles or characters. Actors who portray others have the opportunity to confront the realities of living as another person without dealing with any of the repercussions of the actions of the character's choices. Actors are aware

and understand that their behavior, language, body movement, and emotions give their audience instructions on how to perceive them. Looking at yourself as a performer and practicing performing can help you overcome self-consciousness. Acting skills help develop an articulate, expressive, and creative self. This ability allows you to have poise and confidence in your everyday conversations and in the public speaking opportunities you might come across. One of the best ways to project confidence and feel confident is to know and like who you are.

The Ability to Put People at Ease

A good actor makes life look easy when it needs to look that way and difficult when hardship serves the purpose. Just as a superior athlete can make kicking the ball into the goal look like the easiest task to accomplish, a good actor makes talking to others in formal and informal situations seem effortless. And often the byproduct is that the people actors are communicating with become at ease as well. Because actors observe others, they learn to quickly read other people to determine their comfort level and personality. Experience in acting will help make you a better communicator. You will be able to use timing, expression, and movement to tell your stories better and to enchant others. You will be able to read and play off other people's cues and in turn help them become better listeners and communicators. This ability helps you make others feel at ease, which in turn can help you be seen as a leader.

The Ability to Empathize with Others

Actors learn to relate to and identify with the characters they portray. They understand why their characters do the things they do, and they bring a humanity to their roles so that audiences can connect to the characters and story. No matter the type of character actors portray, good or evil, oppressive or victimized, they must understand why the characters behave the way they do. As a result, actors tend to have a strong ability to empathize with people in very different situations in real life as well. When you perform different roles in your life, you are more likely to gain empathy for those in similar situations. For example, it can be hard to understand the grief of another person until you have felt it yourself. Likewise, the fears and joys of parenthood are difficult to understand and appreciate unless you have experienced them for yourself. The famous Russian actor and teacher Constantin Stanislavski, whom we'll discuss later, asked actors to use what he called the "magic if" to create dimensional and truthful characters. Simply put, the "magic if" begs us to answer the question "What if I found myself in my character's circumstance?" Off the stage and away from the cameras, the "magic if" can help you engage emotionally with another person. In this way the "magic if" can give you the ability to relate to another person's feelings, or the ability to empathize with the emotions, circumstances, or choices of another human being. This ability helps you see the world from another person's perspective, and you are able to come closer to experiencing the world as that person experiences it.

The Ability to Let Go

The ancient Greek philosopher Aristotle wrote *Poetics* around 335 BCE to provide a description of dramatic theory and to discuss the nature of poetry, which he determined to consist of drama, comedy, tragedy, and satyr (satirical) plays. In the *Poetics*, Aristotle brings forth the notion of catharsis. According to Aristotle, *catharsis*, an element of tragedy, meant a purification or purgation of emotions that resulted in renewal or restoration. Freudian psychoanalysis has borrowed this term and notion to help clients express emotions that may have been repressed.

Though there is still debate in the psychoanalytic community, most people agree that having an outlet to express negative, strong, or difficult emotions can help people come to terms with where the emotions come from and then to release the unwanted feelings. Being able to healthily express a variety of emotions can help you maintain balance. The ability to let go teaches us that emotions are normal and that both positive and negative emotions need to be released. Through acting, emotions can be explored in a safe and contained environment and even assumed through a character, separate from the performer's identity.

The Ability to Understand and Harness Emotions

Just as important as it is to express emotion is the ability to understand where emotions are coming from and to harness the power of emotion. Our emotions govern us to a great extent. We all have hopes and dreams, goals, and purposes. When we get what we want, we feel something. When we don't get what we want, we feel something, and in the journey of pursuing what we want, we often ride a rollercoaster of emotions. Actors ride this rollercoaster on a daily basis in a very heightened way. Because they are presenting a story and a character to an audience, they need to show the feelings of the character to the audience so that the audience can relate. By exploring emotions in an enclosed environment, by learning to reflect on their own emotions, and by observing emotions in others, actors acquire the ability to understand where emotions come from and how to use the power of emotions in the service of a character's needs.

The Ability to Receive Criticism and Make Adjustments

Being able to positively respond to criticism is incredibly important for everyone. Actors are regularly critiqued. It's part of the game and often the best way for actors to improve their performances. In the classroom, teachers and fellow students repeatedly analyze and evaluate the actor's performances. There is also a great deal of self-reflection and assessment involved in the training of an actor. This is for two reasons. First, receiving critiques from the general public is inherent in the performance process. Professional, amateur, and couch critics are always ready to comment on the actor's performance. Second, reflection is the best way to learn how to get better. Actors perform a scene, receive feedback about their work, and then perform it again, then again, then again, always with feedback in between. This cycle creates an ability to incorporate feedback and audience responses into the next performance. Because of this, actors are generally able to respond positively to advice and criticism from a plethora of others.

The Ability to Solve Problems and to Multitask

Actors are endlessly confronted with problems. Whether it is a problem for their character, a problem another character in the play or film or show is dealing with, a problem on the set with a co-collaborator, or any one of the numerous problems during performances that might occur, actors deal with problems constantly. They have learned to solve problems before anyone else, especially the audience, even finds out that a problem exists. The adage "the show must go on" sums up the philosophy of every actor who has ever had more than one gig. And actors have developed an ability to continue working while they solve such problems. Actors are multitaskers. They must remember where and when to move, recall lines, and deal with properties, costumes, and set pieces, all while solving the many problems that arise in the alternative reality that exists in a show or film. Problem solving and

multitasking are abilities that all employers look for today, and acting forces a cultivation of these abilities.

The Ability to Imagine Possibilities

Actors must connect to the characters they are portraying. This connection helps actors believably depict a person other than themselves. In order to interpret another human's life and reveal a different temperament and individual traits and qualities of a character, actors use their imaginations in conjunction with their own experiences. They are constantly drawing on their imagination to bring a character to life. Actors also use their imagination to suspend their own belief. Educational scholar Eliot Eisner tells us that imagination also has a "critically important cognitive function" (1968, 5), in that our imagination allows us to try out behaviors and actions in our mind before we do so in reality. The ability to imagine helps us play out scenarios in our minds and to see them through to a conclusion. In this way imagining allows us to experiment with and rehearse different possibilities for the future.

The Ability to Be Open to Change

Actors are constantly living in another person's shoes. When they take on another character, they come to understand the world through their character. They respond to events, the environment, and other people as the character. And when the show or film or series ends, so does the character, and a new role is undertaken. This constant change requires that the actor develop an openness to new experiences. Actors continually discover themselves in new situations. Whether it is working on a new play or film with an entire new group of people, portraying a new character in a production, taking a new class or workshop to learn new methods and techniques, or going on a new audition, actors must be open to the change that comes with each new situation. With consistent change comes the ability to adapt to new locations, positions, people, and traditions.

The Ability to Work Well with Others or in Groups

Acting requires collaboration and teamwork. Whether it is a simple acting exercise, a scene an actor is performing with another person, or a play or film the performer is in, acting requires an ability to listen to others and to react to what they are saying and doing. It also requires a willingness to share thoughts and offer constructive feedback to others. Learning to give, receive, and incorporate feedback translates into working well with others and being a productive member of a team in any situation. Acting also demands and cultivates an ability to compromise. It is not typically solitary work, and because of this, actors learn how to incorporate the ideas others have with their own. The ability to work well with others continually tops employers' wish lists and for this reason people who have studied acting often do well in group or team work.

The Ability to Guide Perceptions

Actors are in the business of influencing others. Their job as a performer is to win the attention of the audience and persuade the audience to enter into the illusory world of the play, film, television series, or game. The way actors use their voice, body, emotions, and intellect cues the audience as to what to think and feel. A good actor can produce feelings of grief, elation, and surprise in an audience member, and she can make an audience love her or hate her. The ability to guide the perceptions of others provides an incredible opportunity in real-life relationships.

It allows individuals to express themselves as they want to be understood and to cultivate interactions with others that are clear and specific. By learning how to influence your audience, you will notice that your audience becomes more tuned in to your communication and that they are more apt to agree with you and to engage with you further.

This book asks you to consider the moments of action in your everyday life—occasions when you are aware that you are being observed by at least one other person—and to see yourself as an actor in those moments. By seeing yourself as a performer, you will automatically find instances when you can influence the outcome of a situation by using the same techniques that professional actors use. By harnessing the skills of the actor, you will naturally develop the broad abilities that lead to a more successful, aware, and content existence. By understanding and appreciating what the specific skills are, and by practicing and exploring them through exercises and techniques that professional and student actors use, you will understand how you can use such techniques in your daily life to assert with clarity your ideas and needs, enhance your relationships, and develop imaginative critical thinking skills to aid in problem solving. I am suggesting that you will improve the interactions you have with others, and your own self-confidence, if you learn to recognize and treat your actions as performances. By widening your concept of what a performance is, you can see your daily actions as performances that communicate your personality, your needs, and your opinions and this clarity will help you achieve success in your professional, social, and familial relationships.

section two

THE
ACTOR'S

SECRETS

THE
ACTOR'S
TRAINING

I'm curious about other people. That's the essence of my acting. I'm interested in what it would be like to be you.

—Meryl Streep

The job of professional actors is to present humanity to their audience. No matter the style or character of the production they are performing in, their function is to expose the audience to lives outside of their own. They do this not just by memorizing lines but by using a variety of skills to capture individual characters and the events and emotions that conspire to create dimensional and interesting beings. In order to do this, actors must be armed with skills in numerous areas. In a 2001 article, Professor Tom Griggs explains why actors need to arm themselves with such abilities: "For the actor, the reason for stretching and strengthening these particular groups of 'conceptual muscles' is to increase the range of mobility, and the flexibility with which one might be able to slip into or between a range of characters that on their surface may seem at first glance impenetrable and impossible to play. In other words, it is the actor's job to be able to 'put her/himself in the shoes' of any character s/he may be called on to portray, however different from her/himself that character may seem, at first glance" (29). Of course, a good actor makes his job look easy. He can comfortably "slip," as Griggs puts it, into any role and transport his audience to his character's world. But chances are that this same actor has spent a great deal of time learning how to do this and how to do it well.

Actors spend years learning to look and feel confident, natural, and ready for anything. Most professional actors want to be flexible enough so that they can portray a variety of ages, emotions, and personalities. Actors who make a living in

their field also need to be able to perform in different venues and mediums, including theatres of all sizes, television commercials, films, television shows, industrial videos, and gaming and radio voiceovers. In short, the acting business demands flexibility from actors. They need to be ready to perform any role, in any place, at any time. In addition, actors in our society are frequently viewed as celebrities. We regularly see actors receiving awards, chatting on talk shows, or socializing in public, and in these instances, as in their formal performances, most actors seem larger than life, captivating, and self-possessed. But this composure does not come naturally for most people, and even famous actors who perform on a regular basis have to train and practice in order to demonstrate such poise and charisma. Actors call this quality "stage presence" and spend years working to obtain this seeming elusive trait that captures and fascinates audiences.

French theatre scholar Patrice Pavis defined *stage presence* as the ability "to know how to capture the attention of the public and make an impression" (1998, 301). In her 2008 book *Stage Presence*, Jane Goodall goes on to state that "command over the time and space of a performance marks out the actor with presence" (15), and in *The Empty Space*, Peter Brook writes about a similar quality he finds in great actors, which "they themselves may only define as 'instinct', 'hunch', 'my voices', that enables them to develop their vision and their art" (1995, 33–34). Joseph Chaiken also identifies the importance of presence in *The Presence of the Actor*, when he writes about the ability of some to "make you feel as if you're standing right next to the actor,

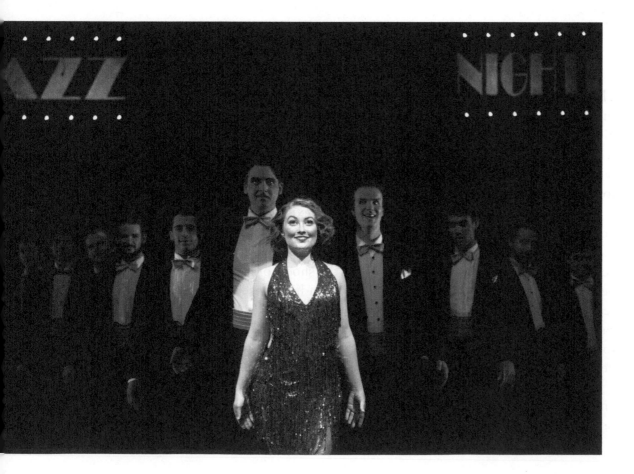

Fig. 2.1 (photo: Terry Cyr.)—Demonstrating presence and confidence, actor Suzanne Gutierrez shines as Roxy in a production of the musical *Chicago*.

no matter where you're sitting" (1991, 20). Elusive as a definition may be, people with presence are comfortable being watched and observed, and they engage their audience, making it almost impossible to turn away. Having presence is a necessity for the professional performer. In order to cultivate presence and create characters, actors undertake the study of very specific skills that make them compelling, believable, and enjoyable to observe. When performers know that they have the attention of their audience, understand the story they are a part of, and empathize with their character, they feel confident. Confidence and presence cannot be separated, as they are both contingent on the other. The commitment to the study of acting and the energy given to develop skills in this area is of the utmost importance to anyone who wishes to pursue a career in acting.

INTERVIEW

Regan de Victoria, a programming librarian at a public library

Generally speaking, my role as a librarian is to serve up a tidy amount of information that is most relevant to the patron's request, with the least amount of emotional projection onto that request. We perform what is called a "reference interview" to ascertain the root of a patron's request for information. The reference interview is an intricate dance between asking and prying, inferring and assuming—it requires skillful observation of the patron's comfort level, and the ability to ask delicate questions with tact and empathy. A good librarian brings people together with the information that they need, without comment or projecting emotion onto the situation—and being aware of my own emotions, and control-ling if and how they are revealed to the patron, is an important skill. To be successful, I need to understand the context in which the patron is asking for assistance, and in order to do that, I have to be able to walk a mile in their shoes—empathy, empathy, empathy. Most inquiries are fairly benign, and it's not much of a stretch to imagine why they might need that information—but I also witness some great moments in vulnerability and suffering, and I try to honor that with a professional response. I don't always experience success, but I'm there—and once I'm there, I'm giving it everything I've got. One hundred percent of that confidence comes from my work onstage—it's the same principle.

These same tools apply in my interpersonal relationships. For example, as a mother I might struggle to control my feelings when my son is acting out. At the very least I can analyze my actions, take a cleansing breath, consider how and where I mis-stepped, and try again; in those moments, I am able to place myself in my son's shoes—smaller than me, less in control of his emotional and physical impulses—and I am motivated to take up the challenge of gentle, kind parenting again . . . and again. Perfect relationships do not exist, but I think empathetic relationships might be a close second. Everyone experiences setbacks, but not everyone is able to scrutinize their own motivations and consider the other party's perspective—these skills are required and cultivated from the actor.

Almost every actor, amateur or professional, has taken courses and studied what is called "the craft." Many have spent years formally studying acting. Undergraduate degrees in theatre or film acting can be earned in conservatories or four-year colleges and universities, and there are hundreds of postgraduate MFA (Master of Fine Arts) acting programs in the United States alone. Those who do not study acting in formal higher educational institutions typically learn their skills in workshops and classes offered at two-year schools or academies, and some actors learn on the job, in the form of an apprenticeship when they are lucky enough to be cast in a play, film, commercial, or other performance program. But even the most naturally gifted actor needs to learn and practice the specific skills of the craft of acting in order to become a stronger and more flexible performer.

There are hundreds of colleges across the United States where students can major in acting as a degree choice. Conservatories such as Juilliard, Cal Arts, and Carnegie Mellon offer BFA degrees and full immersion in the craft with little course offerings outside of the arts. Liberal arts institutions such as the University of Minnesota, the University of Montana, and Chapman University also offer BFA degrees with specialized training but in concert with a

Fig. 2.2 New York University's Tisch School of the Arts offers one of the top acting programs in the country.

full liberal arts education. And other institutions such as Amherst College, Duke University, and Manhattanville College, to name just a few, offer the more broad-based BA degree in theatre or film with specializations in acting. Though the East and West Coasts and major metropolitan areas may offer more choices, every state in the union has an accredited four-year institution with an acting degree option. Regardless of the type of degree pursued, an acting student will take several courses in the acting discipline each semester for four full years. Typically such students take an acting class each semester, alongside classes in stage movement, voice and speech, theatre and film history, singing, and performance theory. Students in such programs also usually perform in at least one major play or screen production each semester or year. Specific classes an acting student might take include subjects such as yoga, tai chi chuan, stage combat, dialects, verse and prose, voice for the actor, directing, singing, improvisation, devising, script analysis, acting for the stage, acting for the camera, and various scene study courses in which scenes from plays and films are explored and rehearsed. In all such classes, students learn to critique their study, receive feedback and assessment, and cultivate their skills.

Fig. 2.3 (photo: Mike Fink.)—Students take part in an acting exercise at the University of Montana's School of Theatre & Dance.

THE ACTOR'S GURUS

The word theatre comes from the Greeks. It means the seeing place. It is the place people come to see the truth about life and the social situation.

—Stella Adler

There have been many acting teachers who have had significant impact on the craft. Not only were they great teachers; their theories have charted the course of the way we perform and the way we have become accustomed to seeing performances. Konstantin Stanislavsky, Stella Adler, Augusto Boal, Jacques Lecoq, Tadashi Suzuki, and Anne Bogart are among some of the greatest acting teachers of the last century. Of course, these names offer only a tiny sample of the numerous acting teachers who have influenced the craft, but this cross-section provides some insight into the types of work an actor might engage in. Most teachers agree that an acting student should be exposed to a wide variety of techniques so that they have access to different approaches of creating a character or story.

Stanislavski and a System

Constantin Stanislavski (1863–1938) is considered to be one of the more influential acting teachers in the Western world. He founded the first acting system, the Stanislavski System, and along with Vladimir Nemirovich-Danchenko founded the Moscow Art Theatre (MAT) in 1898. One of Stanislavki's principal goals was to help actors achieve a more realistic acting style. The Stanislavski System

Fig. 2.4 Constantin Stanislavski performs in Chekhov's play *Three Sisters*.

of acting, as it is formally known, is a psychological approach that has been the dominant approach to stage, film, and television acting in much of the world since it spread outside of Russia in the 1930s. Born into a wealthy and theatre-loving family in 1863, Stanislavski began acting in his teens and continued to study and gain performance skills while he worked in his family's business. He founded the Society of Art and Literature in 1888 and worked there for ten years, performing in and directing plays. European theatre at that time showcased a representational style of acting, whereby actors represented characters and emotions rather than experiencing their characters and thereby exposing the audience to a more realistic portrayal of human life and the authentic emotions that accompany humanity. Stanislavsky forever changed the approach to acting by teaching actors and directors to create natural and believable characters that held up a mirror to life. In the early 1920s he toured Europe and the United States with the Moscow Art Theatre, and after teaching and performing in New York City, several members of the company relocated to New York and continued to teach Stanislavsky's system. Notable actors who promulgated this method of acting in the middle of the twentieth century were Marlon Brando, Maureen Stapleton, Jessica Tandy, James Dean, and Marilyn Monroe. These actors made realistic acting popular and influenced world theatre and film. Though many student actors do not know it, acting training programs in the United States, from small, informal classes to formal conservatory courses, typically begin with the system of training originally developed by Stanislavski.

STANISLAVSKI EXERCISE: This exercise is from Stanislavski's book *An Actor Prepares* (1964), which is written in narrative style from the perspective of a fictional young acting student who is taking classes with a fictional master acting teacher, Tortsov. In the book the student recounts an exercise from class in which Tortsov has given another young student, Maria, some fictional circumstances for her to personalize and then act out on the stage. He asks her to imagine the following:

> Your mother has lost her job and her income; she has nothing to sell to pay for your tuition . . . In consequence you shall be obliged to leave tomorrow. But a friend has come to your rescue. She has no cash to lend you, so she has brought you a brooch set in valuable stones. Can you accept such a sacrifice? . . . Your friend sticks the pin into a curtain and walks out. In the end you accept, your friend leaves, and you come back into the room to get the brooch. But—where is it? (35)

With this as the background, Tortsov gives Maria direction: "Go up on the stage. I shall stick the pin in a fold of this curtain and you are to find it" (35). In the book the young student recounts how Maria runs onto the stage and acts her heart out, by pretending to express emotion and by "holding her head with both hands" (36), before returning to join her fellow pupils

filled with a feeling that she has acted brilliantly. When Tortsov asks her for the brooch, however, she has completely forgotten her task because she has focused on trying to *pretend* like she was looking for it, rather than really looking for the brooch. This exercise can be done with any object or circumstance; the goal is to stop pretending to undertake a task and to really engage in the action.

Adler and American Intellect

Stella Adler (1901–1992) is one of the more infamous American acting teachers. She was born in the United States into an acting family; her parents were well-known actors in New York, and by the time she was five years old, she was performing with her parents on the Yiddish stage. Adler performed in New York until at the age of eighteen, she traveled to London, debuted on the London stage, and remained there to perform for the next year before returning to

Fig. 2.5 Stella Adler in a 1941 still from the Hollywood film *Shadow of the Thin Man.*

the United States. For ten years after her work in London, she performed across the United States, Europe, and South America. When Constantin Stanislavski visited the United States, one of the first people he contacted was Stella's father, Jacob Adler. Stella Adler was a founding member of the Group Theatre in the early 1930s, and in 1934 she traveled to Russia to study with Stanislavski. Upon her return, she began teaching her ideas about Stanislavski's system to members of the Group Theatre. Adler drew on but expanded Stanislavski's principles, and at the heart of her teaching was the idea that one's own life and experiences are not enough to draw on for roles, and that actors must use their imaginations to create dimensional characters. In 1937 she left New York for Hollywood, where she worked in films and continued to spread her theories on acting. In the 1940s she taught at the New School for Social Research in New York and later opened up the Stella Adler Theatre Studio—now called the Stella Adler Conservatory of Acting. Though she died in 1992, the legacy of her work is still evident in every aspect of American theatre, film, and television. Some of the many actors who studied with her are Robert De Niro, Warren Beatty, Candice Bergen, Kevin Costner, Melanie Griffith, Diana Ross, Martin Sheen, Benicio del Toro, Teri Garr, Harvey Keitel, Naomi Watts, and Edward Norton, to name only a few.

STELLA ADLER EXERCISE: Stella Adler was very interested in helping actors develop their imaginations. She created and offered hundreds of exercises in which her students had to use their imaginations to justify character actions and circumstances. In her book *The Art of Acting*, compiled and edited by Howard Kissel, she says, "Every action grows when you imagine it in circumstances" (2000, 145). Below is a simple exercise that asks the actor to do three things: (1) create justifications, (2) break down actions into several smaller actions, and (3) weave actions together to create a story.

Take three simple actions in sequence and build a plot around them:

(1) Look out the window
(2) Straighten the desk
(3) Take your hat and coat and leave

Or:

(1) Write something in a letter
(2) Start to telephone someone
(3) Pick up your pocketbook and leave (Adler 2000, 145)

An exercise such as this one asks actors to pair imagination and action. In other words, an actor in this exercise might use her imagination to create a justification for straightening the desk after looking out the window. What, for example, does the character see outside the window that propels her to her desk?

Boal and Social Justice

Augusto Boal (1931–2009) was a Brazilian teacher, theatre practitioner, and politician. Boal earned a doctorate in chemical engineering at Columbia University in the early 1950s, and then returned to his native Brazil to run the Arena Theatre in São Paulo. Bothered by the lack of plays that depicted the reality of Brazilian culture, people, and their lives, Boal developed an arsenal of techniques that he called the "theatre of the oppressed," which began by taking theatre to rural areas of the country to perform plays about topics of interest to local residents. The first of his techniques, called "simultaneous dramaturgy," involves the presentation of a play that presents an issue pertinent to the audience. After the performance, audience members are invited to offer suggestions to the actors about ways in which the characters might alter their behavior to bring about a different ending. This technique was very popular in the 1960s, and when one audience member became frustrated at the actor's inability to understand her suggestion, she took to the stage herself to show the performer what she meant. With this event came the birth of what Boal calls the "spect-actor," someone who both observes and acts, and simultaneous dramaturgy transformed into "forum theatre," a technique that has since grown very popular throughout the world. The notion of active participation is at the heart of forum theatre, where spect-actors observe short plays, then identify the protagonist, antagonist, and their allies, and finally brainstorm ways in which the issues at the center of the story can be discussed and dealt with before taking action to begin to problem solve. In forum theatre, which is documented more specifically in Section 4, the observers are also the participants. When a spect-actor calls out, "Stop," he or she then takes to the stage to replace an actor and continues the story via improvisation to test new actions, behaviors, and ways of thinking. Many different forums are played out, and in this way the group is able to discuss an issue and try out options. As mentioned in Section 1, because of his work in Brazil in the 1960s, Boal was imprisoned by the military dictatorship and eventually self-exiled, first to Argentina and then to Europe. In Argentina he created the "invisible theatre" technique, in which spect-actors do not know that they are witnessing a rehearsed and staged performance. Invisible theatre explores topical issues in short, site-specific locations. Later, in Europe, Boal developed the "rainbow of desire" technique, a process whereby participants work to uncover invisible elements, obstacles, and emotions in their lives that hinder their success or progress.

Fig. 2.6 Augusto Boal lectures at the Riverside Church in New York City, 2008.

When the military dictatorship ended in the 1980s, Boal was "invited" back to his home country. Encouraged by the new democratic government, he ran for political office and used forum theatre to pave the way for "legislative theatre," a process whereby different possibilities are explored as a way to propose new bills and laws. Boal died in 2009 after participating in the establishment of numerous centers for the theatre of the oppressed all over the world. With thousands of agencies, schools, and companies using his techniques, and with his concern for utilizing acting skills offstage, Boal has been established as one of the leading acting teachers in the world.

AUGUSTO BOAL EXERCISE: Boal believed that over time our responses to others and to our environment become habituated. In an effort to get people to utilize their senses—to really see, hear, and feel what they are looking at, hearing, and touching—Boal developed a series of games to stop participants from relying on habitualized patterns of actions. This game, "Person to Person," is designed to integrate the senses and to build a rapport with another person.

> Everybody gets into pairs. The workshop leader calls out the names of parts of the body, which the partners must touch together; for instance, "Head to head"—the partners must touch their heads together; or, "Foot to elbow"—one partner's foot must touch the other's elbow. The body contacts are cumulative, so that when the partners have put two parts of their bodies together, they must keep them together while carrying out the next instruction. The actors can make the contacts in any way they choose, sitting, standing, lying, etc. After four or five instructions which have tangled the pairs together, and taken the game to the limit of physical possibility, the workshop leader shouts "person to person" and the pairs separate and everyone finds a different partner—then the process starts again. (Boal 1992, 78)

Lecoq and Corporeal Expression

Jacques Lecoq (1921–1999) was the founder and director of Ecole International de Theatre Jacques Lecoq, where he taught classes in various acting traditions, movement, mime, and mask until the day before his death. Lecoq came to the theatre by way of athletics; he was involved in many sports growing up and studied at a college of physical education. During World War II, Lecoq vented his opposition to fascism through experimental performance work that involved gymnastics, mime, movement, dance, and song. With Les Compagnons de la Saint-Jean, he helped put on performance events, including an enactment of the homecoming of the prisoners of war to Chartres in Northern France, and it was in such a performance that he was spotted by theatre professional Jean Daste, who invited Lecoq to join his company and to also head the physical training of the company actors. Lecoq began his foray into acting education at this time, later saying, "It was not a question of training athletes, but of training dramatic characters such as a king, a queen—a natural extension of the gestures acquired through sports" (Lecoq 2001, 5). The similarities between the two disciplines of acting and athletics were forever a central focus for Lecoq, who said of the comparison, "I hardly noticed the difference" (5). After the war he traveled and performed, continuing to develop his theories that combined the laws of movement and dramatic creation, which he applied to many different acting forms, including melodrama, commedia dell'arte, and clowning. His curiosity for sharing his new ideas led him to found first the theatre school of the Piccolo Teatro in Milan and then his school in Paris, which continues to attract students from all over the world, many of whom go on to be performance educators.

Fig. 2.7 (photo: Mike Fink.)—An actor works with a a Lecoq inspired neutral mask.

First and foremost an educator, Jacques Lecoq developed a tool for actor training called "the neutral mask," which remained central to his teaching. This mask is a perfectly balanced mask that allows the wearer to experience complete neutrality which Lecoq defined in part as "a state of receptiveness to everything around us, with no inner conflict" (Lecoq 2001 36). The neutral mask has since become a part of many actor training programs all over the world because it offers the actor the ability to discover full neutrality to use as a starting point for character creation.

JACQUES LECOQ EXERCISE: Play and improvisation are important aspects in Lecoq's pedagogy that form the foundation for subsequent work. This is an improvisational exercise from Lecoq's book *The Moving Body* (2001) and was used in his beginning acting classes. It is a solo improvisation of indeterminate length played out in front of a group of other performers with vocal guidance from the instructor, so that the player does not know what is coming next and can truly experience the moment:

> You are sitting in a café. Opposite you, at another table, someone makes a small hand gesture in your direction. You wonder if you know her or not. Out of politeness, you respond in the same way. The person opposite, put at ease, begins to gesture more wildly, making large movements, playing with an object, smiling. Little by little, a complicity grows between you, a dialogue conducted in gestural signs or facial expressions. In the end, the person gets up and comes toward you, smiling. You too get up to greet her...but she passes beside you and goes on to someone behind you. (34)

Suzuki and Cultural Connections

Tadashi Suzuki (1939–) is a Japanese director and developer of the Suzuki method of actor training. Born in 1939, he studied at Waseda University and established his own company, The Suzuki Company of Toga. Suzuki is still working today, and his acting method focuses on a psychophysical approach to performance and on developing the actor's perceptive abilities. Suzuki works with performers to use their whole bodies as tools for expression. He emphasizes the connection bodies have to the earth beneath them as well as the connection the body has to emotion. His method blends martial arts, traditional Kabuki and Noh Japanese theatre techniques and practices, and physical actions to explore how the body and psychology work together. Suzuki's contemporary work builds "a bridge between Japanese and western theatre; his most famous productions are adaptations of Greek myths" (Brockett 2007, 637), and because his approach has been so successful in Eastern and Western productions alike, many performance companies and schools in the West have begun to offer classes and workshops in the Suzuki method. In his book *The Way of Acting*, published in 1986, he explains how movement is tied to language and how what he calls "the grammar of the feet," or the way in which the feet are used, is essential to establishing a basis for the rest of the body to move. The language of the body, the fundamental feelings produced through body positions, and even the sound the voice creates all begins, Suzuki believes, with the feet (1986, 10–13).

TADASHI SUZUKI EXERCISE: This exercise is taken from Chapter 1 of Suzuki's book *The Way of Acting*. Though this specific exercise might take place many times over the course of days or weeks and is accompanied by very specific instrumental music, this brief description by Suzuki offers us an excellent example of the juxtaposition between motion and stillness that Suzuki favors. The goal is to develop a "concentration of strength in the body" (1986, 8).

Fig. 2.8 (photo: Mike Fink.)—Students working with the Suzuki stamp.

I have one exercise in which I have them stamp their feet in time to rhythmic music for a fixed period. Stamping may not be the most accurate term, for they loosen their pelvic area slightly then move themselves by striking the floor in a vehement motion. As the music finishes, they use up the last of their energy and fall to the floor. They lie flat, in a hush, as though they were dead. After a pause, the music begins again, this time gently. The actors rise in tune with this new atmosphere, each in his or her own fashion, and finally return to a fully vertical standing position. (1986, 8)

Bogart and New Directions

Anne Bogart (1951–) is an American teacher and director. A professor at Columbia University, where she runs the graduate directing program, she is also the artistic director of the Saratoga International Theatre Institute (SITI), which she cofounded with Tadashi Suzuki in 1992. Her book *A Director Prepares* (2001) focuses on the artist's process of preparation and offers thoughts on how memory, violence, eroticism, terror, stereotypes, embarrassment, and resistance as human issues play out through performance. In another book, *And Then, You Act: Making Art in an Unpredictable World* (2007), Bogart explores the importance of making meaning and taking action with one's performances. Perhaps Bogart's most relevant work for young actors is *The Viewpoints Book* (2005), co-written with Tina Landau, which chronicles the development of a system of ensemble building and acting training called "viewpoints," which grew out of dancer and choreographer Mary Overlie's "six viewpoints of dance." Bogart first worked with Overlie in 1979, when they were both on the faculty at the Experimental Theatre Wing at NYU's Tisch School of the Arts. The original six viewpoints—space, shape, time, emotion,

movement, and story—provided a way for Overlie to structure her dances. Bogart expanded these to form the "viewpoints of time" (tempo, duration, kinesthetic response, and repetition), the "viewpoints of space" (shape, gesture, architecture, spatial relationship, and topography), and the "vocal viewpoints" (pitch, dynamic, acceleration/deceleration, silence, and timbre). Aside from the numerous acting programs and courses that now make use of viewpoints training, the work is important to note because of its departure from what Bogart has called "the Americanization of the Stanislavski System" (2005, 17), which places psychological intention at the fore of actor training. By contrast, the viewpoints system offers the actor a way to make choices based on not only a character's psychology but on an awareness of time and space as well.

ANNE BOGART EXERCISE: Bogart and the viewpoints training facilitators ask participants to begin working as an ensemble from the first moment. The work begins physically and demands focus from the collective unit before gradually increasing the level of difficulty. This beginning exercise, called "High Jumps," is taken from Bogart and Landau's *The Viewpoints Book* (2005):

> Standing in a circle, the group jumps in place together, as high as possible. The jump is not initiated by any individual but, rather, happens because of a shared consent. The goal is to simultaneously jump as high as possible, to land together in the same instant, and to land on the floor with as little noise as possible . . . This exercise should be repeated until the group has discovered how to accomplish the task. (26)

Fig. 2.9 (photo: Mike Fink.)—A viewpoints workshop at the University of Montana.

INTERVIEW

Zoe Alexandratos, an educator in a public elementary school

My experience and training in acting are integral to my work as a teacher. I tend to think of my teaching as a one-woman improvisational piece that happens each school day. A teacher must engage her audience, the students, impart her message, and entertain the group. I need to be able to play to my crowd, to be flexible, and to feed off their energy. I have to have a sense of humor, because kids always want to have fun. My gestures, my stance, my voice, are all part of this "character" of the teacher. Like any performance, I want my audience to go away satisfied, feeling that they have gotten something out of the experience.

These skills are also important as I deal with parents. When I am with parents, particularly those who are anxious about their child, I need to be able to observe the parents carefully to best understand what they need from me. I have to read the situation, and I have to be very sensitive to their insecurities. I have to be able to imagine their perspective and worries, to see their child through their own eyes.

I am constantly calling upon my own imagination to develop lessons and create interesting educational experiences for my students. I also encourage my students to develop their imaginations to move beyond mere concrete thinking into the abstract world. They must imagine a vast universe, the beginning of the Earth, or what it must have been like to live in the Middle Ages. They must be able to imagine what they want the world to be like in the future, what they want their own lives to be like, in order to begin creating those realities.

My co-teacher tells me that one thing I am the best at is speaking the truth to people in a way that they can hear and understand—that I truly see the good in everyone, that I can find something to love about everyone, and that I can help them see what is true about themselves. I think that may be the highest goal of an actor: to love humanity, and to show humanity the truth about what is good.

My acting skills have also opened many doors for me in my personal life. Being able to step outside myself and have the confidence to take risks has helped me start many a friendship. Having empathy and being able to read a situation has made it easier to navigate social situations. Before my training in theatre, I was not comfortable in large social settings, but I was able to learn how to "schmooze" when I had to. And, of course, being a spouse and a parent often takes good acting skills. I am not being false with them; I am using good body language, intonation, eye contact, and improvisational skills to be more real. I can express what is in my deepest heart in a way that my husband and my son can access. I am unafraid to tell them how I really feel, to be playful with them, and to imagine a future with them that we all want and can work for together.

WORKSHEET: WHAT WORKS FOR YOU?

Describe your experience with the above exercises. What did you like? What was a challenge? What resonated with you? What did you not understand? Why do you think actors might benefit from training in such various methodologies?

Constantin Stanislavski: _____

Stella Adler: _____

Augusto Boal: _____

Jacques Lecoq: _____

Tadashi Suzuki: _____

Anne Bogart: _____

Choose one of the exercises and explain how it might help an actor develop into a stronger performer.

Choose another one of the exercises and explain how it might be useful for a non-actor as he or she cultivates communication skills.

THE
ACTOR'S
SKILLS

Good acting—real acting—is impossible to spot.
Do you ever catch talents like Robert Duvall
or Kathy Bates acting?
No. I defy you to show me where.

—William Esper

Just as a mathematician has a set of tools to draw on to solve equations, so does an artist have tools that she draws on to create. A painter needs not only paint and brushes but also an understanding of perspective, an appreciation for color and texture, and knowledge of different painting techniques. A musician typically has an instrument but also the coordination to play the instrument, the ability to read music, score timing, and create rhythm. Actors too have a variety of tools that help them produce strong performances. But these tools are not something that the actor is born with any more than the mathematician is born with knowledge of prime numbers. The tools the actor uses must be learned, cultivated, and then continually sharpened so that they are at the actor's disposal, ready when needed. Actor training involves learning specific communicative tools and then applying and rehearsing such tools. These must be honed and perfected, and rehearsed into skills—extraordinary abilities the actor can make use of in every performance. So, what are the communication skills actors spend years learning, and why are they the key to great performances?

Fig. 2.10 (photo: Mike Fink.)—Actors take part in a vocal warm-up.

The Voice

One of the most important tools an actor has is his or her voice. The ability to use sound and language enables actors to communicate with their audiences and with other characters in a story. Actors use their voice to be heard; to convey character personality; to show class, education, and ethnicity; to express feelings; to react to events; and to guide the attention and responses of others. Actors study how to use their voice to direct us when to listen, how to listen, and what to hear. To gain a talent in this area, actors learn a variety of different skills that develop their vocal apparatus and support them as they use their voice to communicate meaning. A class in voice or speech or an acting class that makes use of the voice and explores vocal possibilities might look at the following components of the actor's sound production.

Volume: Volume is the degree of loudness produced in a sound. Of course, actors need to be able to be heard by an elderly person sitting in the back of a two-thousand-seat theatre, but they also need to be able to vary their volume, sometimes very rapidly, and they need to be able to produce a whisper of a sound that is loud enough to be heard but soft enough to suggest quietness. Finally, actors need to be able to be loud or soft without harming their voice. In voice classes students engage in the process of expanding their volume while supporting their vocal instruments, so that they can be vocally effective day after day, year after year.

Projection: Projection is the control of volume and the placement of sound for greater audibility. An actor needs to be able to position sound so that it lands in a certain area. An actor who has studied projection is able to position his or her body and mouth so that the text can reach the audience or microphone, which is often far away. As with volume, it is important for an actor to understand how to take care of her voice as she projects so that the sound is freed and not forced or pushed.

Diction and Articulation: Diction is the pronunciation and enunciation of words to create a better clarity of speech. Articulation is the joining of individual words, phrases, and thoughts to create such clarity. It is important that the audience hear the exact words an actor speaks as they have been written by the playwright or screen or television writer because they have been written for a specific purpose. Actors need to learn to enunciate carefully without sounding unnatural and to articulate words strung together as thoughts so that the audience does not hear disjointed words or phrases but rather clear and whole thoughts and statements that combine together and have significance. If an audience has a difficult time ascertaining what is being said, they stop listening.

Pitch: Pitch is the position of a sound within the complete range of sound, from low to high. Having a wide range of pitch is important for any actor. Higher pitches often connote youth or femininity, whereas lower pitches can express power, age, or seriousness. The opposite of a varied pitch is a monotone voice, which uses the same note over and over. Just as a song uses varying notes, so must the voice to convey character, feeling, urgency, and intention.

Pace or Tempo: Pace, or tempo, is the speed at which a sound is produced, ranging between fast and slow. Varied pace is important to creating diversity in the language and sound and also demonstrates the urgency and importance of the subject matter. There are also technical aspects of pace that an actor needs to be able to master. Sometimes a line needs to fit into a specific time slot. For example, an actor might need to speak very rapidly (think of the commercial actor who has twenty seconds to convince you to buy a certain product) and still be understood.

Timing: Timing is the regulation, placement, or occurrence of sound to achieve a desired effect. Timing includes how long or short a time a certain word or sound might take to make, as well as pauses in between words, sounds, sentences, or phrases. Actors need to develop an acute sense of timing in the delivery of their lines to create an effect on the audience and the other characters in the story.

Rhythm: Rhythm is the regular and repeated pattern of sound. People often have specific rhythms or cadences to their speech. They may, for example, tend to stress the first word of each sentence or slow down their pace toward the end of a thought. Actors need to be aware of their own speech rhythms and adapt these to suit the needs of the characters they portray.

Resonance: Resonance is determined by where the vibration of a sound is placed. Air passes through body cavities on its way out of the mouth. The sound quality and timbre is affected by where the sound vibrates on its way out of the body. Actors use many parts of their body to create resonance. They learn how to place a resonance in the nasal cavity to create a bright sound versus a chest resonance, which creates a richer and deeper sound and perhaps a warmer or more intimate voice.

Tone: Tone is the quality, feeling, or attitude expressed in a word or sound. Actors often use tone to support what they are saying or to express something different from the text. Tone adds another layer and dimension to the language itself. Although tone can and does encompass many of the other vocal aspects, including pitch, volume, and resonance, it is the incorporation of these that builds to an overall characteristic of a sound that tone establishes. An actor is able to add meaning beyond the language itself when she expresses her feelings through tone.

Inflection: Inflection is the rise or the fall of a sound. Actors learn to control their inflections minutely. Often audiences perceive lines being finished or points being made when inflections fall because a falling inflection often signifies that the conversation is over or that the focus is being passed to another person. Conversely, when an actor's inflection rises, audiences tend to continue listening and giving their focus. Classical actors make great use of rising inflections. The American dialect typically deflects consistently at the end of each sentence and sometimes at the end of words and phrases. Deflections tend to change the direction or course of any statement and thereby drive the audience further away from what has been said. This can serve a positive purpose if, say, the speaker wishes to change the subject, confuse the listener, or end the conversation. Could this be a reason British actors often pull off classical roles better than Americans? Actors need to be aware of the implications of deflecting or inflecting their sounds and the results that accompany such surges.

Intensity: Intensity in sound is a more abstract concept. Intensity is the degree of strength or force behind something; think of an intense heat, an intense light, or an intense conversation or person. The intense conversation, for example, might be long or short, good or bad, but it leaves a lasting impression and seems to have an energy behind it. The same pervading idea is involved with an intense sound quality—it is unforgettable. Actors use intensity in their sounds to stress or give more emphasis or energy to a word or phrase, or to juxtapose meanings.

Breath: Breath is the air that is taken in and sent out from the lungs through the nose or mouth. Having strong breath control, while allowing the breath to remain free and unforced, permits actors to speak often and for long periods of time, without pausing to catch their breath. Breath also supports the other aspects of the voice. For example, it takes more breath to speak loudly than it does to speak at a regular volume. And breath is key in taking care of managing the voice and the vocal instrument. When breath is inhibited, sound is not as easily made. Vocal expert Kristen Linklater tells us in her book *Freeing the Natural Voice*, that a beginning goal for breath support is, "to develop the ability to observe without controlling." She goes on to conclude that to "remove habitual muscular controls and allow your involuntary processes to take over" will help to ease breath and produce a stronger sound source (2006, 44). Actors learn to support their breath by freeing up specific muscles in the stomach (including the diaphragm), chest, neck, jaw, and mouth.

Regionalisms and Dialect: Sounds or pronunciations that are characteristic to a particular geographic area offer audiences clues about the story and the characters in it. Our speech conveys much, and the patterns, rhythms, inflections, and articulations of our speech influence the way we think, the way we move, and the way we feel. Actors spend a great deal of time losing their dialects and developing a more neutral way of speaking. In the United States actors learn to speak what is called "standard" or "general" American English," a dialect that offers

no clues whatsoever about where a person is from or has resided. Not only is this general speech important for plays with undisclosed or all-encompassing settings, but it is also a wonderful jumping-off point for an actor to learn any other dialect, from Russian to Cockney to South Asian Indian. Actors master standard or general speech by studying the international phonetic alphabet (IPA), a codified set of symbols representing all sounds made in language.

EXERCISE

Try delivering a short speech in front of a group without considering any of the aspects of your voice. Any speech will do. It can be a monologue, a poem, something from a newspaper or magazine, or a speech referenced in the back of this book. Try delivering the lines in front of an audience. Now, warm up your voice with a vocal warm-up such as the one below. As you take part in the warm-up, consider exploring one or more of the vocal components listed previously. After your voice is warmed up, recite the speech again in front of an audience. Discuss the differences.

VOCAL WARM-UP: Stand in a neutral position, relaxed and ready. Start with good posture and deep, relaxed breathing. Relax your jaw and let go of unwanted tension. Run through vocal singing scales using a humming voice. Start quietly and with a low pitch. Do this ten times. Repeat the scales using the five vowel sounds again, keeping it low and slow. Slow vowel scales, in lower registers, will allow you to extend the range of your voice from high to low. As you progress through the warm-up, your higher pitches can be engaged. Keep checking in with your breath and tension. Next, experiment with lip and tongue trills using the consonants B, P, and R. Try adding in the scales with the trills to extend your range. Try a tongue twister such as the one below. Try the tongue twister using different dialects, volumes, and resonances:

> *Betty Botter bought a bit of butter*
> *But the butter Betty Botter bought was bitter*
> *And it made her batter bitter*
> *So Better Botter bought a bit of better butter*
> *To make her bitter batter better.*

WORKSHEET: YOUR VOICE

What did it feel like to warm up your voice? Did your voice feel more free or open or ready to use after the warm-up?

Which aspects of your voice did you incorporate into your speech the second time around (volume, resonance, breath)? Why did you choose those specific components to explore?

What was the outcome the second time you spoke? How did your performance change between the first and second speech delivery?

What vocal components would you explore if you were to do the speech again? Why?

Set a vocal goal for yourself. Work on this weekly until you see improvement.

A vocal goal I have is to _____

Fig. 2.11 (photo: Terry Cyr.)—Professor Nicole Bradley Browning works with students to warm up their bodies before performing.

The Body

The body is perhaps the most visible tool the actor needs to have at his disposal. The ability to communicate through movement, both subtle and demonstrative, is considered one of the most important skills any actor can possess. An actor's body, along with his voice, communicates story, character, and feelings. The entire body, from the top of the head to tip of the big toe, plays a part in the actor's performance, and it is up to him to learn how to use the body as a whole unit to convey meaning and also how to isolate body parts. The body, and the way the body moves in space and around other people, communicates meaning to the audience and to other characters in the performance. The body also gathers and stores emotions for the performer himself, thereby creating a feedback loop between the mind and the movement the mind presents to others. Actors must have physical strength and agility, and they must be comfortable in their bodies so that they can use them in a variety of ways. Actors also need to be able to conceal nerves or emotions in their speech and not have their bodies reveal these hidden aspects; as such it is important that actors have an understanding of kinesics, the interpretation of all body language, including the use of gestures, body positioning, and facial expressions. Classes in movement, physical theatre, and dance are essential components of acting programs because they expand physical awareness, offer new approaches to creation, and connect the body to the voice, mind, and emotions. Classes in these areas might deal with or incorporate some of the following areas.

Body Language: Body language is a term that encompasses the entirety of nonverbal body posture and movement and often reveals clues about unspoken intentions or feelings. Any nonverbal behavior, either from isolated parts of the body or the body as a whole unit, is considered to be a language that the body communicates to itself and to others. An actor uses body language consciously and often overtly to clue the audience into an attitude or state of being that perhaps is even hidden to the character. It is an actor's job to be in control of the audience's perception of his character, and having another tool in the form of body language to express either conscious or unconscious feelings is important.

Eye Contact and Eye Movement: Eye contact is important for any actor. You've probably heard the old English proverb, which has been attributed to many different sources, "The eyes are the window to the soul," and articulates how important the eyes are in expressing and reading sincerity. Actors use their eyes to express their thoughts, needs, and emotions. Furthermore, maintaining eye contact expresses how much a person is willing to share with another or how much control they are willing to relinquish or assume. Actors use their eyes in a very intimate way to communicate, and even when the audience is far away, they generally focus their attention on the performer's eyes first and foremost.

Kinesphere: Kinesphere is best described as the area the body is moving within and how the mover pays attention to, and exists within that area. There are individuals who demand a very large kinesphere, and others occupy a small kinesphere. A person can make large movements in a small kinesphere or make small movements within a larger kinesphere. Some people make certain that their kinesphere does not enter into the kinesphere of another, while others will consciously or unconsciously enter into another's space. There is a wonderful 1994 *Seinfeld* episode titled "The Raincoats," in which Elaine's new boyfriend Aaron is what Jerry calls a "close-talker." Aaron enters into the kinesphere, or personal space, of everyone he talks to; this provides great comedy for the audience while frustrating almost everyone he communicates with. Actors become aware of their own kinesphere and also understand that the kinesphere of their character can be different from their own.

Gesture: Gesture is a movement of part of the body, most commonly associated with the hands, arms, or the head, to express an idea or to suggest or make meaning. Gestures often have universal connotations, and as such they are very helpful to actors to express meaning but also to demonstrate emotions. Many gestures are unmistakable in nature. Take, for instance, a gesture with both arms raised high in the air in a "V" formation. If you assume this gesture and combine it with a forward and straight-ahead gaze, it offers the performer a sense of power and accomplishment, and it showcases these same feelings to the audience. A hand over the heart offers both performer and audience a feeling of strong emotion, and an arm outstretched with a pointed finger has the connotation of a threat of some sort. Actors often study gestures as they observe people who make gestures and internalize the meaning so that gesture becomes another layer of storytelling at the actor's disposal.

Gait and Stance: Gait is the manner of foot movement and includes the sequence and rate of movement. Stance is the manner and position in which a person stands. Whereas gestures often emanate from the torso and utilize the arms, one's walk and standing position typically

originate in the feet and legs. Beginning with the foot positioning in a standing posture, the placement of the feet reveal a great deal. Feet close together express propriety and sometimes submission. When feet are placed together, the body appears smaller and offers the audience dominance. In comparison, feet placed wide apart are often an attempt to make the body appear larger than it is. If you've ever hiked the backcountry, you've probably been told to make yourself appear smaller if you come across a bear and larger if you come across a mountain lion, and you'd probably do this first by positioning your feet and legs together or apart. An actor knows how to use the placement of feet to give off the air of intimidation or openness. The direction toward which the feet are placed also conveys a great deal and influences the receiver of the communication. Actors learn to place their feet directly toward the person they are speaking to if they want to give that person their full attention. A shifting of weight or tapping of feet lends a feeling of impatience, and a cocked hip reveals attitudes of boredom, judgment, or a powerless posture seeking to conceal itself under a mask of conceit. Gait, or foot movement, is used by actors to communicate as well. The pace, rhythm, and lead of the gait can establish character motive, want, or emotion, and it can indicate age, gender, health, and class.

Alignment: Physical alignment for an actor means the placement and adjustment of all body parts so that they are in proper relative position to one another. Alignment often begins in the spine, and actors learn early on how to stack their vertebral column so that each of the thirty-three vertebrae build off the vertebrae underneath. There are numerous exercises actors engage in that help them learn how to align their spine and, from an aligned spine, how to align the rest of the body so that the parts can work together and separately. The posture that an aligned body presents is one of readiness, confidence, and health, and knowledge of how to create this posture is invaluable to an actor who needs to present himself to an audience. Standing tall instills confidence in the performer and in the audience's perception of the performer. Slouching or hunching the spine presents an inward curve to the audience and is connotative of insecurity, age, ill health, and poor composure. Actors are often exposed to the Alexander technique, developed by Australian actor Fredrick Mathias (F. M.) Alexander at the beginning of the twentieth century. Alexander found a strong correlation between his own alignment and his vocal production and subsequently went on to look for such connections in others (McEvenue 2001). The Alexander technique is now used by millions of individuals, performers and non-performers alike, around the world and by people from all disciplines to learn how to get rid of harmful tensions in the body and to learn to move with ease.

Balance and Stamina: Balance is the equal distribution of weight to create steadiness. Physical stamina is the ability to sustain a prolonged effort in the body. Both work together and alongside many other skills to enable actors to move flexibly as they inhabit the body of their character and, through the character, inhabit another world. Of course, an actor needs balance and stamina to play a nimble dancer, but these skills are also necessary for the actor who plays the sick character who is twenty years her senior. Such a character might have a very different posture, gait, and endurance from the actor; thus, the actor needs to have the strength and balance necessary to engage with this role for a sustained period of time.

Flexibility and Agility: Flexibility is the range of movement in joints and muscles. Agility is the ability to change the body's position efficiently, with ease, and at any desired pace. When an actor portrays another being in the form of a character, he is assuming, if only for the duration of

the performance, the voice, mind, heart, and body of someone other than himself. His character behaves and thinks differently, talks and sounds differently, and moves differently. If he is in a play, he might perform his role every night for months. If he is in a film, he might perform his character for shorter but very intense moments for the duration of the filming, which can take up to one year. Assuming the physicality of another can take its toll on the actor's body, and, therefore, it is essential that the actor take care of his body to make sure that it is limber in the joints and muscles and able to move into any position that his character might assume.

Neutrality: Neutrality is the relaxed, lengthened, and aligned state of the body. It is a position of readiness and equips the actor to be prepared for any subsequent movement, emotion, or event. It is the essential position for an actor to take just before entering into the world of the character or story. Yet with so much tension in our bodies and because our thoughts, feelings, and behaviors transpose themselves into the physical, neutrality is a difficult state to find and one that requires tension-free focus. The neutral position is a stance that actors become well accustomed to holding, and they spend a great deal of time learning how to let go of their personal tensions and postures.

EXERCISE

Choose an extremephysical task to pantomime in front of a group. Examples might be rowing a boat, lifting weights, cleaning the house, or getting ready to go out. Perform the actions before warming up physically and then again in front of the same group after you have followed a physical warm-up such as the one below. The second time focus on some of the specific physical skills listed above.

PHYSICAL WARM-UP: Run through the basic sun salutation series in yoga, Suriya Namaskar. If you are unfamiliar with this series, as many people will be, there are excellent examples on the Internet, including this video from Brooklyn Yoga School (www.youtube.com/watch?v=73sjOu0g58M). Perform the sun salutation three times, slowly and with breath. Then warm up your joints by rotating each part of your body clockwise and counterclockwise ten times: head, shoulders, arms, elbows, wrists, legs, and feet. Next, twist your spine to the right ten times and then to the left ten times. Roll down your spine, vertebra by vertebra until your body is forming an inverted V. Bend your knees and let your arms hang loose like a rag doll. Roll up slowly, vertebra by vertebra, letting your shoulders roll back and your head float up at the very end. Pick up your wrists, now your elbows, then your arms, and let them rise above your shoulders and rotate behind your back so that your spine is now curved and your chest is exposed and opened up. Come back to a neutral standing position with unlocked knees and vigorously shake out your right hand ten times, your left hand ten times, your right foot ten times, and then your left foot ten times.

Repeat with each limb nine times, then eight times, then seven times, and so on. Finally, expand your kinesphere and face to make them as large as possible and then pull in your kinesphere and facial muscles to make them as small as possible. End by returning to a relaxed and neutral position.

Observation

An actor cultivates an increased awareness of the world, the other inhabitants of the world, and herself through habitual daily observations and observational exercises. The knowledge gained through observation gives her the ability to reproduce, as close to possible, authentic moments, actions, and persons, which in turn are performed for an audience. The ability to observe is a skill gained and maintained by consistent and thorough watching and listening and by continually reflecting on what has been taken in. All any actor really knows to begin with is her own experience. She can use her experiences in the service of many of her characters, of course, but when she portrays someone different from herself, she relies on her observations of other people. In this way her observations are a collection of material for use in performances. Her inquiries and explorations into observation are yet another tool in her arsenal.

The World: Actors observe the world around them in minute detail. It is their job to do so. They are generally hyper-aware of the natural, physical, social, and cultural environments of their habitat, and this is because they have learned how to observe details that exist within the environments that they move in and out of. It is because the actor has observed many different environments that she can create and live in an imaginary world in a rehearsal or performance; she is merely drawing on previous observations to provide the foundation for the fictional environment.

Fig. 2.12 (photo: Mike Fink.)—A classroom exercise in observation.

Others: Actors observe people and the ways in which they function, behave, and relate to one another. They do this constantly, and they store away the information gleaned for future use. Through the observation of others, actors learn how specific and varied individuals are. They study the gestures and movements, the voices and language, the actions and reactions, and the behaviors and moods in order to more completely understand people and how and why they do the things they do. Actors are anthropologists of the human heart; they are studiers of human behavior. They collect and catalog their observations of others in order to draw on them as they perform characters other than themselves.

Situations and Moods: Through their observations of events and situations, actors learn to read the tone or mood of a circumstance. Actors typically can "read" a room fairly accurately, almost as if they were taking the temperature of the space and its inhabitants. They do this naturally because they have been taught to observe small details in environments and to constantly be aware of how people relate to each other. This skill enables them to easily gauge emotions and attitudes that are prevalent because they have observed and recorded those same sentiments in other circumstances.

Actions and Reactions: Actors have learned from observation that for every action, there is a corresponding reaction. They have witnessed this rule countless times in their daily observations of people and events, and they have internalized this rule and used it to guide the psychology of the character they are playing so that their character authentically reacts to every action witnessed. Actors transfer the knowledge they have gained through the observations of the actions and reactions that exist between people and events into the role they are performing.

Self: Actors also observe themselves and their relationships, their environments, their actions and reactions, their emotions, and their sensorial responses and perceptions, and they use this information from self-observation when they create and perform their characters. The more an actor understands herself, the more she can understand others. Many actors use Stanislavski's concept of "sense memory," which values the importance of the five senses in our perceptions, interpretations, and feelings. The concept of sense memory is that our memories are connected to physical conditions we experience. Actors observe their experiences with an awareness of their sensory perceptions and responses, and they store this away, often subconsciously, for future use.

EXERCISE

Choose a person in the group to observe, but do not let that person know that you have chosen him or her. Perform your observation of the person twice for the group, first without any additional observational time. Stand up in front of the group and seek to incarnate the person you observed by capturing his or her movements, voice, personality, and so forth. After you have done this, take time to observe your chosen person much more carefully. Observe his or her voice, physical mannerisms, emotions, dress, interactions with others, self-awareness, and habits. Watch him or her closely, record your observations, and rehearse your observations so that you are capturing detailed and specific behaviors in your performance. Now perform the person you observed a second time in front of the group. Discuss these two performances. See if there is recognition from the group of the individual you imitated.

Imagination

Imagination is the ability to form new images and ideas, based not on what is seen, heard, felt, smelled, or tasted but on things that have not been experienced firsthand. Imagination is how actors portray characters other than themselves and how they make the experiences their characters have in fictional or historical performances seem real. Imaginative skills help actors see beyond what is real or obvious to form new ideas and behaviors. Conceiving of characters, emotions, stories, behaviors, and ways of thinking that are different from those the actor himself has ever experienced requires a vivid imagination. And developing imagination is like developing any other skill; imagination must be practiced and explored before it becomes second nature. "The theatre," Stella Adler used to tell her classes, "exists 99 percent in the imagination." Acting classes consistently draw on the imagination to ask actors to create characters, relationships, events, and worlds and to suspend that belief for the duration of the exercise, rehearsal, or performance. Actors are constantly imagining. They imagine that they are staring out at the ocean when they are only looking toward the back of the theatre, or they imagine that they are drinking a ripe, old scotch rather than apple juice, or they imagine that they are flying through the air when they are really only standing in front of a green screen in a studio simulating flight with their arms.

Fig. 2.13 Even adults can benefit from imagining that they are a superhero.

Visualization and the Senses: An actor, whether performing his character live or on camera or video, is working in a fictional world. By this, I meant that he is, generally speaking, in an environment that has been manufactured for the specific production. He might be filming a scene in which his character is driving eighty miles per hour on a curvy mountain road car, but in actuality he is in front of a green screen with only a steering column to work with. Or he might be performing in a play that is set in a beachside resort, but in actuality he is on a small wooden stage in the basement of a building in a metropolitan city. In both of these cases the actor must visualize the aspects of the setting that are not present. And sight is not the only sense an actor draws on for visualization, although it might seem the most obvious. The actor must also draw on the other senses to build a full picture. He must also imagine that his other four senses are experiencing the sounds, smells, sensations, and tastes that correspond to the world of the story in which his character exists. Actors also often need to visualize other people who are not present. For a close-up shot, for example, the actor might be speaking directly to the camera, as if the camera were another character. Without the ability to visualize and use his other senses to imagine, the actor experiences only what is in front of him in reality.

Imaginative or Fantasy Play and Transformative Play: All play involves using our imagination to move outside of the bounds of the current reality. In imaginative play, also referred to as fantasy play, we invent scenarios from our own imagination and live through them mentally or act them out. These often involve the participant playing a character different from her personal or social self. In transformative play, participants use their imagination to transcend beyond what is known or understood. They might wonder about things that they have no experience with or knowledge of, but through imaginative thinking they unearth new knowledge or abilities within their own mind or body. Of course, actors engage in imaginative play whenever they assume a character. They might have a great deal of information from the writer of the script they are performing from, but no author can provide all of the information essential to creating a dimensional human being. It is the actor's job to use the circumstances provided by the author, called the given circumstances, and to fill in the blanks by imagining everything else.

Problem Solving: An actor is always solving a problem. Whether it is how to cover for a missed line, how to juggle an awkward prop in a scene, or how to ignore a ringing cell phone in the audience, the actor must be able to solve a variety of problems quickly and without losing focus. Problem solving is a mental process that involves discovering, analyzing, and imagining the solutions to a problem and the repercussions that might ensue before actually tackling the problem to ensure a high rate of success. In live performances problem solving is incredibly important because a missed line, a dropped prop, or an actor who acknowledges a cell phone in the audience destroys the illusion that the performance depends on. A film or video actor must solve problems quickly because of the money involved in the production. In this instance an actor who can't solve a problem quickly and calmly is difficult to work with and costly. Problems occur at a very high rate in performance, because it is in performance that the worlds of reality and fiction meet, causing friction for the person who inhabits both worlds simultaneously, as actor and as character. Because of this constant practice actors tend to be able to solve a variety of problems with ease.

EXERCISE

Try creating an entirely new superhero in your mind, a hero you have never considered before. What would this character be? Explain your superhero to a group. Now, take some time on your own to really imagine your superhero. Find a spot where you can be alone and close your eyes. Try visualizing your superhero in front of you. What does he or she look like? What costume is he or she wearing? How does the superhero move? What magical or supernatural powers does he or she possess? How does he or she use such powers? Visualize the superhero saving someone. Open your eyes and stand up. Try acting out the superhero so that you can experience him or her rather than observing him or her in your mind only. Ignore the others in the room, the walls, and the boundaries. Give yourself permission to try this. Really commit to your imagination! See only the world of the superhero—the colors, the objects, and the images he or she sees. Imagine that anything is possible. Imagine that you can fly, leap, or shoot webs out of your wrists!

Concentration and Relaxation

Often we think of concentration and relaxation as two separate abilities, and they certainly can be, but they also work together. *Relaxation* is about reducing stress and refreshing the body and the mind. When the mind and body are refreshed and unstressed, their ability to attain and sustain concentration is increased. Physiologists understand relaxation as a lengthening of inactive muscles, and physicists view relaxation as a return or adjustment of a system to equilibrium following displacement or abrupt change. Relaxation provides new energy and allows us to more readily focus on a task. According to the staff at the Mayo Clinic, relaxation techniques reduce stress symptoms because they slow the heart rate and breathing, lower blood pressure, increase blood flow to major muscles, reduce muscle tension that causes chronic pain, improve concentration, and reduce anger and frustration, all of which boost confidence to handle problems (Pestka, Bee, and Evans 2010). The ability to pair relaxation with concentration assists the actor in maintaining both qualities. *Concentration* is the ability to give something close and undivided attention and is more readily achieved when one is in a state of relaxation. Actors depend on their abilities to concentrate and relax all the time, because without these fundamental skills, nothing else is possible. Classes in acting teach and promote concentration and relaxation and also demand that the actor use these skills on a daily basis.

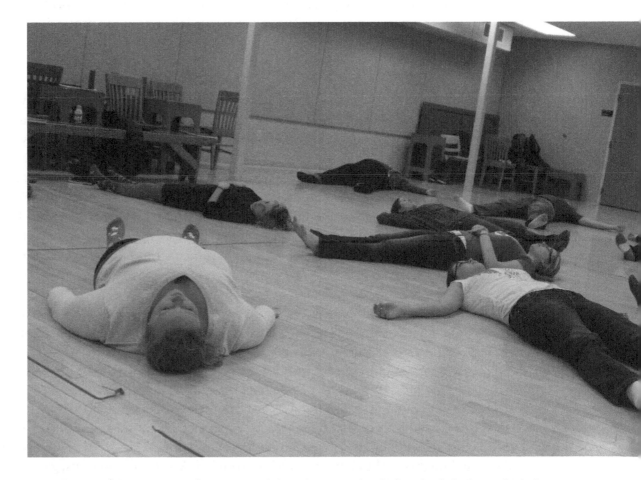

Fig. 2.14 (photo: Mike Fink.)—Actors participate in an exercise designed to help them relax before they engage in scene work.

Memory and Recall: Most actors need to be able to memorize huge portions of lines and to recall those lines in difficult situations (in front of a demanding audience complete with crying babies, giggling teenagers, and coughing patrons, or in front of a crew of fifty with microphones dangling just above their head). And they need to be able to recite the lines perfectly, as they were written, and in a specific amount of time, which requires infinite amounts of concentration and relaxation. Yet most actors will tell you that memorizing lines is the easy part of the job. This is because actors have learned how to memorize quickly and accurately. Professors Helga and Tony Noice, study memory. In a 2006 article they discuss how actors approach memorization, "At no time did the actors attempt to memorize words directly, but rather they tried to discern why the characters would use those particular words to express that particular thought" (15). Because actors view lines as clues about the character, they are not just memorizing language; they are connecting the language to the story and the character's personality and intentions. Actors also memorize lines at the same time that they are memorizing the physical movements their characters make. This pairing of mind and body provides a harmony of speech and action and assists the memory and ability to recall.

Repetition: The French word for rehearsal is *répétition*. This is what actors do in their training: they explore through repetition and repeat, over and over, exercises, observations, characters, and scenes until they discover what works best. Theatre performances occur night after night, and film and video work is rarely caught in one take and often involves repeating scenes and portions of scenes numerous times. Because repetition is inherent in the profession, actors have learned to embrace recurrence and to concentrate through repetitions. And accurate repetition is more easily accomplished when an actor is relaxed and able to concentrate.

Endurance: For an actor, endurance offers the ability to exert energy in an activity for a prolonged period of time, even in the face of adversity. Actors need to be able to resist and recover from the fatigue, problems, and pain and suffering that they might experience as well as what their character might face. An actor learns how to narrow her focus so that she can offer her full focus, and this helps filter out everything else, including her level of exertion. Endurance and concentration work hand in hand. Relaxation decreases the stress on the actor's mind and body and allows her to concentrate and endure concentrated amounts of work, late nights, and early mornings, and problems that arise in and because of productions. The training the actor takes part in cultivates the ability to endure difficult times as well as fatigue without succumbing to illness and stress.

Clarity: Whether it is the communication of a theme, a character's motivation, or a message, the actor is always communicating to her audience. The more clear her communication, the more likely it will be understood and remembered. Clarity arises when the actor herself has clearness of thought. Relaxation and concentration work in concert and engender the actor with the ability to define her ideas. With clear ideas comes the ability to clearly express such ideas, which then allows for the communication to be received in the way it was intended. Clarity assists the actor as she looks to discover why her character behaves the way she does. Clarity helps her to solve problems, and it helps as she communicates her own thoughts to her ensemble members as well as the thoughts of the character she is portraying. Actors, like all of us, gain clarity more readily when they are able to focus their close and complete attention.

EXERCISE

Take five minutes to try to memorize the following portion of a song from the 1879 Gilbert and Sullivan musical, The Pirates of Penzance:

> *I am the very model of a modern Major-General;*
> *I've information vegetable, animal, and mineral,*
> *I know the kings of England, and I quote the fights historical*
> *From Marathon to Waterloo, in order categorical;*
> *I'm very well acquainted, too, with matters mathematical,*
> *I understand equations, both the simple and quadratical,*
> *About binomial theorem I'm teeming with a lot o' news,*
> *With many cheerful facts about the square of the hypotenuse.*
> *I'm very good at integral and differential calculus;*
> *I know the scientific names of beings animalculous:*
> *In short, in matters vegetable, animal, and mineral,*
> *I am the very model of a modern Major-General.*

Try speaking the text a few times, and then without looking, see how much you can recall and how accurate your recollection is. Now find a space in which you can relax. Lie down or sit in a comfortable, tension-free position and forget about everything else. Focus not on the task of memorizing but on the words. Who is singing or speaking this speech, and what is it about? Repeat the first line again and again out loud, as the character of the Major-General himself: "I am the very model of a modern Major-General." Once you have repeated it at least six or seven times, add the second line to the first: "I am the very model of a modern Major-General; I've information vegetable, animal, and mineral." Continue in this vein until you have made your way through several lines. Now try reciting the lines in front of a group and see if you were able to be more accurate. If you would like, try this again with movement. Choose a specific place or position to be in for each line and see if your memory improves when the lines are connected to a physical statement.

Improvisation

Improvisation is the ability to be in action without planning the action in advance. Actors use this skill overtly when something goes awry in a production to keep the action moving forward or in improvisational performances, which often involve audience participation and make use of the actor's ability to create on the spot. Improvisation can also serve as a way to devise stories or characters. Finally, actors use improvisational skills as they work to discover who their character is and what their character wants and needs. An experienced actor uses improvisation to explore the depths of their character's psyche. In his younger years, Stanislavski would often inhabit his characters for a significant period of time in order to understand how they might go about their day-to-day activities. He had no script to follow, only the given circumstances of the play and his own imagination; yet through improvisation he explored and discovered facets of his character previously unseen. In the United States, Viola Spolin is credited with having developed the form through exercises she taught and wrote about in her book *Improvisation for the Theatre* (1999). Her son, Paul Stills, used her techniques to work with actors in the Chicago-based group The Compass Players and later The Second City. Improvisational skills help actors practice thinking and acting clearly, quickly, and instinctively. Naturally, most people have put systems into place that guide how they act and react. Though these systems are often socially necessary, they also have a tendency to halt or censor creativity. Improvisation frees an individual's thoughts and

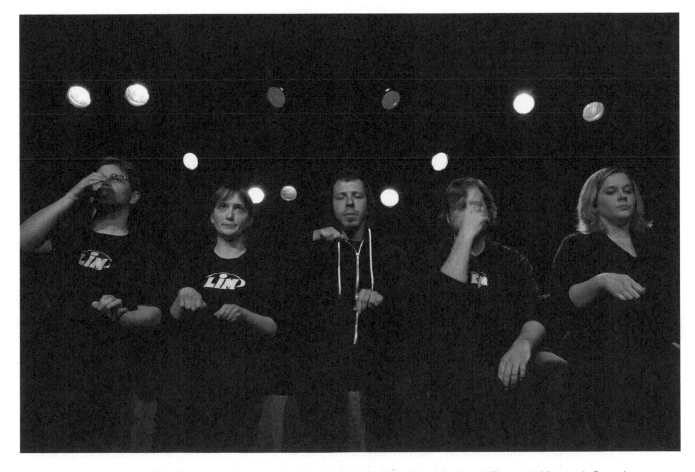

Fig. 2.15 An improv performance by the League of Improvisational Theatres, Montreal, Canada.

cultivates creative thinking. In film, directors Mike Leigh (*Secrets and Lies*, 1996) and Henry Jaglom (*Irene in Time*, 2009) are known for mixing improvisational and textual materials by using dialogue that is improvised based on ideas from written scenarios and defined characters. Of course, early filmmakers Charlie Chaplin, Buster Keaton, and the Marx Brothers also used improvisation in their film performances. Most acting programs offer courses or opportunities to participate in improvisation.

Confidence: Actors, like everyone else, suffer from bouts of self-consciousness. Training in improvisation helps actors stop second-guessing their ideas, movements, and language. Precisely because improvisation demands quick thinking, there is no time for censorship. Improvisation demands that the actor rid himself of self-consciousness; he is far too busy working to concern himself with his insecurities. When the actor is feeling and moving while simultaneously writing the script, he is unable to exert the extra energy that comes with self-judgment. And once the actor has succeeded in improvisation and gained the ability to create a character, scenario, and dialogue on the spot, he will experience a tremendous boost of self-confidence.

Extemporaneous Speaking: Actors learn to enjoy being put on the spot. Rather than becoming terrified about what to say, they realize that often how something is said is what is remembered. This is not to imply that an intelligent and thoughtful remark is not crucial but to demonstrate that how something is said is just important. Tackling improvisation, whether in short scenes, à la the television show *Whose Line Is It Anyway?* or in long-form improvisations that expand on a single idea or stimuli to create fully realized stories with multiple characters, gives actors practice in spontaneous speaking and acting, and it also teaches them that they can rely on their bodies, voices, observations, and imaginations to create off-the-cuff characters and stories.

Listening: Improvisation exercises, games, and scenes force participants to really listen to each other. Because it is impossible to respond to what someone is saying or doing if one is not paying attention and really engaging with the other person or people in a scene, the improvisation actor becomes incredibly attentive. He is listening with his ears but also with his eyes and his instincts, so that when it is his turn to take action, his actions fall into place in the storyline. In improvisation the actor cannot just wait for his partner to finish and then recite his line; because he has no idea what is going to be said or done, he must be ever alert and tuned into what his partner is communicating to him. If an actor is not really listening, he will not be able to formulate an intelligent, witty, or poignant response.

Humor and Embarrassment: Acting is often humiliating. By this I mean that it exposes intimate thoughts, feelings, and behaviors. Part of what actors learn to accomplish is how to show the private moments their characters experience, in public (in front of an audience). What connects an audience to a performance is seeing glimpses of themselves and their worlds. In plays, films, and television shows and even in commercials, the connection to the character and to the story they are sharing is what engages the audience. Actors get use to sharing a character's private, revealing, and secretive moments with their audience. Improvisation not only teaches actors how to enjoy and relish the humor that comes from life's embarrassments; it also helps actors realize that embarrassment is a normal part of life that everyone experiences.

Nerves: Most actors I know experience nervousness on a regular basis. Some learn to keep their nerves in check through relaxation techniques, some are beholden to their nerves and battle them constantly, and others harness the energy that exists in nervousness. *Nervousness* is extra energy that is often agitated and apprehensive but also spirited and vigorous. The best actors are able to channel that vigor and strength of their nerves into the emotions their character might be feeling or the actions and responses their character is experiencing so that these are also forceful and clear. Because improvisation demands that actors create many characters on the spot, the actor has the opportunity to practice this transfer of nerve energy often. Alternatively, in improvisation, the actor is forced to use all of his mental prowess. His mind becomes so focused on creating the story and character out of thin air that he is more easily distracted from the nervousness. For many people nerves diminish over time, so the more performance opportunities an actor experiences, the less he is governed by his nerves, or the better he can cope with them.

EXERCISE

Stand up in front of a group with one other person and perform an impromptu scene about a topic that is solicited from someone in the audience. It doesn't need to be long, but it should have a character, a story, and a conflict. Just see if you can create some characters and some dialogue. How difficult was that? Now, let's try improvising again, but this time with a specific game and rules to guide you. The improvisational game "Freeze Frame" begins with two actors on the stage in two frozen action images (these can be made by other people in the audience or by a facilitator, but they should be still poses that suggest action). Using the positions as a stimuli, Actor A begins the improvisation by offering a line of dialogue that suggests a location, character, or problem. Actor B then responds with a line that builds the scene by adding more information to the story. Once the dialogue begins, the actors move out of their frozen positions and use movement to help tell the story and define the character. Thirty to sixty seconds into the scene, the facilitator or another audience member should call, "Freeze." The two actors freeze wherever they are, and one member of the audience rises and takes the place of one of the performers by tapping him or her on the shoulder. The original actor joins the audience, and the new actor assumes the frozen position and then uses that position to come up with a first line of dialogue, which creates an entirely new scene, problem, and set of characters. Lines of dialogue should remain short, as should performance time—just enough to develop a scene and deal with a conflict. Discuss the difference between improvising without a framework and then again with a specific game and rules to follow.

WORKSHEET: YOUR ABILITY TO IMPROVISE

As a performer, what was the difference between the first and the second improvisational performances?

How enjoyable was the first attempt? Explain. _____

How enjoyable was the second attempt? Explain. _____

As an audience member, what was the difference between the two?

How did your level of nervousness change?

How did your ability, and desire, to listen change?

Set an improvisational goal for yourself. What specific talent related to improvisation do you want to be able to do better? How will you achieve this goal?

Character

When an actor is cast in the role of a character other than herself, her job is to breathe life into something that exists only on a page, or in the imagination or past. More often than not, the character she is portraying is fictional or an historical reenactment of an actual person, and the actor is given a skeleton of a character on which to build. The character might have a name, some obvious personality traits, dominant emotions, or associations with other characters and events, but the character is, nonetheless, not a wholly dimensional human being like you or me. It is the work of the actor to develop her character into a dimensional and unique being. We generally say that the actor creates her characters from what the writer gives her and from her own imagination. Character development is at the forefront of all acting classes, and there are many different approaches as to how to successfully create a character. Generally, actors discover their individual character development process by melding the varied techniques they have been exposed to. One approach studied by many acting students comes to use from Uta Hagen, one of the twentieth century's great acting teachers and performers, whose process drew on her own varied studies of the craft and her own acting experience. In her book, *A Challenge for the Actor* (1991), Hagen asked her students to begin by asking six questions, in the first person, of their character:

> Who am I?
> What are the circumstances?
> What are my relationships?
> What do I want?
> What is my obstacle?
> What do I do to get what I want? (134)

Understanding: In order to portray her character with integrity, an actor must locate the qualities of the person she is portraying, and she must understand why her character has such qualities. She needs to identify why her character's personality evolved the way it did, what her character's behaviors and actions are based on, and how her character's language and movement are indicative of her intentions. The actor works hard to understand why people behave, speak, and act the way they do. She is a social scientist of sorts, constantly observing and analyzing human behavior so that she can appreciate and recognize the intricacies of individuals, their relationships, and the society in which they live. She does this so that she can locate such elements in her characters as a starting point for creating a dimensional being for a performance.

Fig. 2.16 Uta Hagen performs in a 1940s Broadway production of Shakespeare's *Othello* alongside Paul Robeson.

Empathy: Empathy moves beyond understanding another person from an outside perspective; it involves understanding another person's condition from that person's perspective. Actors literally do this with their characters. They first understand their character from an outside perspective (their own). They conduct the research necessary to learn about their character's life and past, and then they step inside the shoes of the character they are portraying and experience their character's feelings, actions, and language from the character's perspective. In "Making Up One's Mind: Aesthetic Questions about Children and Theatre," Richard Courtney unpacks what it means to perform a role: "When we 'put ourselves in someone else's shoes' we understand the Other through the Self and the Self through the Other—and the resulting meaning is greater than either" (1991, 125). In other words, an actor is able to portray her character realistically because she has empathy for her character. While she is performing, she understands the events and other characters in the story from the character's perspective.

Consequences: An actor learns from the consequences her character faces, but she does not face the consequences herself. The character undertakes actions in the story, and as a result, the character experiences the repercussions of such actions. If a character emotionally wounds another in a film or play, for example, there is likely to be a series of reactions from the other characters. This might even set in motion another event or conflict, or it might end a relationship. However, when the play or film scene ends, so do the fictional circumstances. The actor herself does not experience any repercussions from her character's actions. But she has gained knowledge. She has experienced what might happen if she undertook her character's behavior. Actors have a very good sense of consequence of action because they experience a variety of consequences, good and bad, as their characters.

Objectives: Simply defined, an objective is a want. In acting, the character's objective is the overall goal the character wants in the story or scene. Uta Hagen's six questions, referenced earlier, came to her based on her understanding of the Stanislavski System and Stanislavski's belief that humans are governed by their system of needs and wants. Once an actor understands her character and can live through that person, she needs to discover how the character's actions are motivated by her wants and needs and by the hindrances and complications that stand in the way of achieving her objective. One of the most essential principles in playing a character is the ability to understand and capture the character's objective. This want, need, or intention guides everything and is informed by the personality and past of the character as well as by the relationships and environment the character enters into.

Obstacles: The goal is what the character wants. The obstacle is what stands in the way of the character getting what she wants. In real life we all have objectives—things we want—and for almost everything we want, there is something standing in our way, be it large or small. In dramatic performances the character's objectives needs a corollary obstacle to in order to cause conflict. If a character wants something, and experiences no difficulty in getting this want, there is no conflict. And conflict is at the heart of most stories; it is what keeps the audience involved in the action and rooting for, or against, a character. Actors know that a strong objective met with a stronger obstacle makes for an engaging moment.

Tactics: Tactics are the strategies the character employs to overcome or move around the obstacle. Tactics are the *how*, as in *how* the character pursues the want. Characters typically don't give

up until they get what they want, because giving up on the objective ends the conflict. Instead, characters will try one strategy, and if or when that strategy proves to be ineffectual, they try another. Multiple tactics are used to evade or destroy the obstacle. For example, a character may threaten another in one moment and try to coax or charm that person in another. Tactics offer behaviors and specific physical, vocal, and psychological actions. Just as they do in real life, tactics and behaviors work together; we tend not to threaten and charm in the same manner, with the same vocal tone or physicality. Characters will pursue a variety of tactics until they reach their objective, because when a character stops using tactics to defeat the obstacles, the story ends, the character dies, or the audience stops watching.

EXERCISE

Perform a short scene or a monologue in front of a group. Initially do not concern yourself with the character specifics; rather, perform the scene using your initial instincts and interpretation. After you have performed the piece, answer Uta Hagen's six questions to learn more about this person and to build empathy for him or her. Put flesh on the character's skeleton and put yourself in his or her shoes. After you have answered the questions, perform the scene or monologue again. Examine the difference between the two performances.

EXAMPLE:

***Play:** The Mercy Seat* ***Playwright:** Neil LaBute* ***Character:** Abby*

Who am I? *I am Abby Prescott. I am forty-five years old and single. I have never been married. I work at a business firm near my apartment in lower Manhattan and am very financially secure. I am educated and smart. I am lonely and restless.*

What are my circumstances? *It is September 12, 2001. I am in my apartment, which overlooks the remnants of the World Trade Center. Smoke and ash are heavy; the streets, sky, and water are gray. Though it is September, I feel cold. I hear sirens and nothing else. I am tired. I haven't slept in two days. I am just beginning to feel hunger. I did not go to work yesterday, September 11. Instead, I called in sick and stayed at home so that I could see my lover, Ben, a man with whom I work. Ben also called in sick to work yesterday morning, and as a result he was not present at an early meeting that took place near our office, in the World Trade Center. When terrorists attacked the WTC yesterday by crashing two airplanes into the north and south towers of the building, Ben was with me. His wife, however, believes he was at the meeting. She has been calling his cell phone constantly since the attack. Ben has not answered it.*

What are my relationships? I am in love with Ben Harcourt, who is married and has two children and who is younger than me. I love him desperately. I believe that he will leave his wife. I believe he is my soul mate. My world revolves around Ben and my work.

What do I want (objective)? I want commitment. I want Ben to call his wife to tell her that he is alive. I want him to tell his wife that he is leaving her, and I want him to move in with me. I want this to happen today. I want him to call her now.

What is in my way (obstacle)? Ben's refusal to call. His stubbornness. His inability to let his wife down. His relationship with his wife. His feelings for his children. His confusion. My anger and frustration.

What am I willing to do (tactics)? I try to make Ben want to be with me. I threaten him. I tease him. I belittle him. I ignore him. I seduce him. I beg him to call her. I manipulate him. I broadcast the future for him.

WORKSHEET: YOUR CHARACTER

Choose a character you are working with in a monologue or scene. Using the given circumstances presented to you overtly by the author, the clues in the text, and your own imagination, answer the six questions. After you have fleshed these out in your mind, incorporate them into your performance. Discuss the difference between the two performances.

Who am I?

What are my circumstances?

What are my relationships?

What do I want?

What is in my way?

What am I willing to do?

How did the two performances differ?

How did objectives, obstacles, and tactics inform the performance?

Did you feel empathy for your character?

Set a goal for yourself regarding characterization. How might your use this skill in your daily life?

Acting is communicating. It relies on interpersonal communication exchanged between yourself and others and the internal language and thoughts of your intrapersonal communication. And just as actors use all of the aforementioned acting skills on the stage or in front of the camera, so can you use the same skills to express yourself, improve your communications, build self-confidence, and guide the perceptions others form about you. In doing so, you will undoubtedly find that you are simultaneously cultivating an imaginative and self-possessed identity and enhancing your personal, social, and professional relationships.

section three

CHANNELING YOUR

INNER STAR

MAKING
USE OF THE
ACTOR'S SKILLS

Why, except as a means of livelihood, a man
should desire to act on the stage when he has the
whole world to act in, is not clear to me.

—George Bernard Shaw

Now that you know what secrets actors use and why they work, let's explore how you can use these same skills to develop a sense of presence, to enlarge your capacity to think imaginatively, and to cultivate an ability to direct the perceptions and reactions of others. In the preceding section we learned how important verbal skills are for an actor. We learned that actors must work to obtain clear diction and articulation, that the time they take to deliver a line is purposeful, and that they must vary their vocal intensity to convey emotion and to communicate levels of intent. We learned how crucial our body language is in communicating meaning. We came to understand how observing small details increases awareness. We now see how refined abilities in imagination, relaxation, concentration, and improvisation help us express ourselves and our needs. Finally, we have fostered our understanding of others through a knowledge of characterization. In short, we have a new appreciation for how and why actors train to develop their skills, from movement and gesture to improvisation and observation, and we have begun to understand that these tools might also be vital for those who live and work outside of the performing arts. This section looks at how and why these same acting skills can help anyone unlock the secrets to personal and

professional success. Like Section 2, the skills have been broken down individually in order to specify attributes and capabilities. After an orientation for each skill you will find a worksheet that connects your professional and personal life to the skill, reminds you of the goal you set earlier, and asks you to explore the skills via an acting exercise. In the final section, Section 4, you will find exercises and lessons for practicing these skills so that you have the confidence to experiment with them in your everyday life and to eventually use them to your advantage when you communicate with another person, talk with a group, or address a large audience.

VOCAL SKILLS

Speaking in public regularly tops the list as one of the things people are most afraid of. This isn't only because we worry about what to say and what our language might convey, but because we know that the way we use our voices means just as much as the content of the language we use. The way we use our vocal instrument goes a long way toward how we articulate our thoughts in a clear, coherent, and impressive way. Renowned vocal coach Patsy Rodenburg has dedicated her life to studying the human voice and its purpose for performers and effect on audiences. She knows that when a person speaks, the audience immediately forms opinions and judgments about the speaker. Our voices convey much information—our mood, our heritage and gender, and how we feel about ourselves, our audience, and our subject matter. In her book *The Right to Speak*, Rodenburg asks,

> What does our voice reveal about us? Quite a bit. Do we sound enfranchised or disenfranchised? Educated or uneducated? Hesitant or confident? Do we sound as if we should be in charge or just subordinate? Do we sound as though we should be heard and answered? (1992, 4)

Rodenburg asks us to understand the importance our voice plays in our public performances. I think most people do instinctively understand how significant voice is; perhaps this is one reason why so many fear speaking in public. Like the actor, you can use your voice to communicate feelings, intents, and needs, and you can guide your audience to really want to listen to you. If you learn to harness the power of your voice, you will reap the benefits of having an audience that wants to listen to what you say and is influenced by your words. Just as the actor uses her voice to influence her audience, we too can learn to use our voice so that our audience hears us the way we want to be heard.

Consider a stage actor. Perhaps she is sharing the stage with several other actors, all taking turns speaking. When it comes time for her to say her line, she needs to direct the audience toward her character so that the line she delivers is heard, understood, and examined within the context of the character and play. In order to do this, she shifts her body slightly before she speaks so that the eyes of audience members swing toward her general area on the stage. She might stress the first word or two of her line and raise her voice over the voice of the character who spoke previously in order to guide the spectators to further narrow their focus in on her. Once she has gained the attention of the audience, she might employ intonation, pitch, resonance, and volume to convey intent and emotion and to keep the focus away from others until her line and action is complete. In essence, she has demanded the attention of the audience, communicated a want, and engineered how her character has been perceived.

Consider a situation you might find yourself in. Perhaps you are in a meeting, or a classroom, or a social setting with several other people, all who are trying to enter the conversation

to express their idea or thought. In order to direct the audience to you and to ensure that you are being understood with your desired intent, you need to get your audience to notice your presence and to choose to listen to you until you have finished. Just as a professional actor might do in a play, you begin by using your body to indicate to your audience that you are prepared to speak. This gentle movement subconsciously directs the attention of the audience toward your general area. You might follow this movement with a word or two that is slightly louder than the preceding, or continuing, speaker so that your audience perceives you as the focal point. Now that you have the attention of the spectators, you express yourself and your thoughts using volume, resonance, pitch, and intonation. Your volume, for example, can control how much someone hears you and how hard that person needs to listen. A louder volume can connote power and strength or a strong emotion and can often capture the attention of a person or group. Your resonance is dictated by where the sound vibrates in your body before it leaves your mouth. Sounds can vibrate in your head, nose, heart, chest, and even your groin, and in each case the sound produced contains a different quality. A sound that vibrates in your heart, for example, might insinuate an intimate or harmonious message. The pitch at which you choose to speak also signifies meaning to your audience. Higher notes can be harder to listen to at times, whereas lower notes might imply seriousness. Finally, your intonation, which is the varying of your pitch and volume, can direct grammar, convey emotion, and create emphasis. For example, when you end a sentence on a lower note, or deflect your pitch, your audience perceives that you are finished talking. When you end your sentence on a higher note, or inflection, you are conveying a continued thought and are therefore less likely to be interrupted. This has a major impact on how long someone will listen to you.

The vocal quality you produce means just as much as the content of the language you use. Being aware of this is the first step in using your voice to communicate meaning and influence your audience. For most people this doesn't come naturally. One must rehearse such skills until they become second nature. So, continue to explore your voice through exercises, games, monologues, and scene rehearsals and performances, but also in your daily life. When you find yourself communicating aurally, simultaneously put on your observer's hat and be aware of how you are using specific tools in this skill set, such as volume, pitch, tone, and inflection. Are these tools aiding your communication or hindering it? Finally, don't be afraid to step out of your comfort zone and try new vocal approaches.

INTERVIEW

Kate Scott, a 911 call receiver and dispatcher

I interact with people from all walks of life, who are, in general, experiencing a high-stress situation, often the worst of their lives. I use intonation, pitch, and tone to calm, reassure, or command, depending on the situation. I have to be able to observe and assess the caller, their emotional state, the information they are giving me, and the information I gather from the background sounds on a call. There are so many variables. A caller might say she is

fine, but something will catch in her voice and give me cause to relay my suspicions to the responding officer. I have to listen for the hints and indications of anything my imagination can conjure.

There are times when I am on the phone with a caller, and receiving an officer's request for information, while typing up a second officer's traffic stop, and typing the information the caller is giving me into another call card. OK, maybe I'm not doing all these things in complete simultaneous time, but it sure feels like it. My concentration has to be at its peak. I have to remember the license plate that was just given to me by one officer as a second officer gives me a second plate, and I need to be able to recall, later in the evening, either of those plates if they happen to come up again. I need to be aware of the radio traffic that is occurring in four different cities, while dealing with the radio traffic of the city I am primarily working with, and if one of my officers has contact with "Joe Blog," I need to remember that "Joe Blog" was mentioned in an ATL (attempt to locate) that was broadcast at the beginning of my shift eight hours ago.

We actually use improvisation when we train. Someone pretends to be the caller, and someone is the call receiver. It's awkward for some people, but it is beneficial. Because of my acting skills, I have the scope needed to improvise in situations that don't always fall into a textbook call. There are specific things that every dispatcher must do, depending on the call, but there are always going to be exceptions in this line of work, and we have to be able to adjust in a split second. The lives of our public and our officers depend on that ability. For example, if I'm on the line with a suicidal subject, can I empathize with her? Can I talk to her and tell stories and keep her on the line until an officer can arrive to give her aid? Can I console the man who's just woken up to find his wife has died in her sleep next to him in bed? Can I call his daughter for him? Can I calm the fourteen-year-old who hears voices in his head?

Then I need to be able to finish my shift and walk out of the building and release all of the kinetic and emotional tension that has built up during my shift. I need to drive home safely, and return to my family and smile, even if I had to help a woman perform CPR on her infant because it meant something to her to try, even though I knew from her description that the child was gone.

I would say I am self-assured and confident. I made a conscious decision in my early teens to be confident in myself, and this decision was made because of my high school drama teacher. I may have tripped a couple times along the way, but I have always come back to that decision, squared my shoulders, and moved forward in confidence. At some point acting confident became reality.

WORKSHEET: USING YOUR VOICE

Take time to fill out the answers to these questions about your voice. Before you answer the questions, choose a small passage from a book, magazine, play, or film to read aloud, or simply tell a story of your own. Make an audio recording of yourself as you speak. Give yourself a few moments (anywhere from a few minutes to a full day) before you listen to the recording and then answer the questions. If needed, get a person you trust to help you with your answers.

How do you feel about your voice? Do you think your voice is pleasant to listen to?

What is your natural regionalism? How have the places you've lived in affected your speech? How have your parents' accents influenced your own?

Do you use the same words often? Is there a phrase or words others might associate with you?

What nonverbal sounds do you use? How often do you preface a statement with the word "like"?

How has your education influenced your speech and language? Do you over- or under-articulate sounds?

Are you able to speak loudly and project when you need to?

When do you find yourself out of breath?

How do you vary your speech? Do you stress all words the same?

Do you deflect your intonation at the end of each sentence? How often do you deflect? When do you deflect?

Where does your sound resonate from?

What adjectives best describe your voice?

Check in with the vocal goal you set for yourself in Section 2. Has your goal changed? How can this goal apply to your everyday life? What do you notice now about your voice?

Fig. 3.1 Then-senator John Kerry speaks to reporters in 2011. How nervous would this make you? How could you use your vocal skills to express yourself clearly and appropriately?

FOLLOW-UP EXERCISE

Try the vocal warm-up from Section 2 again, or any other vocal warm-up. Then jump ahead to Section 4 and follow the two vocal exercises offered there. After doing so, revisit the monologue or speech you recorded previously. Perform it for the group, keeping in mind your vocal goal and the use of your voice in your everyday life. Are you finding it easier to assert ideas, provide clarity, and express yourself confidently and accurately? Are you aware of using or not using these vocal tools?

PHYSICAL SKILLS

How and when you move your body both directs the attention of your audience and offers or implies significant meaning. In fact, those who study body language will tell you that more of our communication is nonverbal than verbal. Our bodies either support and emphasize our

language or belie what we are saying. And sometimes we do not need to say anything. The English proverb, "Actions speak louder than words," reminds us that what we do and how we do it offers more information about our personality and intentions than the language we choose to use. An early study done by psychologist and UCLA professor Albert Mehrabian found that as much as 93 percent of all communicative meaning is nonverbal. Mehrabian also noted that nonverbal communication is most valuable when it is incongruous with the verbal statement being made (Mehrabian and Ferris 1967, 250). For example, a nod of the head and a brush of the arm often indicate a desire for intimacy. Crossed arms signify a closed mind-set or an unwillingness to engage. Confidence, insecurity, or defensiveness are often attitudes that we do not recognize in ourselves as easily as others recognize them in us, perhaps because we do not see the same full physical picture that our audiences sees.

Some cultures rely on codified gestures and movements to communicate. For instance, ancient Sanskrit drama presents us with more than 470 mudras, or hand gestures, each with a completely different meaning; this set of symbols tells stories and shares feelings. And although most Westerners today may not use gesture to that extent, we can agree that there are many gestures and poses that communicate very obvious meanings, and there are multitudes of other less obvious gestures and stances that imply attitudes, feelings, or needs. And let's not stop with the body. The face and eyes also communicate a great deal of meaning. Expressions and eyes do this overtly with a wink or an eye roll; for example, how many parents and teachers have said to an adolescent, "Don't give me that look," only to be confronted with the irreverent response, "What look?" And if our faces and bodies are communicating so much to others, imagine what they are communicating within ourselves, intra-personally. We have known for years that our expressions and gestures are intimately linked to our psychology and that our bodily and intellectual responses are interwoven. The studies of Paul Ekman and, more recently, communication professor Brene Brown tell us that our bodies and our psychology work together and that by changing our facial expressions, body positions, or gestures, we alter our internal emotional states (Brown 2012). Eye contact, too, is incredibly important in establishing relationships. This may seem simple, but our ways of looking at others and holding a gaze are habituated and often grounded in our childhood culture. I know of many people who were taught not to stare and that looking at another person in a fixed manner while engaged in a conversation is rude. While this may be the case at times, a person who has difficulty establishing and maintaining eye contact is often viewed as untrustworthy.

Consider the actor. Perhaps he is on location shooting a film in which he is playing a superhero. Even if he has oodles of confidence, he is still a human, with ordinary strength and regular physical abilities. In short, he is bereft of special superpowers. What does this actor do with his body and body language to present the likeness of the super character he is portraying and how can his physicality influence his psychology so that feels capable of also thinking like a superhero? He might begin by spreading out his chest and broadening his shoulders so that his upper torso appears larger and therefore stronger. He might take on a wider stance and lift his chin slightly, again, to offer the illusion of an increased size. He might smile with closed lips to lend an air of poise and superiority, and he might bend his elbows slightly so that he appears ready to tackle any problem. He may even lift one arm and slowly point it at another person in a gesture to indicate approval. The film actor, therefore, is using posture, facial expression, eye gaze, and gesture to command the perception of his audience and to construct a psychological response and mind-set appropriate to his character.

Consider a situation you might find yourself in. Perhaps you are at a party and want to attract the attention of another person. Just as the film actor used his body to broadcast strength, pride, and conviction, you begin by opening up your body so that you are approachable. You stand up straight and drop your arms if they are crossed, allowing them to hang from your sides. You arrange your feet so that they too are uncrossed and facing the person whom you wish to attract. By opening up physically, you are subtly sending a message to the other person that you are open to receiving his or her response. Conversely, turning your body away from someone indicates that you do not want to establish communication, so by turning your full body and face toward the person you are hoping to attract, you are establishing a more direct line of communication without saying anything. Your face is an incredibly important component in nonverbal communication, so you make eye contact and smile to start a communication exchange. When you look directly at this person, chances are that your pupils are dilated and you are blinking more. This is a natural physical response you are experiencing, possibly without knowing it, as a result of looking at something (in this case, the person at the party) you like. You keep your mouth slightly open because it is also welcoming to others; it transmits a willingness to exchange words and possibly personal information. All of these physical modifications also affect you internally.

Fig. 3.2 Former Philadelphia 76ers coach Doug Collins expresses his frustration with a very demonstrative gesture.

By opening up your body, making eye contact, and smiling, you are sending messages to your brain that you are confident, appealing, and capable. Because you were aware of your physical communication, you were able to make adjustments in your body language and facial expressions, and as a result, you began an intimate moment with the person you were drawn to, and you sent a message that you were receptive to his or her communication.

A picture is worth a thousand words, and the movements, gestures, and language of your body are images, or pictures, to those who observe you. They offer a strong form of interpersonal communication by sending messages to your audience. But they are also intrapersonal communication in that they influence the way you feel and think. Your posture, walk, alignment, and placement of your feet, legs, arms, neck, head, and eyes, as well as the gestures you make with these body parts, create, affirm, or refute feelings. And these feelings are then broadcast to others. So, the next time you are feeling self-conscious, note your body position. Lift your head, focus your gaze, and find balance in your body and alignment in your spine. Unclench your hands and uncross your arms, and you will be surprised at how this changes the way you feel about yourself and the situation you are in and the responses you garner from others.

WORKSHEET: USING YOUR BODY

Stand in front of a full-length mirror and observe your natural standing body position, in other words, your "go-to" comfort posture. Walk toward the mirror and walk away from it. We look at ourselves often in mirrors, but we typically see ourselves from our own perspective. Imagine that you are another person, observing the person in the mirror. What do you see? Get a person you trust to be kind, but honest, to observe your physicality at rest and in motion. Now, take some time to answer the questions below and have your partner answer these same questions about you. Compare notes.

How do you feel about your body and the way you move?

What part of your body do you find the most attractive? The least? Why?

What part of your body leads you in space? How does this affect the way you move?

Do you make and keep eye contact? Do you maintain eye contact too long?

What facial expressions do you most commonly use?

Is there a gesture that others might associate with you?

In a natural standing position, where do you keep your arms?

How do you naturally stand and sit? Do you stand up straight, or do you hunch? Are you balanced, or do you lean in one direction?

Do you have a large or a small kinesphere? Why? Do you enter into or avoid the kinesphere of others?

Do your movements support your language, or do they ever weaken your communication?

Do you have any physical ticks or habits that get in the way of your communication or presentation of yourself?

Check in with the physical goal or goals you set in the previous section. Have you paid attention to them? What can you do now to continue to work toward these goals?

FOLLOW-UP EXERCISE

Explore the physical exercises in Section 4, "Basic Neutral" and "Body Language." How do you feel when you are in a neutral position? How do you feel when you make your body as large as possible? How do you feel when you make your body small? Explore gestures. What happens to your mood when you smile? When you frown? What happens to your psychology when your arms are raised above your head, as if in a victory pose? Find two gestures that you habitually make. Show them to someone. What are these gestures communicating to others? What are they communicating to yourself?

OBSERVATIONAL SKILLS

We can learn a great deal about other people by observing them, their reactions, and their engagements with others. We can learn about societies by observing the social and professional groupings that occur within them. We can learn about the world we live in through the observation of events, the environment, and the responses others have to such happenings and surroundings. In short, we glean information about our world, our society, human interactions, and individual and group trends and attitudes from watching people, sometimes even those we don't know and will never meet. We also learn about ourselves and others through observations of people we know closely, such as family members or friends, and even through self-observation. Often we study people we know more casually or formally, such as a teacher or boss, coworker, or acquaintance. In these observations we form opinions and associations that govern the new relationships. And we too are being observed in these ways. Though it might feel awkward overtly watching others and being observed, developing this skill will help you gain insight into why people behave the way they do, how groups and communities form and engage with one another, and where our world is headed.

Consider the actor. Professional actors often base their characters on their own experiences or on their observations of others. They might even use themselves or another person they have observed as the model for characters they are playing. Stanislavski believed in the power of observation and in using what we know in the service of a role: "Always and forever when you are on the stage you must play yourself," he tells us, "but it will be in an infinite variety of combinations of objectives and given circumstances which you have prepared for your part, and which have been smelted in the furnace of your emotion memory" (1964, 192). Actors are continually relying on events, emotions, relationships, and behaviors that they have observed first- or secondhand in their own lives. A young and single actor with no children might find herself playing the role of a mother. Here her powers of observation will tell her all she needs to know. She probably has or had a mother, or mother figure, in her life, and she can draw on these observations. She has also no doubt observed many other mothers with their children. All these observations are important information for her as she creates, rehearses, and performs her mother character. Many actors, once they are cast in a role, spend countless hours researching, through observation, real people who are similar or in similar circumstances or relationships as their character. An actor playing

a character in jail might do well to visit a jail in order to observe the incarcerated and their surroundings. She might interview or attend an interview of an imprisoned woman. Though she herself might have never experienced any sort of confinement, violence, or detainment, she can observe those who have, and she can use this information to begin to understand the circumstances of her character as well as potential character actions and reactions.

Consider a situation you might find yourself in. Perhaps you have found yourself needing to appeal to a person or a group whose culture, age, or gender is different from your own. Maybe you are working with a group of older individuals who experienced war, or maybe you are working with a group much younger than yourself and you need to keep their attention. Before jumping into the communication headfirst, you take a moment to observe your audience. You note their individual and group dynamics, and you observe their relationships with one another. You make note of their postures and gestures. In effect, you read your audience, and then you filter through your memory to recall a time when you yourself or someone close to you was similar to your audience. You recall through your previous observations the concerns and feelings you or others had at that time in your life and how you, or they, responded. Perhaps you recall how an intimate of yours dealt with the world around him when he was in a similar circumstance to your audience. Armed with your present observation and reflections on previous observations, you now address your audience with some insight into how they might be apt to respond or engage with you.

All observation is knowledge, information stored away and ready to be accessed when it is needed. Being able to observe and recall one's observations is not an easy task, yet the powers of observation can be cultivated over time, leading to a richer life. Observation teaches us about the abilities, likes and dislikes, behaviors, and temperaments of ourselves and others. Paul Bloom's May 2013 *New Yorker* article, "The Baby in the Well," discusses the value of observation: "We've learned," he tells us, "that some of the same neutral systems that are active when we are in pain become engaged when we observe the suffering of others" (90). Observation allows for great empathy because it connects us to the experiences of others and allows us to see others as we see and understand ourselves—as contradictory, dimensional, and emotive beings. As we become more involved in the technology that surrounds us, we can find ourselves increasingly cut off from our intimate and sustained relationships with others. Moments of live observation reconnect us to others and to our own empathy for the events, relationships, and feelings other people experience.

Fig. 3.3 Taking the time to really observe another person can build a connection and a new perspective.

INTERVIEW

Deny Staggs, the Montana state film commissioner

Observation is just as important in my professional life as I deal with film producers and directors as it was in my acting career. Being a good observer has helped me understand my surroundings and the given circumstances and has been critical to decision making, especially in group gatherings. While location scouting with a studio film team, I use my observational skills to know when a director or producer is comfortable or not. I need to know if they like what I am offering or if they need to move on. Their clues are very subtle. Physical presence is also critical to making an impression. My stance, gestures, and eye contact are crucial to my ability to make an impression on a producer or director.

WORKSHEET: USING YOUR OBSERVATIONS

Find a public spot to place yourself in so that you can spend some time observing an environment and the beings that inhabit the space. Look over the questions below before you engage in your purposeful observation, then, after you have quietly observed for twenty to thirty minutes, take time to answer the following questions.

How difficult or easy was it for you to sit and observe? Do you feel you were able to really watch your environment and its inhabitants? Why or why not? How long did it take before you were distracted from the exercise?

What were your initial observations? What is most clear in your memory now? Why?

Describe the setting. Be as specific as you can. _____

Can you recall one person you observed? What was he or she doing? What was he or she wearing? What did he or she sound like? How did he or she move? Based on this observation, what can you infer about this person?

What were the environmental conditions? What was the temperature? Light? Humidity? How many people were present? Did you notice any behaviors or interactions between individuals that might have been influenced by the environmental conditions?

What feelings, memories, or behaviors did your observation bring up? Did you feel anything for, or about, the individuals you observed? What specific emotions or recollections did the observation of the physical setting or the environmental conditions elicit?

Check in with your observation goal. How are you using observation in your daily life? What do you need to do in order to become a more active and insightful observer?

FOLLOW-UP EXERCISE

Try Exercises 5 and 6 from Section 4: "What You See" and "What They See." These are similar in some ways to the above exercise in observation, but they also ask that you be even more specific in your observations. Think about or discuss with others the differences between your observations of yourself and your observations of others. How can exercises such as these help you with your observational goal? Choose something you would like to get better at. This can be anything—a sport or discipline, such as running or writing; a simple task, such as doing the dishes; or a job, such as parenting, fighting fires, or programming computers. How can you learn how to be better at this endeavor through observing someone who excels in this area? Try it. Learn from that person and his or her successes and mistakes.

IMAGINATIVE SKILLS

Every one of us is called on to imagine every single day. Whether it is the paleontologist who needs to imagine what a creature might have looked like thousands of years ago, the psychologist who must imagine what her client is recalling, or the musician who is able to imagine a new melody or rhythm, we all rely on our imaginative abilities to form new ideas. Children engage their imaginations more often and at a much higher level than adults. For a child, the formation of new worlds, circumstances, and characters is second nature. This can be seen in dress-up games, the belief of fantasy circumstances and events, and in imaginary friends. But somewhere during adolescence most of us lose the ease with which we imagine, opting instead for a more logical and factual view of reality. We stop imagining that we can be a superhero when we grow up, and we realize that there is no monster under our bed and that animals can't actually talk to us in our language. But although we stop using our imagination as freely, we are still presented with situations that demand imagination. Because of this, we are less equipped to create new ideas, solve problems in new ways, and visualize the experiences of another person.

Consider the actor who is assigned a role in a play that takes place several hundred years ago. Of course, he can undertake a great deal of research in order to understand the era and culture in which his play is set, and he will strive to glean as much information possible about the social life of that time and place. He might even be able to locate factual historical information about an actual person who existed during that time who is similar to his character. However, no matter how much information the playwright provides or the actor himself learns from conducting his own research into the period, he still needs to know his character more intimately. He needs to know the inner workings of his character's mind, heart, and soul. He needs to understand how his character feels about himself, others, and his world. He needs to know what his character's likes and dislikes are, what idiosyncratic traits he holds, and what his aspirations for the future are. All of these the actor must *imagine*. Fortunately, the actor has been trained to imagine. He has taken part in so many exercises and classes that have asked him to form new images, ideas, characters, and stories based outside of himself and his experiences. And so, armed with the given

circumstances of the play and the research he has compiled, the actor imagines what it would be like to be this person, in this world so far away, and in doing so his character's responses to the events of the story are authentic and layered, and the character that is offered to the audience is dimensional and believable.

Consider a circumstance you might find yourself in. Perhaps you have found yourself dealing with a difficult colleague. Maybe his ideas and his approaches to problem solving are foreign to you. Maybe the way he acts and speaks is unlike anyone you have ever met. This problematic situation is one most of us have found ourselves in, yet the choice to disengage is typically not a good one. We must try to work with this person, and in doing so we learn more about him and how he understands the world around him. Like the actor, you can use the information you know about your colleague coupled with your own imagination to try to understand his perspective. You might begin by imagining his home life, and through that imagining, perhaps you conceive

Fig. 3.4 16th century portrait by an unknown artist of Hungarian calvalryman Gregor Baci. Imagine what might have happened to this person.

that he might be feeling pressure to accomplish a great deal at work. Maybe you imagine possible ways in which he might have been brought up and, through that imagining, discover how he might have been rewarded for attacking problems aggressively and on his own. Possibly you even imagine the various ways in which you can begin to address your relationship with this person. Maybe you play out scenarios in your mind and imagine how he might respond to each alternative until you find a potentially successful way to communicate with him. In imagining such possibilities, you are wondering about his life in a detailed way and imagining why he might be the way he is. Imagining this will not only cultivate compassion and help you understand your colleague better; it will also help you imagine how he is likely to approach you, others, or problems in the future and to imagine potential ways in which you might begin to improve your interactions.

Repeated use of your imagination will make it stronger and more facile. Like any skill or muscle, the imagination will atrophy if it is not exercised, and although it will never disappear, if it is not used it will hide, making you less inclined to use it. Exercising your imagination takes practice, but once it gains force, there is no stopping it. You'll begin to use it to create stories, solve problems, see images in your mind, and imagine other places and people. Albert Einstein once said, "Imagination is more important than knowledge." And this is precisely because it is our imagination that enables us to create new knowledge.

WORKSHEET: IMAGINATION

Give three or four examples of how you made use of your imagination when you were a child. _____

Is there a moment or time in your life when you felt your imagination dwindle away? When was that, and why did it happen? _____

Give an example of how you use your imagination now. _____

Give an example of a recent event in which you could have made better use of your imagination. Explain what held you back and how, if you could go back in time, you would use your imagination: _____

Test Your imagination

- Finish the story: On a dark and stormy night…

- Look back at the previous image. Use your imagination to create a story about what happened to the person in the image and why it happened. Imagine what events, emotions, and relationships might have existed in the story this image seeks to tell.

- Use Legos, paper, or any other building material to design a spaceship. Try to make it lightweight, strong, and aerodynamic.

- Describe what it would be like to be the size of a fly. How would you go about your daily tasks if you were tiny in a large world?

How difficult were these imaginative tasks? _____

How enjoyable were these tasks? _____

How did your imagination help you complete the work? _____

You made a goal for yourself involving the use of your imagination. Have you begun to think about imagination more? What have you done, or can you do, to cultivate this skill? _____

FOLLOW-UP EXERCISE

Choose a character from a play or film or a person from real life whom you do not know intimately. Write down everything you know to be true about this person. Consider his or her background, personality, age, gender, ethnicity, relationships, occupation, and anything else you know. Now, armed with this information, imagine that this person or character were caught stealing something. Perhaps this is an unlikely circumstance, but if your use your imagination, anything is possible! Most people are capable of most things. Imagine such a theft, and use your imagination to write a monologue from this character's perspective in which the character explains the theft to a law enforcement officer. Read this aloud or perform it in front of a group.

CONCENTRATION AND RELAXATION SKILLS

We live in world that is increasingly disjointed and disrupted. We have learned to multitask and to switch rapidly from one task to another, and we've become good at both of these challenges. We have learned to divide our time into small chunks, and many young people have never known any other way of focusing. But maybe we've become too good, thus impairing our ability to concentrate on one task at a time. So while it may be true that some of the time we do not need to focus our energy on one thing for a long period of time, there are many times when events, jobs, and relationships do demand a more substantial and sustained concentration. And when these moments occur, when we are asked to really focus on one thing, we have a difficult time doing so because we have gotten out of practice. Concentration is just like all other skills in that it requires training and practice to achieve.

Consider the actor. She has had a long and difficult day. She is tired. Financial issues and problems in her family relationships abound. Nevertheless, she has come to a rehearsal, and she must tune out her problems and give her full attention to her role and to the story that her character exists within. She does this by arriving a bit early and by finding a quiet space. She lies down on the floor and rests her body fully into the ground. She takes deep breaths in and out of her nose, allowing for large amounts of oxygen to reach her brain. She empties her mind and relaxes first her toes and then the soles of her feet, her arches, her ankles, her calves. Slowly she makes her way through her body, allowing for a sense of calm to wash over her. Once she is breathing deeply and consistently and has allowed her body to find a restful state, she tunes her mind into the world of her character. She imagines the scene that is to be rehearsed, and she pictures the scenario in her mind's eye. She runs through her character's lines, movements, and actions. She allows herself to concentrate on one thing wholly, and when her present-day real-life circumstances and worries nudge into her meditation, she reminds herself that it will be waiting for her at the end of the rehearsal, but that there is nothing she can do now but focus on her work. When she has found such relaxation and concentration, she awakens each part of her body individually by flexing and tightening the muscles and then again allowing them to relax. She is waking up her senses, galvanizing concentration through nurturing a relaxed and tension-free energy.

Consider a situation you might find your-self in. Perhaps you are at home, with family members. Maybe it's a hectic time, just before dinner, and people are engaged in different tasks simultaneously. Perhaps everyone takes it upon themselves to procure their own meal, only to retreat back into their individual chaos. Someone might be watching TV and eating, another doing homework and eating, and a third eating while standing up and talking on the phone. There may be individual levels of concentration, but there is no concentration on the communal, on the relationships within the family group. A sense of disorder and commotion prevail. Discovering relaxation and concentration in such a moment can go a long way toward developing a peaceful and concentrated evening. Perhaps you take a moment for yourself before engaging with oth-ers. As the steward on the airplane tells us, "Put your own oxygen mask on first." You leave the chaos and find a quiet place to breathe deeply and to sit for a moment, allowing your brain to unclutter before returning to the action and calling everyone to a center area. Perhaps you are feeling more relaxed, and because of this you have the energy and impulse to ask everyone to sit down and to put away their tasks for a moment. To ease everyone's anxiety, you offer a time frame for this time together: ten minutes, fifteen, or forty-five. You offer a topic for a conversation, one subject that everyone can attend to together. Maybe you notice that now that everyone is in close proximity, particularly if all people can see one another and manage eye contact, the group's focus has shifted away from the individual tasks and to each other. Perhaps you all share a moment of the day with one another. You uncross your arms and legs and relax your face. You let your shoulders widen and open up. In other words, allow yourself a tension-free body, and perhaps you will find that the others in the room follow suit by subconsciously mirroring your physicality. You concentrate on this one moment and the people you are with.

Fig. 3.5 A yoga practitioner practices relaxation to achieve concentration.

When we carry unwanted tension in our lives, we experience difficulty on many fronts. Once we release stress and negative tension, our minds and bodies become calm and relaxed, and from this state we experience a higher level of mental ability and stability. Because concentra-tion comes from letting go of worry and tension, it cannot be forced, but, rather, it must be given time and space. This often seems difficult, but it is amazing how much more a person can get done when they are in a solid frame of mind. And, of course, like all the skills mentioned so far, relaxation and concentration take practice. Such techniques need to be rehearsed so that they become ingrained and begin to occur naturally. Only then can we experience the power of relaxation transforming into concentration.

WORKSHEET: USING RELAXATION AND CONCENTRATION

When are you relaxed? How does this manifest itself physically, mentally, vocally, and emotionally?

When are you tense? How does this manifest itself physically, mentally, vocally, and emotionally?

How would you rate your general ability to concentrate on a task?

What happens when you are tense or unable to concentrate?

How often, and how, do you relax?

How often, and when, do you need to concentrate?

What connections do you see between relaxation and concentration?

Have you found ways to relax more? What are they? How have they helped?

What have you recently discovered about your concentration abilities? Have you noticed any difference in terms of the way you approach tasks that demand concentration? Have you paired any relaxation techniques with actions that involve concentration?

FOLLOW-UP EXERCISE

Consider the moments in your life that would benefit from a deeper and prolonged attention. The next time you are about to enter into one of these moments, give yourself just ten minutes by yourself to relax. If you are presenting at a meeting, for example, and need to bolster your focus and ability to respond with full attention to a barrage of questions or needs, locate a private space, reduce the stimuli if possible (noise, light, anything that pulls your focus), and set an alarm for eight minutes (how could you relax if you feared missing the meeting?). Close your eyes. Take in long and deep breaths, finding a rhythm and consistency to the inhale and exhale. Drop your shoulders and imagine your head floating on your neck. Unclench your hands and make room between your toes. Unknot your stomach and curve your lips ever so slightly into a tiny smile. Empty your mind. Relax your jaw and unlock your knees. Enjoy. When the alarm goes off (preferably somewhat quietly), open your eyes. Bring yourself back to the room you are in. Shake out your hands, your shoulders, your face, your legs, and your feet. Jump up and down lightly ten times, and bring your mind to the reality of the said meeting and to the opportunities inherent in that event or task.

IMPROVISATIONAL SKILLS

People who can improvise well come across as confident, and they generally are. Improvisation involves speaking, moving, thinking, and acting without any preplanning. And good improvisation involves not only doing these things without preparation but also demonstrating confidence while relying on the ability to invent and ad-lib. Planning and rehearsing one's plans typically produces a feeling of security, so much so that often the person who seems willing to "wing it" seems extra self-assured and poised. But even the most composed-looking person can be experiencing internal panic when unprepared. The skilled improviser, however, has learned that if he acts confident, over time he will *become* confident, and he will be able to invent his speech and movement as needed and when called on. The good news is that improvisational skills can be learned, and the great news is that although it might sound daunting, exploring improvisation through games and exercises can also be fun.

Consider the actor. Possibly she is in a play, and early on in the run, another actor misses his entrance, leaving her alone on stage. She knows that she cannot leave the stage or break the illusion of the story and character; rather, she must continue with the action and improvise until the other performer shows up. In addition, above all else, she must not let her audience know that there is a problem. Her improvisation must appear so effortless that the audience does not even know they are witnessing actions, movements, and speech that arenot a part of the original play. Her first step is to remain calm and to continue with her action. Perhaps there was a wardrobe malfunction and her partner will come on stage shortly. She improvises movement and actions, and after a moment, if her partner still does not appear, she might repeat her line in case the other actor missed the line cue. She might alter the line slightly and offer a different intonation or tone so that the audience does not hear the line as a repeat, but as a different tactic or thought. If her co-actor still does not

appear on stage, she might even begin to improvise her way through the two-person scene without her partner by turning the dialogue into a monologue. At some point the other actor arrives on stage, and now he too must improvise because the scene has now changed and so together, they improvise their way back to the dialogue. Though we hope this rarely happens, I have yet to meet an actor who at some point has not had to improvise his or her way through a moment or scene.

Consider a situation you might find yourself in. Perhaps you are leading a meeting or a portion of a meeting. Maybe you are giving a presentation and offering new information, which has been prepared and documented via a slide show of some sort. Perhaps you are projecting images, charts, and key points onto a screen when technology fails you. Your carefully planned work is not available. When this happens, it's easy to think that the presentation is ruined, that it cannot continue. But the improviser, like the actor, knows that "the show must go on." In this instance you realize that remaining calm and appearing as if nothing is wrong is essential. The audience, in this case the colleagues present at the meeting, do not have time to come back later or to wait while you scramble to try to fix the problem. If you are the one responsible for the presentation, you are the one who must continue the presentation in the face of the lost data. You begin by expressing a control over the situation. You acknowledge the problem quickly and move along, presenting your data verbally and using your vocal skills to express the excitement that perhaps your images did. You move about the room so that you are not standing

Fig. 3.6 Participants in a "theatre of the oppressed" workshop take part in a large group improvisational exercise.

only in one place or sitting, because you recognize that part of the appeal of the technological component of the original presentation was that it offered another place for the audience to gaze on. You use your memory to recall important key points, improvising the language but offering the same content and intent, just as the actor in the play did when her partner did not appear.

Improvisation is an important life skill. We can always plan for the expected, but rarely does what we expect to happen actually occur. Life is full of surprises, and an ability to roll with it and to make the best of any situation is invaluable. Improvisation asks participants to become hyper-listeners, to listen to the language, the physicality, the emotions, and the very subtle cues that express the wants, needs, and intentions of others. Precisely because improvisation occurs on the spot, with no planning or preparation, and because it is often very quick, there is no time to ruminate on the past or to worry about the future. The participant must fully commit to the moment in the performance. And as a wonderful by-product, when the improviser commits fully to the moment, the past and the future fall away, along with feelings of self-consciousness.

INTERVIEW

Ryan Fuller, the director of operations for a restaurant group

Once I made the decision that I'd rather be on the business stage than the actual stage, I went on to earn my MBA. My undergraduate theatre degree prepared me for the business world far better than my graduate business degree could have because it taught me so much about the learning process and about myself.

Some of my most cherished memories from my acting studies were the activities that involved improvisation. I was part of an improvisation troupe in college and had a blast doing it. When you're performing improv, you need to be imaginative, you need to synthesize ideas quickly, you need to be confident and make quick decisions, and you need to be willing to have fun, to laugh, and to be laughed at. When you are leading a business, all of those principles apply absolutely.

Acting has helped me in leadership. Every unique person and situation deserves a unique leadership style and approach. In my acting classes I was meticulously taught how to read and understand emotions, to improve self-awareness, and to properly read situations. Because of that foundation, it is effortless for me to analyze each scenario individually and to apply situational leadership.

I also use my theatre degree in a much more direct approach in the restaurants. When people go and watch a movie or watch a play, they often go to escape their lives for a brief amount of time and enjoy the moment. I believe we offer that same recess to our customers in the restaurant industry. I train all of my employees that they are "on stage" for our customers and that it is their duty to put on a sincere show—beginning to end.

WORKSHEET: USING IMPROVISATION

Describe a moment in your life when you had to improvise because of the unexpected.

Does planning and preparation make you feel comfortable as you approach new tasks? Why or why not?

Do you find joy and playfulness in extemporaneous speaking? Why or why not?

How do you think you would fare improvising on the stage? Would you enjoy making up a story and a character on the spot? Why or why not?

Do you consider yourself a good listener? Explain why.

Can you find a sense of excitement in being nervous? Why or why not?

Test your ability to improvise. Choose a word from the list below, or have a partner choose a random word for you. Without any preparation or time to think, speak about the subject for two full minutes. Do not take pauses, repeat yourself, or ask questions; rather, discuss the word and other things that relate to the word. Stay on topic.

RATS SYMBIOSIS COPPER
ICE FISHING ROMAN ALPHABET MEDIEVAL HEALTH

Did you find this task difficult? Enjoyable? Boring? Scary? Why?

You set an improvisational goal for yourself. What have you done to work toward this goal? What can you continue to work toward?

FOLLOW-UP EXERCISE

How difficult was the above exercise in which you spoke about one of the subjects for a full two minutes? Now try one of the improvisational exercises from Section 4. Was that any easier? Now try the other improvisational exercise from Section 4. Continue working with improvisation, possibly taking part in the lesson in Section 4: Improvisation. After you have experienced multiple improvisational opportunities, go back to the words on the worksheet and choose one (RATS, SYMBIOSIS, COPPER, ICE FISHING, ROMAN ALPHABET, or MEDIEVAL HEALTH). Speak about the subject for two minutes. Was this exercise any easier the second time around? Imagine how you could develop this skill over time.

CHARACTER SKILLS

Assuming a character other than yourself might seem illogical at first. Sure, actors do this—that's their job—but why should you? As discussed in Section 2, a great deal can be learned about others by assuming their perspective for a short while. While reading a book about a person very different from yourself or having a purposeful discussion with someone can really help you understand the other person's situation, feelings, and actions, true empathy comes from understanding the person and his or her emotions and thoughts from his or her point of view. And our world is in need of great empathy, not only because it increases our understanding and appreciation for difference, but because it also encourages our desire to help others. When we have assumed the viewpoint of another person, we have gained an intimate knowledge of that person, and we often feel more inclined to believe that we can be of help. In addition, portraying a character distinct from yourself opens up your mind to new ways of thinking, acting, and responding to others and to the world, so in this way performing a role opens up the mind to new possibilities.

Consider the actor. Perhaps he finds himself cast in the role of a villain of some sort. Maybe his character is morally reprehensible, deplorable, and crass, while the actor himself values honesty and pleasant behaviors and actions. The actor knows that his job is to find the humanity of his character, something that is impossible to do if he holds his character in contempt. The actor must make a connection with his role so that he can understand the world from his character's perspective. He must, in other words, stop himself from disapproving of his character and find some of the admirable qualities of the role. He must cultivate respect for the character and believe that the character's actions are necessary. How does the actor do this? He uses the given circumstances, his imagination, and his own life experiences to understand the world as the character understands it. He finds or develops moments out of the character's past that have led him to behave the way he does. He identifies his character's objective and sees the objective as a need. He raises the stakes for his character's objective so that his character is unable to function if he does not reach his objective, and he deploys a variety of tactics to achieve his objective. In this way the actor is able to justify his character's insensitive and vulgar actions when he is in role because he is not assessing his character; he is simply carrying out the actions of his

character as his character must. He sees the story and the other characters in the story as his character does.

Consider a situation you might find yourself in. Perhaps a friend of yours commits a disgraceful act. Perhaps he makes a disparaging remark about your appearance or the appearance of someone you care about. Of course, there are times when such a remark must be addressed, and if this behavior is continual, it must be dealt with, but let's say for the sake of this argument that your friend is not typically bad mannered. Your job as a friend, in such an instance, is to find the humanity in your friend. Like the actor, you can do this by understanding your friend's circumstances and by stepping inside your friend's perspective so that you can understand the offensive comment from his point of view. You begin by stepping away from your own emotions. Just as the actor does, you drop your own assumptions, and you become willing to find a justification—not necessarily for the remark—but for the person's believe that the remark was necessary. You refer to the given circumstances of the moment and of your friend's life. You look for reasons why your friend might feel compelled to criticize another person. You imagine the circumstances and events your friend is enmeshed in, and you look for the objective of the remark. You ask yourself, what does this person want to accomplish with his ridicule? Perhaps you discover through your analysis that your friend has recently been dealing with

Fig. 3.7 Playing another character offers us an insight into the feelings and experiences of others and helps us gain sympathy and empathy.

low self-esteem. Maybe you recall that he himself was the receiver of a similar remark. You now adopt his perspective, and with his objective in mind you explore tactics that might help secure his objective. Your first few tactics might be more in line with ones you might have adopted yourself, but you continue to frame the situation as if you were in your friend's shoes. Eventually you will find his perspective, perhaps a feeling that making a disparaging remark provides solace of some sort, however brief. You then return to your own perspective armed with the knowledge and understanding of the remark and with empathy for the speaker. Now, when you address the problem with your friend, you are coming to the conversation with an ability to truly see his side because you yourself have come as close as possible to experiencing it.

Incorporating perspective through characterization into your daily life will do wonders for your relationships, insights, and personal growth. As an actor you know that understanding comes from observation followed by empathy. By thinking about the objectives, obstacles, and tactics other people use, we can glean much information about the people in our lives, from the angry colleague or client to the quiet family member. Being able to adopt the point of view of another person will become easier the more it is practiced, and the more comfortable you become holding a perspective different from your own, the more fluidly you'll be able to switch back and forth between perspectives. And eventually a deep understanding of characterization will help you be able to articulate your own perspective to others so that they can have better access to your point of view.

INTERVIEW

Nazneen Joshi, the lifestyle editor for a beauty, fashion, and lifestyle online magazine

Acting gave me the confidence I needed early on in my life. I learned to immerse myself in a world I truly believed in without giving a hoot of what people thought. When I was onstage all my insecurities went for a toss as I took on my role with earnestness. A lot of what I am today is a gift given to me by the stage. The confidence that acting gives you is unparalleled. Now my work requires me to constantly sell ideas—and more than the ideas, it is the confidence through which I present my ideas that really makes an impact. Being able to pitch an idea, sell confidence, and show belief comes from my acting skills. I have effective vocal delivery—stressing the right syllables and speaking with fluidity, and simple and consistent eye contact assures my colleagues that I am engaged and listening to them. Eye contact forces you to listen, enabling you to understand better and then act in an effective manner, and it also builds a bond between you and the respective party involved. A simple tool, such as hand gestures to accompany your speech, makes it a lot simpler for people to grasp what point you are trying to make, and the physical distance or proximity you keep while holding a conversation is important—these acting skills are all tools that give the workplace a humanistic approach that in turn proves to be a lot more productive and efficient.

Acting classes force you to think differently and unconventionally, and this has forced me to approach most problems and challenges in a similar manner. In life, acting skills translate to examining how people act and react to you and how you respond to them. Someone might say or do something to you that may seem illogical; this sometimes makes people judgmental. But if you take a moment to see what the motive behind a particular action is, you can find a way to understand instead of judge. If you are able to pick up on character nuances, motives, and objectives that people might have in the workplace, you are able to understand where they are coming from and work with that. This ability to understand adds a layer of sensitivity to your response and behavior. I have been able to pick up on little things and make amendments in my work, which gives me clarity and compassion.

WORKSHEET: USING CHARACTER

Do you feel that you are able to understand people who are different from you? In terms of age? Gender? Ethnicity? Religion? Politics? Explain. _____

When have you felt empathy for another person? Describe the feeling. _____

What circumstances led up to your experience of feeling empathy? In other words, why did you feel it?

Share an experience when you had absolutely no empathy. _____

Share a moment when another person expressed no empathy for your circumstances or feelings. _____

Choose a person you know well but do not understand. Explain your differences of opinion. _____

Revisit your character goal. How are you using the tools of character development to better understand and empathize with others?

FOLLOW-UP EXERCISE

Take a moment to return to the worksheet above and to review the person you listed as someone whom you do not understand. Think about pertinent background information, relationships, and upbringing. Use the given circumstances along with your own imagination and inferences to flesh out the story. Now, try adopting this person's perspective. Begin by thinking in the first person (use "I" versus "he" or "she"). Answer the questions below as the person, not as yourself. In other words, he or she is now you.

What is your objective? What is it that you want to gain by acting, believing, or responding the way you are? I WANT: _____

What is in your way? MY OBSTACLE IS: _____

What six or seven tactics can you use to get what you want in the face of your obstacle? I AM GOING TO DO THE FOLLOWING TO GET WHAT I WANT: _____

Now, return to your own self. What potential new information did you assemble about the person you identified earlier and his or her opinions and actions?

It is true that much can be learned from taking in a performance as a spectator—watching a film, play, television show, or video, or playing a role-play video game or listening to a radio program or another form of entertainment. Viewing stories, fictional and or otherwise, allows us a glimpse into the minds and hearts of other people. But inhabiting those worlds by performing as the people in them allows us much more than a glimpse. Acting allows us to exist in another person and to learn from that person's life before returning to ourselves, armed with new knowledge and a new experience. Performing a character distinct from one's self is an incredibly educational experience and can in certain circumstances affect the performer so profoundly that his or her views, actions, and behavior changes. Businesses employ marketers to tell them all about their clients. What might happen if the businessperson stepped inside the shoes of a potential client for a brief moment? Similarly, what might a parent might learn about a child by playing him or her? Or, what might a doctor learn from performing as her patient? Or, can you imagine, for example, what a perpetrator of violence might learn from portraying his victim? Role-play exercises, which ask participants to act out the "other," have been successful in changing the culture of various workplaces and communities, so imagine what you can do by yourself to open up your perspective and to learn more about and understand others.

The craft of acting teaches students the importance of conveying and receiving information through sound, body language, observation, concentration, imagination, improvisation, and characterization. We all know that being able to communicate thoughts, feelings, and ideas with others is essential, but excelling in this area will open up worlds of opportunity. Employers consistently cite the ability to communicate, alongside collaboration and creative and innovative thinking, as being one of the top five skills they look for when hiring (Adams 2013; Benedictus 2013). The skills acting imparts will help you land a job, keep a job, rise in rank, and enjoy the work. And the benefits don't end there. Acting teaches compassion, empathy, self-expression, and an ability to harness emotions. These skills will enhance your social and personal relationships, making you easier to be around and connect with. By learning, cultivating, and rehearsing acting skills, you will discover ways to make all of your communications more purposeful and meaningful.

Fig. 3.8 (*Jumping Into Fire*, photo by Terry Cyr.)—Through their characters, actors Kelly Bouma, G. Stephen Hodgson, Hana Sara Ito, and Leah Holmes are transported back to the fourteenth-century Ming Dynasty in the 2013 play *Jumping Into Fire.*

section four

REHEARSING FOR

REALITY

APPLYING THE SKILLS

Now that you see yourself as an actor, regardless of where and when your performances occur, how long they might last, and how large or small your audience might be, you recognize that you have the ability to communicate with your audience in a number of different ways, and you know that your acting skills can enhance all of your interactions. The actor in you is aware of the moments when you are being observed engaged in a task and has a talent for steering the audience in the direction you want them to go. Finally, as an actor you have learned when to use specific skills to benefit your daily interactions and experiences.

This section will help you cultivate and apply skills that have been discussed throughout this book, first by practicing one skill at a time and later by putting several together. In rehearsing such abilities you will begin to experience the multitude of ways in which performance skills will help you succeed in both formal and informal presentations. As you participate in the individual exercises and longer lessons, refer back to the goals that you set. The exercises and lessons can be explored and used over and over again in different permutations. They can, and should be, expanded and changed to suit your needs. If you are working with a group, it might be helpful to share your goals with other members before delving into this section. Before and after each pertinent exercise and lesson, your goals can be reexamined and discussed so that they are not just theoretical but practical ambitions that you can actively strive toward.

INTERVIEW

Daphne Braun, JD, a member of the New York Bar of Attorneys

In law school my acting skills helped me be empathetic: that is, to understand someone else's perspective. I found I was able to quickly consider the perspectives of the judge, jury (if applicable), legal team, and opposing counsel, all while keeping the applicable law at the forefront. In one moot court experience in law school, my teammates commented that I seemed to have a particularly great read on every judge during my arguments; I wasn't pandering to the judges, but rather was focusing on the information the judges needed to have, both written and oral, to see my side of the argument and feel satisfied. Every seasoned and competent lawyer has an ability to consider many perspectives at once, but I had a tremendous advantage in law school over those who never had theatrical experience or training.

Acting, and more specifically training in improvisational theatre, helped me in my work with abused, neglected, and abandoned children at the Los Angeles Dependency Court. One of the major tenets of improvisational theatre is to accept everything and move the scene forward. After a particularly good acting class in improvisational theatre, I decided that accepting everything and moving forward would be a life motto. Years later, nothing tested that decision more than in my work at the Dependency Court: the children that came through the court (and there were twenty thousand children in the system when I worked there) had gone through horrific life experiences. Many of the abused and neglected children in the system were also very difficult themselves: behavioral, and in many cases physiological, problems were the norm. I am not sure I would have been uncertain in my ability to "accept everything" at the Dependency Court if I had not been inspired that one day in acting class and had witnessed—and experienced—that accepting everything was the only option to move an issue forward in a positive way.

An education in the performing arts made me a solid presenter. I think young people underestimate how often presenting is required in adult life. Whether it is to a superior, a potential client, a dissertation committee, a group of investors, or just a large gathering, the professional adult world requires prepared and extemporaneous speaking. Since so many people are not particularly good speakers, presenting effectively has become a valuable and bankable skill. An education in the performing arts gave me the confidence and the skills necessary to communicate effectively in front of groups: time and again in my life, I am grateful for it.

INDIVIDUAL EXERCISES

The next several pages consist of individual exercises that can be done alone, with a few people, or in a large group. Each exercise can take ten to thirty minutes, depending on the participants and their needs and interests. Each exercise description provides a brief background that describes what the focus is, what skills will be cultivated, and why those skills are important. This background information, which seeks to help the participant translate the acting skill into a life skill, introduces each exercise and is followed by a description of the exercise. Finally, the exercises are rounded off with examples of daily opportunities to practice the skills developed.

VOCAL EXERCISES

Now that you see the voice as a very powerful tool in your arsenal of communication techniques, you might agree that you can learn to be more expressive with your voice in order to communicate with others and also to boost your own self-confidence. Most people use only a part of their vocal potential. We have the ability to be loud, expressive, and varied with our voice, but for some reason, over time many of us adopt a more quiet and conservative use of our vocal instrument. An example might be the individual who has spent ten to twenty years speaking in a high-pitched tone; for this person it will take practice to develop a working use of the lower vocal register. Alternatively, a person who has been encouraged, for whatever reason, to speak quietly will need to learn, and practice how, to increase volume.

EXERCISE 1: VOLUME

Background: Volume *is the amplitude or loudness of a sound, and it is your friend. Being able to access volume and feeling comfortable doing so is a great gift. Volume is often equated with power. Often the louder a person speaks, the more confident she appears, and the more commanding her words seem. At the same time, speaking quietly can also imply power, because the listener must concentrate on, and move closer to, the speaker. Quietness can also insinuate introversion or wariness, or it can imply a mysterious, intimate, or emotional state. In short, volume communicates a great deal to the audience and informs what is being said.*

Try this: *Take the following piece of text from Shakespeare's* A Midsummer Night's Dream, *spoken by the fairy queen Titania, who is chastising her lover, Oberon, the king of the fairies, after he has accused her of seducing another character:*

> *These are the forgeries of jealousy:*
> *And never, since the middle summer's spring,*
> *Met we on hill, in dale, forest, or mead,*
> *By paved fountain or by rushy brook*
> *Or in the beached margent of the sea,*

To dance our ringlets to the whistling wind,
But with thy brawls thou hast disturbed our sport.

Whisper these lines as you say them. Then try reciting the passage again, and this time use your everyday speaking volume. Recite it a third time, speaking as if you were performing in front of an audience of five thousand and without a microphone. In each case, how did the volume of the poem affect the meaning of the language, the feelings of the orator, and the audience's perception of the speaker? Next, try reciting the same poem by beginning very quietly and raising your volume on each line, so that by the end of the poem your volume is quite loud. Try this again but invert the sequence; begin loud and end quietly. How does this change in volume also change the meaning of the speech? How did you feel as you spoke the lines? Did your volume lend an added layer of meaning to the words? Finally, try juxtaposing your volume as you speak the text. Rather than building or reducing volume gradually, try whispering a line or two and choosing a few words to speak loudly. Though this exploration may at first seem exaggerated, it will help you discover how your volume can both bolster your confidence and direct your audience. You can try this same exercise with any speech you wish.

Use when you: need to be heard; want to get the attention of a group; want to surprise your audience; need to come across as powerful; wish to draw in your audience and create suspense; want to create a build in a story you are telling.

EXERCISE 2: INTONATION

Background: *You might recall from Section 2 that* intonation *is the modulation and speech pattern of the voice. The intonation we use when we speak conveys a great deal of information to our audience. The audience can tell, for example, if we a feeling a certain emotion, or if we are insecure or confident about what we are saying, and they can gauge the level of importance of the language being spoken through the use of the speaker's intonation. By understanding intonation and using it to your advantage, you can direct your audience to listen to you better, and you can be more clear in what and why you are communicating. Have you ever had a teacher who did not use intonation but spoke at one level or one pitch, with little emotional content to the language? How did that affect your ability to comprehend and retain the information provided? Conversely, have you ever heard someone speak and been greatly moved by what they were saying? Ask yourself how intonation plays a role in the audience's enthusiasm for the subject.*

Try this: *Take the sentence "I'm going now." Say this in a monotone voice, placing equal emphasis on each word and never varying your pitch or tempo. How does this robotic voice hinder communication? Next, say the same phrase, "I'm going now," with the emotional quality of rage. How did the addition of that emotion change your intonation? Did you speak slower or faster? Did you stress any specific word? Try the same phrase with the emotional quality of fear. Try it again with the quality of love. How did your intonation change with each emotion? Try the same sentence and raise your inflection on the word "now." Try the sentence again, lowering your inflection on the last word, "now." Try it again and change your pitch on one of the words. How do these changes modify the meaning of the language? Try other sentences. Play with emotional quality, pitch, inflection, and other vocal qualities mentioned in Sections 2 and 3.*

Use when you: *want to emphasize something; don't want to be misunderstood; need sound to aid your language; are delivering any type of speech that requires you to speak for more twenty seconds; are with your family, friends, or colleagues and need them to understand the severity, excitement, or lightness of a situation.*

PHYSICAL EXERCISES

We know that a substantial portion of our communication is nonverbal. Every day we respond to, and send off, thousands of nonverbal cues that communicate meaning to our audiences. Your physical presence constantly sends out messages that communicate intention, self-confidence, emotion, and thought. Other people read these messages and respond accordingly. Understanding and being able to control your movements, postures, gestures, eye contact, and facial expressions will go a long way in helping you express what you mean, make stronger connections with people, and develop meaningful relationships.

EXERCISE 3: BASIC NEUTRAL

Background: *Body language is prevalent in all cultures. Anywhere you look, you will find people who are communicating their thoughts, feelings, and needs with their bodies consciously and subconsciously. Speaking with your body is incredibly powerful, but so is body neutrality. Earlier in the book you learned about a neutral expression, a neutral stance, and a neutral walk. Being neutral with your body conveys nothing to your audience and therefore enables you to be able to assume any movement or emotion quickly. It allows you to conceal your needs, feelings, and thoughts from others, and it helps you and your audience concentrate on the verbal language. A neutral position also permits you to clear your mind and relax.*

Fig. 4.1 The human spinal column with all thirty-three vertebrae, including the five that are fused to form the sacrum and the four coccygeal bones that comprise the tailbone.

Try this: *Stand upright with your feet shoulder-width apart. Let your arms rest comfortably at your side with your palms open and fingers extending downward. Unlock your knees and let your pelvis shift forward so that it rests precisely beneath your spinal column, rather than jutting forward or backward. Now visualize all of your vertebrae stacking on top of each other lightly, and feel a tiny space in between each bone. Imagine that there is space between each vertebra. Breathe in and out through your nose. With each breath feel yourself grow taller without having to make any adjustment. Roll your shoulders back so that you are standing up straight. Feel your head float above your spine so that it is not raised, lowered, or pushed out. Let your jaw unhinge to gently drop open your mouth. Begin to breathe in and out through your mouth. Drop your head gently so that your chin is resting on your chest. Slowly, one vertebra at a time, roll downward, allowing gravity to pull you gently toward the floor. Keep your legs upright and your knees unlocked. See if you can let your fingertips or the back of your hands graze the floor. Don't force this. Only roll down as far as is comfortable for you, keeping your sacrum and coccyx vertebrae either upright or parallel with the floor. Keep breathing consistently. Now, roll back up, beginning with your coccyx, sacrum, or lumbar vertebrae, depending on how far you felt you were able to roll down. Focus on stacking your vertebrae one on top of the other. Don't work out of sequence. For example, your ninth thoracic (Th9 in Figure 4.1) vertebrae is only going to rise after the tenth thoracic has risen, and your cervical spine (C1–C7 in Figure 4.1) should not lift until all of your thoracic vertebrae are upright. Take time in allowing the cervical vertebrae to lift. Slowly let them float up, with C1 rising last. This is relaxed neutrality. Are there times and places in your daily life when you can assume this posture?*

Use when you: *are stressed at work; need to collect your energy; are about to get into an argument; want to avoid conflict; have been sitting for a long time; are feeling nervous; are experiencing anxiety; are angry or afraid; don't want others to know what you are thinking.*

EXERCISE 4: BODY LANGUAGE

Background: *You might recall from Section 2 that our kinesphere is the area our body moves within and how we move our body within that area. Regardless of our actual size, we all have the ability to make ourselves appear and feel larger or smaller. When we feel powerful, we tend to occupy more space. When we feel powerless, we tend to collapse into ourselves in an effort to hide or to offer less physical presence. It is also possible to make ourselves feel like we have less control, command, or potential by taking up less space or, alternatively, to make ourselves feel more powerful, more engaged, or more confident by expanding our body and taking up more space.*

Try this: *Make your body as big as you can make it. Make your body as small as you can make it. Practice switching from big to small several times. Now amplify these sizes. Strive to make your body even smaller. Scrunch yourself up as tight as possible. Pull in your arms, your legs, and your face; pull your head in and down, and roll yourself into a tight ball. How does this make you feel? How does your literal size affect your confidence and mind-set? Try relaxing your face just a bit and putting both feet on the floor and straightening up just a bit, so that you are standing but still remaining small. How does this make you feel? Try the opposite. Make your body big and keep it large. Lift your head and extend your arms and legs, broaden your shoulders, and fill your chest with space. Take up as much space as you possibly can. Extend your limbs into any direction you choose. Jump around if you can. Take up more space than you thought possible. Now, try relaxing just a bit but continue to keep your head extended, your arms and legs out, and your torso and chest puffed up. How does this make you feel? Keep this expansive use of space in your limbs, torso, and head as you begin to walk around the room. Don't allow yourself to wrap up, look down or away, or pull your body inward. Make eye contact with others as you pass them. Don't look away. Open your mouth and smile at others as you pass them, in a genuine way. See if you can keep your physicality large as you pass by and look at others who are also large. Allow this physicality to affect your self-confidence. Try to find confidence without intimidation.*

Use when you: *feel disempowered, frightened, or insecure; need a boost of self-confidence; want to convey a sense of power or confidence to any audience; want to get someone's attention.*

OBSERVATIONAL EXERCISES

We form impressions of others quickly. Sometimes we don't even have to interact with someone or hear that person speak before we've formed an opinion about him or her. When we observe with intention, we gain even more information because we are adding another

layer to our impressions. Close and effective observation goes beyond merely looking and receiving information. It means purposefully using as many of your senses as possible and storing the information gained for possible future use; in other words, *observation* is collecting data that can potentially be used later on. Observations are a great source of information because such examinations often offer reasons behind why events, relationships, and actions occur.

EXERCISE 5: WHAT YOU SEE

Background: *We experience so much over the course of our day that we often become accustomed to overlooking details in favor of paying attention to one or two bigger or seemingly more important targets. For example, if we are looking for a friend in a crowded space, we tend to narrow our vision to include only aspects that relate to that person. In doing so, we miss out on all the other people; we literally do not see them. You can deduce a great deal of information about your world and the people in it when you pay attention to details, but doing so takes practice.*

Try this: *Choose a public area to observe—perhaps outside. Treat the area as if it were the scene of a crime. Imagine that the people in the space are potential suspects or witnesses. Allow yourself the time to observe without focusing on anything else but the space and the items and people within it. Imagine that you have forgotten your recording device or notepad and that you must remember all that you are observing. Imagine that you are the camera—recording all of the information so that you can play it back later on to solve the crime. Look for little things as well as the big picture. Close your eyes and see if you can visualize the space before you. Where are things? What is the architecture of the space? What is the light like? What sounds are present? How many people are there, and what are they doing? What are they wearing? What objects are present? Open your eyes. See what else you can record. Leave the space and either write down or verbally tell someone everything that you observed. Be as specific as possible.*

Use when you: *are reading or writing to gain or offer more detail; want to learn more about a specific environment; don't understand a situation or event; need to uncover information about a person or a relationship between people; want to test your focus and concentration; are looking for clues or answers.*

EXERCISE 6: WHAT THEY SEE

Background: *As hard as we try to be aware of ourselves and what we might look like to others, it is very difficult to do this objectively. When we look in the mirror, we may not see what others see when they look at us. When we listen to our recorded selves, we may not hear what others hear. This is because we have little objectivity when it comes to perceiving ourselves as others might. If we knew what others saw in us, we would have powerful information. What would it be like to see yourself as others see you?*

Try this: *Ask someone to observe you as you are going about your daily actions and interactions. If you are working with a class or group, choose a person from that group to observe you. Perhaps a facilitator can assign a group member for each person to observe. Your observer should observe your pace as you move, your gait, and what you do with your arms. He or she should pay attention to what part of your body you lead with, where your head and neck are positioned, and how your spine curves. He or she should observe your speech patterns and intonations as well as the language you use. He or she should watch your interactions with others and note patterns that occur in such connections. After your partner has observed you, tell him or her a simple story about a recent event in your life. Discuss the story and allow the other person to ask questions; perhaps tell the story again. Now ask your partner to retell the story as if he or she were you—capturing your moments, speech, vocal patterns, emotions, and relationships to others, including the audience. What did you discover about yourself by watching yourself? How accurate do you feel your observer was? Now, ask others how accurate they think your observer was. What did you like about yourself as you were presented by another? What did you dislike?*

Use when you: *are preparing for a public presentation of some sort; want to assess the way you come across to others; want to learn something about the way you are perceived by others; are ready to discover things about yourself that you want to change; are looking for characteristics in yourself that you enjoy.*

IMAGINATIVE EXERCISES

Imagination is a creative ability. Being imaginative can help you confront issues and solve problems because a strong imagination helps you form mental images and stories in your mind that are not present in reality. Being imaginative is one of the best skills any individual can have, and it is valued by many employers above all else. In other words, imagination is an intelligence. Acting cultivates imagination because it asks us to imagine stories, events, characters, and actions.

We all have an imagination. In some, it is highly developed, and in others it is quieter but still there nonetheless. Training your imagination is important because the more you use it, the stronger it will grow. If you want to have imagination at your disposal, you need to practice using it consistently.

EXERCISE 7: IMAGINING PEACE

Background: *Many of us suffer from anxiety or stressful feelings. We try to cram so much into each day, and sometimes it becomes a rush against the clock. Being able to relax your mind and body can help you regain energy and resettle your mind. One of the keys to developing imaginative skills is to relax and not push images, sounds, or ideas. If you can relax, often images, ideas, and feelings will begin to come to you.*

Try this: *Lie down on a clean floor in a space where you will not be interrupted. Uncross your legs and let your arms rest at your sides, with just a bit of space between your torso, and rest your open palms facing up. Begin to breathe in and out of your nose. Feel your spine settle into the floor. Adjust your body if necessary as you make these changes in your positioning. Close your eyes. Imagine that with each breath of air you take in, you are breathing in a favorite color. This color fills your body, flowing into each limb, into your forehead and hair, into your chest and belly, until it covers you inside. Imagine that this color is light, so light in fact that your body is being lifted and carried gently away. As you float up and away from the room, imagine that you begin to hear the sounds of the sea. A quiet and gentle repetitive crash of waves is in the background, and the temperature is warm but not hot, with a gentle breeze that slowly lets you come to rest on the sand. Imagine that you are lying in the sand and that it is smooth and cradles your body. Feel the warmth of the sun radiate down on you and comfortably warm your body. Relax into the sand, let it hold you up, and allow your body to let go of any unwanted tension as you rest. Hear the cry of some seagulls and the laughter of a young child. Put a smile on your lips and enjoy this sensation. Run your hand through the sand and let your toes wiggle into it. Shimmy your back and tailbone to dig into the earth. Take in a deep breath through your nose and exhale through your mouth with a quiet sigh. Try this repeatedly, and each time allow your sighs to grow louder, until your chest feels warm and loose. Imagine that you are on a beach, either a real one or a fantastical one, but, either way, the perfect beach. Imagine that you have no worries, no problems, and that all is good. Enjoy this place. When you are ready to move, wiggle your toes, rotate your ankles, and move your legs. Move your pelvis and stomach and undulate your spine. Rotate your hands and wiggle your fingers; lift your arms off the ground slightly and wave them around. Roll your shoulders back and let your*

head wiggle on top of your neck. Open your eyes and find yourself back in the room, but with the sensation of relaxation still present in your mind and body. Keep a part of the sea in the form of the color you breathed in, inside you. Visualize where that color rests. Does it find a specific part to reside in, or does it live throughout your body in a light hue? When you are ready, roll over to your side and curl into a fetal position. Rotate your body so that you are facing the floor and let the soles of your feet find the floor. Place your open palms in the ground and press up your legs. Roll up your spine one vertebra at a time until you are in a standing position. Shake out your body and make a sound as you are doing so. Let yourself bounce and gain energy from the movement and the sound.

Use when you: *have ten minutes before a meeting and need to feel rejuvenated; need to bolster your imaginative skills; need to think creatively; feel stressed and want to find some inner peace; are tired but can't stop working; are beginning your day.*

EXERCISE 8: IMAGINING SUCCESS

Background: *Training your imagination involves learning to use it on a daily basis and trusting that it is there. A strong imagination means that you are able to use it to reimagine and then reshape your life. If you can imagine a possibility, you are closer to attaining your goal than if you cannot even fathom it happening. Imagination helps us build self-efficacy, a term coined by Albert Bandura and used by psychologists to describe an individual's belief in their ability to succeed in their endeavors (1997). Being able to imagine a situation and successful outcome helps us approach the situation with confidence and it gives us a mental image of success, thereby bringing success closer to our reality.*

Try this: *Find a spot where you will not be disturbed; perhaps lie down, as you did in the previous exercise. Focus on something you are hoping to accomplish in the near future. This should not be a farfetched dream but something you are ready and willing to put work into and something that you have been working toward already, such as applying for a new job, asking for a raise at work, working out more regularly, or being kinder to your child. Just as you did with the relaxation exercise previously, allow your body to rest comfortably and breathe deeply and consistently. Focus your attention on the task you want to accomplish. Visualize the person or people who will be*

around you in this situation. Picture the location and environment involved clearly and specifically. Visualize colors and textures, hear the sounds that emanate from this locale, and smell the scents you associate with this place. Picture yourself in this location. See yourself standing there, strong and energetic and confident. Imagine the other people who will be present when you accomplish this task. See them focusing on you and imagine that you have their full attention. After you have imagined this on your own, sit or stand up and share your imagining with another person. Tell them what you envisioned and how it played out. Next, reenact the imagining with the help of your partner. Use your body and voice to walk through the accomplishment as if it were actually occurring.

Use when you: need to accomplish any task outside of your normal routine; want to improve your relationship with someone specific; are going to ask a favor of someone; are presenting an idea to a group and need to bolster your confidence; need to prepare for any task; want to enhance your belief in your ability to success in a specific task.

CONCENTRATION EXERCISES

Concentration is defined as the action or power of focusing and sustaining one's mental attention. Humans use to be quite content engaging in a single job for hours on end. We saw plays and films that lasted far more than two hours. We sat in university classrooms for three hours at a time and listened to lectures delivered by professors without a break. We caught up with friends and family by talking on the phone for hours, even when the phone was corded and kept us located in one place. Now not only do television shows have commercials every eight minutes; the scenes and camera shots are also shorter. TED talks seek to condense great lectures to sound bites digestible to the average person, and phone conversations, which used to last hours, are now relegated to five-second texts. But tasks and activities that require focus and concentration are not disappearing. Though we seem to be losing our ability to concentrate for significant periods of time, demands are still placed on us to concentrate and focus, and there are rewards for those who can undertake a single duty and commit to it until the task is finished. There are careers, such as those of surgeon, air traffic controller, race car driver, computer programmer, teacher, and lawyer, that require high amounts of sustained and lengthy concentration. And there are many daily activities that require concentration, such as completing homework and reading assignments, navigating a difficult road, or playing a good game of cards.

EXERCISE 9: SUSTAINING FOCUS

Background: *Concentration helps us by directing our energy toward the accomplishment of a single task, an object, or a person, and the quality and quantity of your work will improve if you cultivate your concentration skills. Think about what you could accomplish if you had better concentration. How much time would you save in the day if you had the ability to focus for long periods of time despite distractions? Most of us do not have the ability to concentration fully on one thing for a long period of time, and our attention spans seem to be getting shorter and shorter. Begin to redevelop this skill in small ways, by being aware of your ability to sustain your concentration on one task.*

Try this: *Try standing on one leg. Balance yourself, and when you feel stable, lift one knee higher, maybe to a thirty-degree angle, and lift your foot so that you can point your toes in the air. Begin to draw a circle in the air, with your big toe moving clockwise. Get this task down; concentrate until you can draw circle after circle without falling or pausing. Now lift your pointer finger and hold it in the air in front of your chest. Try keeping the circle with your toes while simultaneously writing your name in the air in cursive. Try memorizing any short piece of text. This can be a poem or a speech or lesson you have to give. But to challenge yourself and your concentration, choose something that you have not already committed to memory. Here are some lines from Shakespeare's play* Twelfth Night, *Act 2, Scene 3:*

> *What is love? 'Tis not hereafter;*
> *Present mirth hath present laughter;*
> *What's to come is still unsure:*
> *In delay there lies no plenty,*
> *Then come kiss me, Sweet and twenty,*
> *Youth's a stuff will not endure.*

Commit these lines to memory, and after you have done so, engage in some physically intensive task, such as doing push-ups, sit-ups, or jumping jacks or going for a run or a hike while reciting the lines of text. After you have succeeded in reciting the lines while completing a repetitious activity, grab a friend and ask him or her to try to distract you. Recite the lines while your partner talks to you, moves around you, and seeks to engage your company. Try to maintain your focus.

Use when you: *need to prepare for a task that requires complete concentration; are about to speak to someone and need to focus; are engaged in an action while someone is trying to steal your attention; find yourself drifting in and out of focus.*

EXERCISE 10: CIRCLE OF ATTENTION

Background: *Stanislavski believed that it was essential for actors to be able to focus their undivided attention on one thing. He created the concept of "circles of concentration" or "circles of attention" to train actors to develop their ability to focus on specifics.*

Try this: *Choose a location and get comfortable. Imagine that there is a circle around you, about six feet in diameter. Your task for the next five minutes is to concentrate only on the objects within that circle. What are these objects? Be specific. Is there a set of keys? A water bottle? Dust on the floor? A sweatshirt or shoe? If the space is empty, focus on the floor itself or a wall within your diameter. Without reaching out to touch the objects, imagine what they might they feel like in your hands. What is their texture, weight, and smell? What materials are they composed of? Try this again for another five minutes but with a larger circle, of perhaps ten feet in diameter. Take in everything that exists only with the circle. Leave everything outside of the circle behind. Try it again for another five minutes and make your circle larger—perhaps it encompasses the entire room. Focus on the room only, keep the focus on objects. Finally, expand your circle to the space outside your room—imagine what is beyond the walls. Repeat this exercise outside if possible. Begin with a very small circle and keep your focus only on objects inside your circle. When your attention moves outside of your circle, just bring it gently back. Try to avoid feeling discouraged. Discouragement is unhelpful, and it is not an object in your circle. Just concentrate on what is in the circle.*

Use when you: *are feeling unfocused; before you begin to work on an assignment; have a task ahead of you that you do not want to engage in, but must; are distracted and need to concentrate on one person or job.*

IMPROVISATIONAL EXERCISES

Improvisation, or "improv," as many actors know it, is the practice of creating something spontaneously. When actors are in a scene or a play, they are given a script to memorize and then rehearse. Improv actors are required to create their story on the spot. There is no text that is memorized or followed; rather, performers invent the language and actions extemporarily. Improvisation demands that performers listen to, agree with, and cooperate with one another. Though improvisation is not always easy, most of us improvise every day. From making dinner for your family at the last minute, to pitching a concept at an unexpected business meeting, to answering questions about your ideas and opinions on a date, the ability to improvise well can help us accomplish our goals. But improvisation is an art, and not everyone does it well. The good news is that improvisation skills can be cultivated so that they become second-nature and even fun.

EXERCISE 11: ON THE SPOT

Background: *Improvisation demands that we think and act quickly. Because of the rapid rate of exchange of information and new ideas, in the form of character and story, performers learn to halt their self-censorship and commit fully to what they are saying and doing. Of course, sometimes people freeze up when it comes to speaking extemporaneously. This exercise places the emphasis on the nonverbal and thereby takes some of the pressure off.*

Try this: *Find a partner and stand about seven to ten feet apart from him or her. Walk toward the other person and hold out your arms, as if to embrace him or her. The moment you begin to make physical contact, freeze. Imagine what you might say in this situation (the moment you embrace someone), but don't say it out loud; instead, let the image (of two people beginning to embrace) tell the story. Have one of you step out of the frozen image while the other remains frozen. The person who has stepped out now steps back into the image but repositions himself or herself so that he or she is creating a different image, and by doing so, another story. As both partners freeze together, they should think of a line that they might say in this position, yet they refrain from speaking out loud. The second partner now steps out of the image and uses his or her imagination to envision another, different story. He or she reenters the frame, keeping the partner still but changing his or her body so that a third image and story is formed. As the partners hold the freeze together, they imagine what their characters might say in a line, and after a moment, they take turns saying the line out loud. This game, often called "Complete the Image" and borrowed from Boal, can be either verbal or remain nonverbal.*

Use when you: *need to think on the spot; find yourself speaking impromptu and need to hold the attention of your audience; are about to interview for a job; want to entertain children; want to develop your imagination; need to practice for a presentation that will include improvisation.*

EXERCISE 12: STORY...STORY....(DIE?)

Background: *Listening is an essential component to improvisation. Being able to listen to your partner, whether you are onstage or off, will help you make sure that you understand the circumstances that are being set up, what your partner is trying to communicate, and what is being implied. Stationary improvisation games help actors think off the cuff, stimulate the imagination,*

and sharpen their ability to create ideas. Movement and character can be used in improvisation games and techniques as well, as in the case of the game "Freeze Frame," detailed in Section 2, but they provide an additional challenge for the performer. This exercise focuses solely on cultivating free thinking and on keeping a story alive.

Try this: *Three to six people stand up before a facilitator or "conductor." The conductor begins a story with any line; an example might be "Once upon a time..." or "On a dark and stormy night..." and then points to one of the players, who must immediately continue to tell the story without faltering, pausing, or repeating any of the conductor's words. The player continues with the story until the conductor points to another player, at which point the new player continues the thread of the story without pausing, repeating, or faltering in any way. The players only tell the story when the conductor is pointing at them; thus, players often stop or start speaking mid-sentence. The goal is for sentences to remain intact and for a story with characters, action, conflict, and a resolution to be presented. Once players grow accustomed to the game, eliminations can be added. If a player is unable to continue the story, or if he or she pauses or repeats a line or word previously said, the conductor can pause the story and eliminate the player. In the original version, this elimination is accomplished through a short and solo performance in which the conductor lists an improbable and strange way for a person to die (e.g., death by being pecked by a chicken, or death by watching too much bad television), and the eliminated player must perform the death before leaving the stage and allowing the game to resume with one fewer player. The game is generally played until one player is left.*

Use when you: *need to cultivate many ideas and don't want to censor yourself; want to generate energy with a group; need to problem solve but are getting bogged down with limitations; want to build teamwork; need to focus your listening skills; need to concentrate quickly.*

CHARACTER EXERCISES

As mentioned at the beginning of this book, we all play many different roles in our lives. We become comfortable playing these roles; we usually have relationships we associate with these roles, we know how to respond to events and actions in these roles, and we have our actions that we perform in these roles. Sometimes this habituated way of being impairs our ability to understand those outside of our social, work, or community group. Playing another character different and distinct from ourselves can provide clarity and perspective. When we create a character, we start at the very beginning, and we flesh out the details of the person, his or her circumstances, and background, and in doing so we better understand what it is that the character wants and why he or she behaves the way he or she does.

EXERCISE 14: MONOLOGUE WITH OBJECTIVE

Background: *When you communicate with someone, you are doing so with your vocal intonation, inflection, and tone, your body language, and your emotions. Actors communicate with these as well, but they also make use of what director William Ball called the "golden key" (70). Their key is to communicate a single objective to the person or people they are speaking to. They might use a variety of tactics to communicate their message, but they have only one aim, one goal, one objective. When actors are given a script, they often write their character's objective in it. This is phrased in the first person and with an active verb, as in "I want to destroy," or "I want to seduce." This golden key, or objective, guides the character and the story and communicates a clear meaning.*

Try this: *Work with the following passage, or find another piece of play or screen text to become familiar with. Read through it several times until you begin to understand what it means. Analyze the script to discover what the character wants from the person he or she is speaking to, and then phrase that want as such: "I want to _____."*

Any good monologue will work, although I've chosen examples from one of the most beloved Western playwrights of the nineteenth and twentieth centuries. The following monologues are from Anton Chekhov's 1897 play Uncle Vanya. *In the first example (from Act III), Sonia confides in her young and beautiful stepmother about her love for the country doctor, Astroff. In the second monologue (from Act IV), Sonya's uncle, Vanya, shares his fears with Astroff.*

SONIA

No, when a woman is ugly they always say she has beautiful hair or eyes. I have loved him now for six years, I have loved him more than one loves one's mother. I seem to hear him beside me every moment of the day. I feel the pressure of his hand on mine. If I look up, I seem to see him coming, and as you see, I run to you to talk of him. He is here every day now, but he never looks at me, he does not notice my presence. It is agony. I have absolutely no hope, no, no hope. Oh, my God! Give me strength to endure. I prayed all last night. I often go up to him and speak to him and look into his eyes. My pride is gone. I am not mistress of myself. Yesterday I told Uncle Vanya I couldn't control myself, and all the servants know it. Everyone knows that I love him.

VANYA

You must tell me something! Oh, my God! I am forty-seven years old. I may live to sixty; I still have thirteen years before me; an eternity! How shall I be

able to endure life for thirteen years? What shall I do? How can I fill them? Oh, don't you see? [He presses ASTROFF'S hand convulsively] Don't you see, if only I could live the rest of my life in some new way! If I could only wake some still, bright morning and feel that life had begun again; that the past was forgotten and had vanished like smoke. [He weeps] Oh, to begin life anew! Tell me, tell me how to begin.

Stand up and rehearse your monologue several times, each time with the sole intention of communicating your objective or want. Don't worry about memorizing the text or where and how you might move; rather, think about communicating your objective and about using your body language, intonation, tone, eyes, and emotional essence to communicate. You'll be surprised that the movement and memorization will come more naturally this way.

Now speak your monologue to another person, making use of all of your actor's tools. After you have performed it, ask the audience if they can determine what the objective might be. How effective were you, and what did you do that aided the communication of your want?

Use when you: need to give a speech or lecture over one minute in length; have a lot to say and need to distill your message; need clarity for yourself about what you are saying and why you are saying it.

EXERCISE 16: THE "MAGIC IF"

Background: *What would I do if I were in the character's position? Stanislavski's concept of a "magic if" is a lever to lift the actor out of his own reality and into the story the character is living. The "magic if" helps us use our imagination and our own experiences to suppose a different circumstance. We do a similar thing by making statements such as "If I won the lottery I would...," or "If I lost fifteen pounds...," or "If I were her, I'd...." The only difference between making statements such as these and the "magic if" is the magic. The above statements don't really imagine that such things will happen. They are fantasy and therefore don't explore how behavior, relationships, and actions might change if circumstances were different. The magic of the "magic if" goes beyond brief fantasy and helps actors personalize through characterization. This technique enables actors to imagine that they are someone else with different circumstances, wants, and needs.*

Try this: *Choose someone you know. This can be a friend, family member, coworker, or acquaintance. Consider this person's circumstances. What are this person's age and gender, financial situation, social status, values, education, family, home, personality, and interests? Think about each one of these areas and imagine what it might be like to have those characteristics be your own. What if you were your fifty-two-year-old female neighbor, for example? What if you were raised in the way she was, experienced her life, had her children, her money, her religion, and education? Now choose an event that you know this person has experienced. It can be as significant or insignificant as you wish, but make it specific and an event that you know actually occurred. Perhaps your neighbor just moved onto your block or building a year ago, and this shift in geographic location is the event. Perhaps she got promoted at work and is now in charge of a lot of people. Perhaps her beloved cat died a few weeks ago. Perhaps her youngest child is moving away from home. Choose one event that this person experienced and think about what might have led up to the event and how the event might have affected this person. Now ask yourself, "What would I do if I were my neighbor with her history as I help my son pack to move away?" Write a monologue and perform it in character, as if you were the person. Capture her perspective and try to honestly portray her feelings, intentions, and thoughts.*

Use when you: *come up against a person or way of thinking that you do not understand; want to gain empathy; want to help someone in need; meet someone totally different from yourself; are struggling with someone you know well when you cannot understand their actions, point of view, or intentions.*

INTERVIEW

Peter Philips, a retired cardiac surgeon

A good physician is a good actor. Acting skills have endowed me with the ability to provide information comfortably to patients and to exude confidence and have success. The appearance and manner at a patient's bedside or before a family in the postsurgical waiting room is important. Maintaining a steady, soft, and clearly understood tone and showing neither surprise, fear, elation, anger, disappointment, nor any other emotional suggestion is vital to maintaining patient and family confidence. Vocal reassurance is vital for comprehension on behalf of the patient and family and in the subsequent moments. The ability to stand up straight and display a positive response, regardless of what might be the eventual outcome, demonstrates capability. This physical posture ensures the likelihood of having all parties speak confidently and without hesitation to ask questions and reply with honest and appropriate answers.

It is almost detective work...the way family members talk to you, their glances: furtive, warm, antagonistic, sympathetic, or full of outright disgust or anger. The way the family reacts to one another suggests to the physician how he must control the situation to encompass all before him, regardless of how the information given will affect the various members of the group. I recall two very prominent surgeons, one pediatric, the other cardiac. Both were like movie stars in their looks, dress, and comportment. The men would approach the bedside, discuss the patient's malady, explain how he was going to repair the defect or remove the violator, and assure the family that he and his very capable staff would take care of the patient's well-being. Watching these doctors "perform" before waiting families after a successful operative procedure on a loved one was like watching an Academy Award performance; the audience loved it.

COMBINING THE SKILLS

LESSONS

Lessons are longer than exercises and make use of several skills simultaneously. Lessons are best followed with a large or small group so that exchanges and interactions can be made, but they can be accomplished alone as well. If you are alone, the more actively you use your body and voice, the more you will discover. These lessons can be accomplished in one to two hours or extended to take a few meeting sessions. Following a specific format, each lesson begins with a stated specific *purpose* so that participants know why they are engaging in the work, and a set of goals, in the form of *outcomes*. These are suggested as outright statements made prior to the work. The *opening* section of each lesson provides questions and a frame for the experience. The *introductory exercise* warms up the participants and introduces them to the subject matter. These are intended to run between ten to thirty minutes and are designed to be preparatory work. The introductory exercise is followed by an *explanation*, which connects the work to the purpose and objectives. The *follow-up exercise* is the body of the lesson in which participants explore and which builds on the new skills they have gained. The *culminating exercise* is intended to use the skills gained in a more overt performance. It is a sharing of work and intended to allow participants to authentically practice the subject of the lesson. The *discussion* pulls the group back together for reflection, questions, and observations, and the final part of the lesson, the *beyond*, asks participants to take what they learned, analyzed, and practiced in the lesson beyond the lesson itself and into the real world.

LESSON 1: EXPRESS YOURSELF (skills used: vocal, physical, observation, concentration, and relaxation)

Purpose: The aim of this lesson is to help you use your voice, body, and emotions to express yourself in casual, formal, or group introductions.

Outcomes: By the end of the lesson you will have an increased ability to
- Introduce yourself to other people in ways that express your personality, wants, and ideas
- Respond genuinely to other people's introductions and analyze your reactions
- Express emotion in a premeditated manner
- Connect emotion to your voice and body movement

Opening: We introduce ourselves to new people every day. At times you might introduce yourself to twenty to thirty people per day. Questions to consider: How do you usually introduce yourself? How do your circumstances change your introductions? What responses do your introductions elicit? How do others introduce themselves to you? How do these impressions dictate the relationships that follow?

Introductory exercise: Gather in a circle. One at a time, each participant says their name as the others in the circle observe. Have a quick discussion about the group's general observations. Try the exercise again and have the participants use their body and their voice to communicate their personality. Each time a participant says their name, the group watches silently and then repeats the said name simultaneously. The goal is to re-create the voice, body, and sentiment of the speaker. It is a nice addition if the group re-presents the name to the owner by looking at the owner as they say the owner's name. The goal is to move quickly, without discussion, leaving little time for anxieties to develop and self-censorship to occur. This exercise can be repeated as confidence builds, so that each time participants are encouraged to be bolder with their bodies and voices.

Explanation: Actors use their bodies and their voices to convey emotion, intention, and want. They also use these skills to elicit specific responses from the character they are addressing or the audience that is watching. What position or pose their still body is in, where and when they move their body, and the eye contact, gestures, and amount of space they use convey a multitude of information. What volume they choose to speak at, which resonance and pitch they employ, and how and when their intonation changes also provide information to their audience. This is also the case with the acting you do in your daily life. Introducing yourself to others is the perfect example.

Follow-up exercise: Choose a scenario or location (e.g., professional job interview, blind date, meeting a friend of a friend, meeting a partner's parent, meeting a scared child, addressing a crowd of two hundred others who have come to hear you deliver a speech). Each participant introduces himself or herself by saying, "Hello," and stating his or her full name to the group in a manner that reflects the given scenario (e.g., "Hi, I'm Jillian Campana; thanks for seeing me."). Repeat with new scenarios and locations and discuss observations.

Culminating exercise: An emotion is chosen (e.g., rage, happiness, fear, grief, relief, enthusiasm, shyness, surprise, pride). The first participant chooses someone who is across the circle to greet using her body and voice to convey the selected emotion. (Any simple greeting will suffice, including "Hello there," "Hi," or "What's up?") The person whom she is greeting then responds by using his body and voice to convey the same emotion. (Any simple response will do.) After responding, the responder then becomes the initiator of a new greeting. He chooses a different emotion and a different person opposite him to greet. In this manner the greetings travel around the full group, so that everyone has the opportunity to be an initiator and a respondent. Repeat as often as desired.

If needed: Continue the exercise. A participant begins by establishing eye contact with another participant from across the circle. The initiator walks toward the chosen partner and stops in front of him, introduces herself, offers a hand to shake, and extends the line to include a question, such as "How are you?" or "What is your name?" or "How can I help you?" (e.g., "Hi there, my name is Jillian. How are you doing?"). The introduction and question are underpinned with a clear emotion conveyed through body and voice. The chosen student then reacts to the question and introduces himself using his body, voice, and emotions to respond in a manner in which the initiator has provoked. The responder then chooses another emotion and another student across the circle to approach, and thus the game continues. In this way everyone in the circle should have at least one or two opportunities to introduce himself or herself and to express and receive an emotion or sentiment.

Discussion: Discuss observations of voice: pitch, intonation, tone, resonance, and so on. Discuss observations of body: eye contact, body language, gesture, and so forth. Discuss emotional content. Questions: What was it like to respond to an angry introduction? What feelings did specific emotions prompt in you? How important is body language and voice in the delivery of an introduction? How important are first impressions? What makes an introduction memorable? What response does a confident and poised introduction extract from a receiver? What does a confident posture offer the initiator?

Beyond: Observe introductions in your life. Watch others as they introduce themselves. What assumptions do you make based on this initial interaction? How do body language and voice convey attitude, thought, and emotion? Examine your own introductions. What tendencies do you have? How can you change the way you introduce yourself so that you feel more confident and so that others see you in the way you want to be perceived?

LESSON TWO: ENHANCING YOUR STORY THROUGH MOVEMENT
(skills used: physical, imagination, characterization)

Purpose: To learn to use staging and blocking to augment the story you are telling, and to guide your audience.

Outcomes: By the end of this lesson you will have an increased ability to
- Recall basic blocking techniques
- Understand which places and positions on a stage are powerful

- Apply picturization and composition in order to tell a story
- Evaluate how images and placement of images draw an audience in

Opening: Think of the small space you are standing in and the radius that exists around that area as your stage. We all have this little transportable stage that travels with us where ever we go. Questions to consider: When does your stage size expand? When does it need to be smaller?

Introductory exercise: Mill around the room without purpose. Just walk around. Keep walking; your only job is to not bump into someone. Freeze. Now let's imagine that you are an actor on the stage and that you are walking around and being observed by an audience while you move. Imagine that your audience is in one part of the room only. See them in your mind's eye. Keep moving around the room, covering all of the space, but don't neglect your audience. Make sure that they can see your face at all times from where they are sitting or standing. Keep moving and being aware of your audience, but this time use your positioning, stance, and proximity to your audience to threaten them. Keep moving, but now change your movement to entice and intrigue your audience. Change your movement again to invoke compassion from your audience.

Explanation: Where and when you move in your performance space influences the way you feel about what you are doing and saying, and it influences the way your audience understands what you are doing and saying. Actors call this precise movement and positioning in a rehearsal or performance "blocking." An actor's blocking in a play or film influences the audience's involvement, interest, and emotions, and it offers clues as to the personality of the character, the relationships of the characters, and the story itself. Just as the actor uses blocking to guide the story, so can you use blocking to change your communication and the way your communication is received.

Follow-up exercise: Find a partner. Mark off your performance space, making it fairly small—maybe just a three-foot-by-three-foot square on the floor. Experiment with moving to your right, to your left, forward, and backward. Try making a small circle in your space, and play with levels in your space, moving high or low. Try moving diagonally in your space and closer to, or further from, your audience in this small area. Have one person, representing the audience, begin facing the square straight on—as an audience would a stage or screen. Have the other person, the actor, turn her body so that she is angled away from the audience. Have the actor tell the audience about a specific recent event that made her feel really good, happy, or proud. Try this again and have the actor turn even further away from the audience so that her face is seen but the front is angled entirely way from the observer. Try this yet again and have the actor face the audience straight on. Try it again and have the actor and audience position themselves so that the actor is lower than the audience. Try it again with the actor higher than the audience. Have the actor stand as far away from the audience in the square as possible. Now try it again, with the actor being as close as possible to the audience. Switch actor and audience and repeat the exercise. Discuss your observations first as a pair and then, if possible, discuss observations among a larger group. When did the audience members feel more connected to the story and the person? What blocking stunted or impeded the audience's interest?

Culminating exercise: In order to make the best use of the space and movement within that space, it is important to understand two staging techniques called "composition" and "picturization." *Composition* is best defined as where the action occurs on the stage and how that placement and movement into the placement define the character and the story. In composition there is general agreement about which positions are considered stronger. For example, downstage center is considered stronger than upstage left, and elevated positions tend to take focus over lower ones. Moving from upstage to downstage is powerful, as is crossing stage right to stage left, because it follows the reading line in Western culture. *Picturization* refers to what the body is doing in the space. It is the aspect of blocking that physically reinforces character, relationship, and story. With picturization the story can be communicated through positions, movements, and gestures. For example, kneeling is typically indicative of a person who is at a disadvantage. A hand or object pointed at someone is connotative of a threat, whereas an open hand extended above the waist often indicates an openness or a welcoming attitude.

Fig. 4.2 (photo: Mike Fink)—The parts of the stage or performance area are named to facilitate blocking.

In groups of three, take turns working as the director. Each director works with his or her own story told previously or a new story that shares something that person recently experienced that brought about an emotional reaction. Each director positions the two actors in places (composition) and in positions (picturization) that give the performers and their audience clues as to the characters and their relationship, situation, and story. Rather than telling the story with language, the director should tell the story through blocking a series of stage pictures. Each story should have at least five different frozen images, but no more than eight, so that the stories are full enough and so that the actors can recall the images.

Discussion: In what real-life situations can you apply blocking? When are you on a large stage? When is your stage small? Can you use composition and picturization to influence your audience? What images do you use to enhance your daily interactions and stories? How can you use blocking in the next twenty-four hours to benefit your communication?

Beyond: The next time you find yourself talking in front of or with a large group, find your stage. Think about your proximity to your audience, the levels you are using, the physical positions you are in, and how you are moving on your small and invisible stage. Use composition and picturization to enhance the mood of your story and to help you tell the story that you want to tell.

LESSON THREE: EXPLORING MOVEMENT AND LANGUAGE (skills used: physical, observation, improvisation, characterization)

Purpose: To understand how language and movement work in tandem to communicate meaning.

Outcomes: By the end of the lesson you will have an increased ability to
- Make meaning from moving images
- Develop a character using movement and dialogue
- Pair dialogue and movement to create a story and communicate it to an audience

Opening: While some people are masters of expressing themselves with language, others struggle to communicate ideas and feelings with words, preferring to express themselves kinesthetically. Books tell us stories through language, but silent films did the opposite. With no sound at all, save maybe the live piano that accompanied some films, silent movies told stories with moving images. Try watching a contemporary film or television show with the sound muted. You're certain to be able to pick up on a great deal of the plot, even without the dialogue. Conversely, listen to any radio or news show and discover how much information you can get without any pictures. The truth is that when movement and language work together, the meanings that are communicated can be even more profound.

Introductory exercise: In groups of two or three (both options are provided below), explore the following blocking, sans dialogue. Try not to force a story or character onto the movement; rather, experience the blocking on its own. Once you have experimented with the blocking several times and can easily recall it, set it so that it remains the same each time you run through the scene.

SCENE FOR THREE ACTORS

A: Sits alone.

B: Enters and walks to A.

A: Stands and faces B.

C: Enters and walks in between A and B.

B: Grabs C's hand and moves C away.

C: Covers face and turns to A.

A: Hugs C.

C: Runs away.

B: Walks away.

A: Sits.

SCENE FOR TWO ACTORS

A: Sits alone.

B: Enters and walks to A.

A: Stands and faces B.

B: Grabs A's hand.

A: Pulls hand away and moves.

B: Turns to go.

A: Walks to B.

B: Smiles.

A: Touches B's arm.

B: Takes A's hand again.

Explanation: Perform these scenes for a group. Have the audience try to imagine what story might have been told in the scene. Next, ask the performers what characters, conflicts, and storylines might have emerged in their minds as a result of performing the scene and moving into and out of the images provided.

Follow-up exercise: Working in the same group or with the same partner, choose one of the ideas generated by either an audience member or a group member after having observed the silent scene. After choosing one scenario to work with, groups or partners sit and talk about what dialogue might ensue based on the characters and conflict imagined. Ask the participants to write down their dialogue and then to rehearse it without the movements. Keep dialogue short so that it can be easily memorized. Each pair or group should then read aloud their scene to the full group. Discuss observations.

Culminating exercise: Working with the same partners, have the participants pair the movements from the first exercise with the dialogue from the second exercise. Although other movements may emerge, ask them to keep the original movements at the core of the scene and remind them that very likely their ideas for dialogue came as a direct result from the movements. Each group should stand up and run through their scene several times. They can be encouraged to develop character, conflict, and backstory in an effort to flesh out the plot. Though the dialogue and scene may be short, there should still be a great deal of information provided. The audience should be able to decipher setting, character, relationships, conflict, and resolution immediately, so clarity and specificity are important.

Discussion: Have the groups perform their scene a third time, and ask the audience to discuss the setting, the characters and their relationships, the conflict, and the resolution. Have the performers explain their scenario. How close was the audience's perception of the scene? Why? What movements, gestures, and language made the story clear?

Beyond: Ask participants to observe how often they speak without moving. Have them make an important phone call, for example, and watch to see how much they move and gesture, even with a hearing-only audience. Have them turn off the sound on the television for a scene to examine how much they rely on movement to tell story. Have them listen to the news on the radio instead of the television. Ask participants to ascertain their favored method of communication: vocal or physical?

LESSON FOUR: TEAM COLLABORATE (skills used: observation, imagination, improvisation)

Purpose: The aim of this lesson is to help you learn to work with a group of people to accomplish a task.

Outcomes: By the end of the lesson you will have an increased ability to
- Appreciate group work and understand how a group can accomplish a task
- Compromise and work with others
- Listen well and share ideas collaboratively
- Analyze the force of unity

Opening: Groups of people can accomplish more than one individual, but only if they work together and not against one another. Questions to consider: How much do you collaborate with others? Give an example of a time in your work or personal life when you needed to engage in teamwork to accomplish a task. Do you consider yourself to be a good collaborator? What are your strengths and challenges when it comes to working with others?

Introductory exercise: The goal of this exercise is to create a knotted circle from which the group must untangle itself. To proceed, have the group form a horseshoe and hold hands. The facilitator or leader then takes the hand of one of the ends of the horseshoe and leads the group to move through, over, and underneath the others, so that the result is not a horseshoe or U shape but a twisted and gnarled mass. At this point the first and last person should grab hands. Without letting go of anyone's hand, the group must now attempt to detangle itself and to form a complete circle with everyone facing inward.

Explanation: Collaboration asks a group of people to work together. In a solid and successful collaboration, everyone involved participates actively and assumes a part of the workload to complete a task. In collaboration, participants subordinate personal interests in favor of creating a unified product. It is often easier for one individual to accomplish a job, but in many instances the advice, ideas, and energy a group can offer is stronger. Working with others isn't always easy, but collaborative skills can be learned and practiced.

Follow-up exercise: Machines offer us a wonderful example of collaboration. They typically are made up of numerous smaller parts working together to perform a task or make a new object. Viewed from far away, machines often appear to be one whole object, but when seen much closer, the individual parts are realized, and an appreciation for how the smaller parts work together to create the whole can be grasped. This exercise is called "Building a Machine" and begins with a circle. One person begins by standing in one place in the center of the circle and by making a

Fig. 4.3 (photo: Mike Fink)—Participants take part in the circle of knots exercise.

simple and repetitive movement with her body. She can also add a repetitive sound to accompany the movement. After the movement has been established, a second person adds to the machine by offering a different repetitive movement (and sound if desired) that works in concert with the first movement. After a moment of the two individuals (or machine parts) working together, a third part is added to the mix, and so on. The trick with this exercise is to avoid making an assembly line. Each new machine part should attempt to engage at least two other parts. The group can build as many machines as desired, and different types of machines can be built. For example, a group can build an ice cream maker, a time machine, or a television. Great success can also be found in building abstract or issue-based machines, such as a machine of happiness or a work or college machine.

Culminating exercise: Participants form groups of three to seven people. Each group chooses a short but well-known poem, speech, or song to perform together. Examples might be the Pledge of Allegiance, a nursery rhyme, or a popular song known by all group members. First, the group memorizes the piece and then collaboratively works to recite the lines simultaneously, so that each participant is saying the lines at the same time with the same rhythm, cadence, timing, and volume. Once the language and vocal aspect have been rehearsed, the team should

add movement to the piece. The individual movements can be different movements that are synchronized and reliant on the others, just as the machine movements of the previous exercise were. The piece is rehearsed several times so that it is purposeful and prepared. Everyone must know his or her job, and all jobs should work together to achieve the end result.

Discussion: What was the most difficult part of the collaborative exercises? Explain the difficulties, and try to brainstorm ways to overcome the obstacles. When did the group succeed, and why? What are the key ingredients in this type of teamwork? What did you learn about your collaborative skills and abilities during the exercises? What can you change about the way you enter into collaborative work?

Beyond: As you go about your day, observe small moments when you are being asked to work as part of a team. Analyze your involvement and skills. Are you able to listen? Are you able to compromise? Are you able to share your ideas and allow others to transform your ideas? When do you get frustrated? Be prepared to share one experience with the group and to explain how you were able to incorporate what you learned in this lesson into your experience in real life.

LESSON FIVE: PSYCHOLOGICAL GESTURE (skills used: physical, characterization)

Purpose: The aim of this lesson is to understand how your body language communicates your psychology to others and to begin using gesture to build confidence.

Outcomes: By the end of the lesson you will have an increased ability to
- Understand what gestures you habitually use
- Evaluate what those habitual gestures communicate to others and to yourself
- Create a new gesture to use in moments of personal uncertainty
- Learn to use a gesture to access hidden emotions or desires

Opening: Gather in a circle and ask for definitions for the word "gesture." Ask the group to define the term "psychology." Ask everyone to contribute one thought about one of these words. There is no right or wrong answer. Ask participants if they are aware of any gestures that they have seen people make repeatedly.

Introductory exercise: We all have our signature moves and gestures, those that we make often. These gestures are unique and define us to others and to ourselves. Ask everyone to show one of their signature moves to the class. Move in a clockwise circle and have the facilitator begin with a demonstration. Each participant should be encouraged to begin in a neutral position and to move into the gesture, to fully commit to the gesture, and to finish in a neutral position. Discuss observations. What did the gesturers communicate? Have you seen these gestures before? What is the implied connotation?

Explanation: Michael Chekhov developed an acting technique called "the psychological gesture" after having worked as an actor for the Moscow Art Theatre (MAT) in the early 1900s. A nephew of the Russian playwright Anton Chekhov, he was considered one of MAT's

most successful students and brightest performers; however, he suffered a nervous breakdown. In the 1920s Chekhov split with MAT and began his own acting program, with much of his work centering around the psychological gesture, a term he coined to define a movement that expresses the psychology of a character. He believed strongly in the connection between the mind and the body, which was controversial at the time, and he sought to link physical actions to the thoughts, feelings, and wills of his characters.

Follow-up exercise: Ask each participant to make three statements about themselves. These should be feelings, thoughts, or wants that are strong, not transitory, and reflect the way the participants feel about themselves. Examples might be "I am lonely." "I don't want to grow up." "I'm afraid to speak my mind." "I feel unintelligent." "I am a generous person." "I am sexy." "Don't mess with me." Have each participant share their statements with the group and ask the group to choose the strongest one for the participants to work with. Once the statement has been decided on, each person should find a psychological gesture to pair with the statement. To find this, work simultaneously, so that no one is being observed. Guide the class by dividing the gesture into three parts: a beginning, a middle, and an end. Have the individuals spend ten minutes honing their gesture while being side-coached. They should be encouraged to amplify their gesture, to minimize it, to make it subtle, and to make it overt. They can try the gesture with a variety of emotions: anger, fear, love, ridicule, paranoia, surprise, and so on. They should explore the gesture at different levels: what is it like to stand and make the gesture versus to sit and make the gesture. They might communicate their gesture to one another, and if the room has a mirror, they should observe themselves making the gesture. Ask them to use as much of their body as possible to make the gesture, and ask them to internalize the gesture so that a move is barely perceptible. Have them continue to make the gesture with a variety of explorations. Once the gesture has been explored in its entirety, ask them to set their gesture so that they can repeat it again and again with exactness. Gather back into a circle and ask the group to show their gestures: first with no language, then by pairing the gesture, in its three parts, with the verbal statement that was chosen. Discuss observations and feelings. What did the audience members feel when they witnessed the gestures? What did the gesturer feel? What can this gesture do to the individual's psychology over time? What does the gesture convey?

Culminating exercise: Ask each person how they hope to be perceived. Ask them to refine their statement or to change it so that it shows them as they want to be seen and as their absolute best selves. For example, "I am lonely" could be stated as "I'd like some company." "I feel unintelligent" could be rephrased as "I'm curious and want to learn." The facilitator and group should actively help each participant frame the statement in an active and positive light. Try the above exercise again, this time beginning with the verbal statement and letting the gesture come from the statement. Explore ways to enhance the gesture so that it reflects the statement being made. Pair the gesture with the statement and show these to the full group.

Discussion: How did this change affect you internally? What did it feel like to make the negative statement? What did it feel like to make the positive statement? How could this positive gesture be used subtly in your daily life? Michael Chekhov used his characters' psychological gestures before he went on stage as a way to enter into the mind-set of the character he was portraying. When he was on stage and felt his character, intent, or emotion fading, he created a mental

picture of the gesture to embolden his action. Other actors use the psychological gesture on stage or camera to reconnect to the character.

Beyond: Actors use this with the roles they perform onstage or onscreen. You too can use it in your daily performances. Experiment with making the psychological gesture in your public and private life.

LESSON SIX: SUBTEXT (skills used: vocal, physical, observation)

Purpose: The aim of this lesson is to help you analyze language and paralinguistic cues to convey and ascertain meaning.

Outcomes: At the end of the lesson you will have developed an increased ability to
- Understand that nonverbal communication makes up a large part of any informational exchange
- Appreciate the importance of using and reading subtext
- Add to, and clarify, your message by using accompanying gestures and vocal effects
- Ascertain the true meaning the sender is communicating by reading his or her subtext

Opening: The language we use represents very little of what we actually mean and even less of what is actually perceived by our audience. We underscore or belie our spoken language with vocal qualities, such as intonation and tone, and with body language, such as gesture, stance, and eye contact. Can you think of moments in your daily life when you do this? When do you use vocal or physical cues to underscore your language? When do you use these to indicate something entirely different to your audience?

Introductory exercise: Take a simple statement, such as "I like you," or "Go away." Consider the meaning of the language of each of these statements if taken at face value. Try saying each of these statements with sincerity and by matching your body language and vocal cues to the language so that your message is clear and straightforward. If you are working with a group, form a circle and take turns, one at a time, starting with the first piece of text, "I like you." Try to use your eye contact and gesture, volume, and intonation to complement the text. Try the exercise again with the second piece of text, "Go away." Again, focus on coordinating your body and voice with the language. Continue this exercise with other lines.

Explanation: The real meaning of our message is presented through body language, attitude, demeanor, and vocal cues, such as tone, pitch, intonation, pace, and volume. Actors call these ever-present cues that exist alongside or underneath the language the *subtext*. Using subtext to communicate meaning and being able to read the subtext that is being communicated are very important skills that can help you send clearer messages and understand the messages that are being sent. Discuss your observations of the previous exercise. What cues were most effective in communicating the text? How did the content underneath the spoken dialogue highlight the meaning?

Follow-up exercise: In the first exercise you focused on using your eyes, gestures, body, and voice to reinforce your spoken language. Now use the same tools in concert with your language

so that a different meaning is implied through subtext. Moving around the circle, each participant uses his or her voice and body to communicate an entirely different sentiment while saying, "I like you." Repeat the exercise with the other line, "Go away." Repeat the exercise with the lines you used in the first exercise.

Culminating exercise: Ask each participant to choose a line of dialogue listed below. Next, choose a line of subtext from below to communicate alongside the chosen line of text. Ask the other participants to decode the subtext.

DIALOGUE: line of text actually said.

Hello.	How are you?	What time is it?
The water is cold.	The phone is ringing.	It's hot out.
She's over there.	Sorry I'm late.	I live in a house.
I'm in school.	I like to read.	I've seen you before.
Do you drink coffee?	He's nice.	It's raining.

SUBTEXT: the real meaning conveyed by the speaker.

Can you help me?	I hate you.	I don't trust you.
I'm afraid.	I'm attracted to you.	I don't care.
Please leave.	I'm late.	You are smart.

Discussion: What similarities did you observe with the subtext? In which subtextual communications did the communicator use his or her eyes? How did the gestures imply meaning? What about volume? Which subtext tended to be louder or softer? What body positions or postures were used to communicate subtext, and how successful were these?

Beyond: We all use subtext daily. At times we use it to reinforce text, at times we use it to offer new meaning to the communication, and at times our subtext belies or contradicts what we are saying. Keep track of the number of times you use subtext in the coming week and observe when you notice someone using it with you. Continue to think about how successful subtext is as a form of communication and how you can you use it to enhance your communication.

LESSON SEVEN: OBJECTIVES, OBSTACLES, AND TACTICS (skills used; vocal, physical, observation, imagination, improvisation, characterization)

Purpose: The aim of this lesson is to help you connect your actions to specific goals.

Outcomes: By the end of the lesson you will have an increased ability to
- Apply the concept of objectives, obstacles, and tactics

- Explore and experiment with different tactics to accomplish an objective in spite of obstacles
- Analyze the use of your tactics and the way others use tactics
- Evaluate how successful tactics can be in the service of achieving a goal

Opening: You know from previous exercises that actors name and analyze their character's *objectives* and use these objectives as a key to drive their character's actions. You also know that non-actors have objectives that they set about trying to achieve. Typically, however, what we want is not so easily obtained. There is usually an *obstacle* that prevents us from reaching our goal immediately. When presented with an obstacle, most of us do not give up. Instead, we pursue a variety of *tactics* to maneuver around the obstacle so that we can obtain our objective. Military tactics might be defined as the science and art of maneuvering forces in combat. Actors define tactics as the strategies used to achieve the character's objective. In both cases, tactic implies a means used to get a want.

Introductory exercise: Place a chair in front of the group. Place a set of keys underneath the chair. Ask someone from the group to get the keys. This should be easy, as nothing is in the person's way, so she should be able to easily procure them. Now, try the same exercise, but this time have a volunteer sit in the chair and place a blindfold over his eyes. Ask the person to stay seated in the chair, but give him permission to use his hands and feet to guard the keys. Have another group member try to get the keys without being touched. When someone is touched, her turn is over, and another person tries to get the keys. Try this several times and observe the number of different ways individuals attempt to get around the person in the chair. This exercise can continue without the blindfold. It should become more difficult without the vision impairment. Finally, see if a small group can work together to get the set of keys without being touched by the person in the chair.

Explanation: The first simple task represents an objective without an obstacle. When the keys are unguarded, they are easy to procure. Once a person is seated in the chair, an obstacle is introduced, and the goal becomes more difficult to achieve. If the actor wants the keys, however, he or she will employ a tactic to overcome the obstacle. If the first tactic fails, the person will try another, and another, until the objective is accomplished.

Follow-up exercise: Gather some chairs and place them tightly together to form an imaginary bus or subway car. Ask each participant to take a seat in a chair. Remove one chair, so that one participant is now standing. The seated participants are all comfortably seated on a bus or subway. The participants who are seated have an objective: to stay seated. In order to make the game work, they should each chose a reason why they need to stay seated (e.g., they just sat down and are exhausted, or they sit in this seat every day and believe it's good luck, or they are looking for something they lost in the seat). The person who is standing also has an objective: to sit. Because all of the seats are taken, the game is presented with a preliminary obstacle. The standing participant begins the game by choosing another passenger to address and to request that the person give up his or her seat. The seated person should initially decline to move, presenting the reason why he or she must keep the seat. It is the job of the standing person to use a variety of tactics to persuade the seated person to move. Each participant involved in

this conversation must make his or her case believable and honest. If a tactic used is made in a convincing manner, and the seated person cannot think of a reason why she should stay in the seat, she should stand up, offer her seat, and thus the game begins again with a new seat seeker. Play at least one round of this, so that everyone in the group has the opportunity to find a seat and to give up a seat.

Culminating exercise: Repeat the subway/bus scenario, but this time, have the person looking to gain a seat use the list of active verbs below as tactics to obtain a seat on the bus. Many of these tactics come from a list compiled by Paul Kuritz from his 1982 book *Playing: An Introduction to Acting*.

TACTICS: strategies we use to communicate and get what we want

To belittle	To repulse	To correct
To comfort	To alarm	To court
To threaten	To antagonize	To frighten
To surprise	To bribe	To goad
To constrict	To beg	To negotiate
To uplift	To challenge	To shame
To seduce	To confide	To support
To warn	To summon	To ridicule
To hoodwink	To confuse	To indulge
To amaze	To please	To inspire

Discussion: How did the use of specific tactics help the participants obtain a seat on the bus? If tactics were divided into two categories, what would the categories be titled? Which of these tactics have you used in your life to get what you wanted? Which tactics have been used on you?

Beyond: In his book *Acting One*, Robert Cohen says that there are two types of tactics: "those that threaten and those that induce—punishment and reward, in other words. . . . Raising your voice is a threatening tactic, smiling, an inductive tactic." (2002, 46). Observe how you use these two types of tactics over the course of the next few days to achieve your objectives. How successful are these types of tactics, and in what situations do you tend to rely on them?

LESSON EIGHT: DEVISING A STORY WITH A GROUP (skills used: concentration and relaxation, imagination, characterization)

Purpose: The aim of this lesson is to help you develop an ability to generate ideas based on a single stimulus and to share your ideas with others in order to create a story.

Outcomes: By the end of the lesson you will have an increased ability to
- Relax and allow your imagination to work without self-censorship

- Conjure up images and characters that exist in a fictional world
- Use stimuli to free your imagination
- Build a story by collaborating with a group of people

Opening: Have you ever come across a piece of art, a place, or a person that sparked something in your imagination and caused you to envision a scenario or even fully formed story in your mind? What was it about the stimulus that engaged your imagination? What types of stories do you imagine? What makes a good story?

Introductory exercise: The participants find a spot in the room and lie down with their backs on the floor, their legs uncrossed, and their arms at their sides. They should focus on allowing their bodies to relax into the floor and on regulating their breathing, keeping it deep and long. They might try breathing in through their noses and out through their mouths. Participants are encouraged to clear their minds.

The facilitator will play a piece of music, one to two minutes in length; instrumental music is a good idea for some groups who might be swayed by language. The participants are asked only to listen to the music. After the music has played once, the facilitator plays it a second time, this time instructing the listeners to allow their minds to focus on a setting. What atmosphere or environment is conjured in the listeners' minds as they hear the music? What temperature or climate does the music suggest? The facilitator plays the music a third time, this time instructing the listeners to build on the setting and to allow characters to emerge from their imagination. What types of characters does the music evoke? What do they look like? What is their demeanor? What do they want? What might they be doing? The facilitator plays the song a final time, making it a total of four opportunities to hear the music. With this final playing, the listeners are asked to imagine a conflict that arises for the characters in the setting they have previously imagined. Participants should be encouraged to hear the moment the conflict is introduced in the music and to watch the conflict unfold. Who is a protagonist? An antagonist? What tactics are used to combat the problem? Finally, as the music ends, the listeners can be encouraged to imagine some resolution, positive or negative, that ends the story.

Explanation: *Devising* is a collaborative way to create a story through a group of people, rather than a single writer, and often begins by using a stimulus as the point of departure. In this way a drama is developed for performance through individual responses to the stimulus, an offering up of ideas, a cooperative discussion of storyline and characters, and a group agreement about form, structure, and conventions used.

Follow-up exercise: The group is divided up into smaller groups of three to five participants. The smaller groups each find an area to work in and begin by sitting together and individually sharing the stories they imagined while listening to the music. Each person should speak for a minute or two and offer the group their general impression of the music as well as the setting, characters, conflict, and plot they imagined. After everyone has shared their imaginings, the group should discuss potential ways to incorporate the different stories so that the group story encompasses something from everyone. The facilitator plays the music again, quietly so that it underscores the later part of the conversation, and continues to guide the devising process.

After the beginning of a story has emerged, groups should stand up and explore acting out the stories while the music plays.

Culminating exercise: The small groups are given ten to twenty minutes to work. After the exploration, they are asked to hone their story down to the essentials so that their performance is between one and two minutes in length. Groups are advised that they are going to show their work to the full group—choosing to use the music in the performance or not. Although actors can choose speak in the performance, they do not need to. If they choose to speak, they should be cautioned to limit their language to only what is absolutely necessary. Performances are shown to the full group.

Discussion: How did having a stimulus aid or hinder your imagination? How did your original imagining change as you continued to listen to the music (after the first time) and then as you shared your ideas with your group? How difficult was it to compromise? What might you build on if you were to spend more time with this story and performance?

Beyond: The next time you are asked to share an idea, in the workplace, in a classroom, or in a social or familial setting, allow yourself to relax first and to take in the totality of the problem or request. Begin by relaxing your body and starting small: locate the task and allow yourself to imagine a scenario that might play out by visualizing the setting, characters, and conflict. When you do share your thoughts, be mindful that others will have thoughts about how to approach the situation as well and that your ideas might be better served by incorporating the ideas of others.

LESSON NINE: IMPROVISATION (skills used: vocal, physical, imagination, improvisation)

Purpose: The aim of this lesson is to help you harness your nerves and explore story and character through improvisation.

Outcomes: By the end of the lesson you will have developed an increased ability to
- Understand that nerves are a natural part of performing
- Harness nerves through concentration and character
- Use the rules of improvisation to develop characters and stories
- Trust others to help you out in improvisational performances

Opening: Improvisational theatre—also called "improv" or "impro"—is a performance or rehearsal technique that asks actors to create the dialogue, action, character, and story collaboratively at the moment it is being performed, with no previous communication about what might occur. Improvisation is also a technique all of us use when we engage in actions or conversation without preplanning. When do you improvise in your life? Are you good at improvisation? What is difficult about improvising?

Introductory exercise: The group stands in a circle, and the facilitator pulls out an object (this can be an everyday object, something that perhaps exists in the room, such as a book, a broom, an earring, a shoe, a phone, or the facilitator can bring in different props that are a bit more

random). The facilitator explains that the object is not what it appears to be, and then she mimes a new use for the object before passing the object to the person to her right. The participant must then improvise a new use for the object, which can be as unusual, imaginative, or abstract as he desires. In this way the object is passed around the circle, and each participant performs a short solo improvisation that depicts a new use for the object. Several objects can be passed around.

Explanation: The facilitator explains that everyone just participated in solo improvisational performances. Improvisation puts participants on the spot, which can be very challenging, and because it does so, it can bring up nerves and fears. With practice, though, the participants will gain confidence, and when the comfort level of an actor is raised, the imagination will be freed and the censorship will decrease. The facilitator explains that many people feel nervous just before they perform but not during a performance, precisely because while they are performing, they are focusing their concentration on the performance, leaving no room to focus on, or experience, nerves. Short performances, such as the previous one, are almost over before they begin, thereby limiting the nerves.

Follow-up exercise: Improvisational theatre follows some basic rules to help keep the story moving and interesting for the audience. These same rules also guide the performers, creating a frame for the actor, guiding him as he creates new ideas on the spot. One of the most helpful rules is called "Yes, and…." The premise of this rule is that in order to keep a story moving forward in improvisation, all actors need to agree on the characters, premise, and conflict in a scene. For example, if I am in a scene with another actor and I say, "Hi, honey. Mom's home. How was your day?" and the other actor responds with, "Who are you? I'm not your son!" we have no scene. Instead, we have two actors disagreeing about what the story is about. The "Yes, and…" rule means that the other actor needs to accept what has been offered to the story before adding new information, which in turn will be accepted by his partner. The "Yes, and…" rule changes the above dialogue to the following:

ACTOR A: "Hi, honey. Mom's home. How was your day?"
ACTOR B: "Hi, Mom. The day was fine. Can you help me in the kitchen?

Participants pair off and face each other to play the "Yes, and…" game. One is A and the other is B. The facilitator throws out a topic or relationship, and actor A begins with an offer in the form of one sentence. Actor B then responds, beginning with "Yes, and…" so that he is agreeing to the offer and statement. B then continues to further develop the scene by adding more information in the form of a sentence. A responds, beginning with "Yes, and…" and then she continues the scene by adding more information. This game should play out for forty-five to ninety seconds before the facilitator throws out another topic or relationship and Actor B begins by making an offer to A.

Culminating exercise: Thus far the group has participated in short solo improvs and in intimate pair improvs not performed for an audience. For the culminating exercise the full group should come back together and use the information gained to play another improv game. This game, sometimes called "Who, Who, Where, What," asks the players to provide specific

information in a particular order to develop a story. The game begins with two volunteers who stand in front of the audience. Actor A offers the first line, which tells Actor B who his character is. Actor B accepts his character and offers the second line, which tells Actor A who she is.

Actor A: Professor Quakenbush is that you?	(WHO)
Actor B: Yes, little Conrad, I'm right here!	(WHO)

This exchange of dialogue tells each character who he or she is, thus the "who, who," and offers them clues as to how to proceed with the improvisation. Because the game alternates the lines of dialogue, Actor A is responsible for the third line, which provides the "where" for the story. Actor B accepts the where and responds with the fourth line of dialogue, which provides the "what." The "what" can provide both the action of the scene, as in "what" the characters are doing, but, more important, it provides the beginning of the conflict.

Actor A: Professor Quakenbush is that you?	(WHO)
Actor B: Yes, little Conrad, I'm right here!	(WHO)
Actor A: Can you see anything in this dark jungle?	(WHERE)
Actor B: Not without my lantern. Wait, I think I just heard a growl!	(WHAT)

This scene can continue for a bit, end here, or turn into the Freeze Frame game listed in the improvisation exercise at the top of this section. There are thousands of improvisational exercises available. For more ideas, look at the websites and books listed in the Resources section of this book.

Discussion: How did having a frame or guide make the improvisation easier? What was it like to have an actor offer you a character? Were you able to take the offering and add to the story? How can you reconcile the "Yes, and…" rule of improvisation with the need to drive a story with conflict? How can the two rules work together? How does movement aid in the storytelling? What happened to your nerves before and during your performance time?

Beyond: In her book *Bossypants*, Tina Fey reminds us that "the first rule of improvisation is AGREE. Always agree and say YES" (2013, 82). She goes on to remind us of the importance of agreeing with others in the workplace, at home, and in life. Of course, we shouldn't agree with everything, especially if it goes against our beliefs, but the general principle of saying "yes" reminds us to "start from an open-minded place" (Fey 2013, 82). Fey tells us to "start with a YES" in our everyday lives. So, try saying "yes" this week. Try stepping out of your comfort zone; look for the potential of "yes"!

LESSON TEN: LISTENING (skills used: vocal, observational, concentration and relaxation, improvisation)

Purpose: The aim of this lesson is to develop listening skills so that messages are accurately sent and received.

Outcomes: By the end of the lesson you will have developed an increased ability to
- Ascertain real meaning from another person's story
- Sit or stand in one place, maintain eye contact, and demonstrate receptiveness
- Concentrate fully on another person
- Communicate engagement and emotion to another person without speaking
- Recall correctly what someone has communicated to you

Opening: Good listeners forge better relationships because they really connect to the sender and to what is being said. They are less apt to misinterpret the message but rather, because they are listening well, receive the message as it was intended. What do you tend to do when another person is speaking to you? What habits have you formed? Do you ever interrupt? Think ahead of the speaker? Think about other things? What listening habits have you formed? What do you consider to be good listening?

Introductory exercise: Find a partner. Take turns being the speaker and the listener. Stand together, back to back, and each share a story of a recent event in your life. Take between three and five minutes each, and ask the person listening to keep track of the time. After both stories have been told, turn around and face each other and have the listener retell the story to the original speaker. Spend some time discussing what was recalled and perhaps what was misinterpreted. Discuss the accuracy of the story and the hierarchy of the what was recalled. Was it told in the same order? Which moments were emphasized, and did the re-teller understand the key moments, emotions, and images originally presented? Take some time to make observations about the accuracy of the retelling.

Explanation: The average person speaks at a rate of 150 words per minute, but people are usually able to interpret information at an even higher speed. This leaves the listener with a lot of extra time for distractions to occur. When you are listening, you might find yourself thinking about things that have nothing to do with the conversation or message being sent. You might find yourself projecting what the sender is going to say next, or you might find yourself already preparing your response. When these things happen, communication starts to break down. In a good communication model between two people, a message is stated, heard, clarified, and confirmed. In order for this to occur, the listener must give the uninterrupted sender time and their undivided attention.

Follow-up exercise: Review some key aspects of good listening: (1) Concentrate on what is being said, the rate of the speech, the body language, and vocal intonation. These all influence how communication is received, and they help the listener stay focused. (2) Don't interrupt the speaker, as interruptions disturb the communicator's ability to send the message and distract the listener. (3) Interact nonverbally with the speaker by maintaining eye contact, nodding your head when you understand, and being physically open to that person. (4) Avoid thinking about your response during this time and instead allow your response to come naturally at the end. Try the exercise again with a different story, and this time turn around and face each other; sit if you would like. Focus on following the four steps to good communication, and see if you are able to garner more accurate information from the storyteller. Make sure as you tell your story that you provide details and help your partner to form a mental image of the event. Use your body and voice to connect.

Culminating exercise: Choose a scene from a play or a film that has not previously been seen by the participants. Actors pair off and find an area to work in. They face each other, make eye contact, and relax their bodies. One actor, Actor A, holds the script and reads a line of dialogue from one of the characters in the scene. Actor B, who is without a script, listens and responds by improvising a line of dialogue, using her listening skills to craft her response. Actor A then reads a different line of dialogue from the scene. This can be from the same character or a different character, but it should be a different line of dialogue rather than a continuation of the same line. Actor B, again, listens to the line and responds to what he has heard. This continues for several minutes. The lines read by Actor A should be just a sentence, not too much information, and the improvised responses by Actor B also need not be long, but must be appropriate to the circumstances, mood, and character of the scene. The lines from Actor A should come quickly and get quicker as the exercise progresses. The purpose is not for Actor B to be witty or funny, but to really listen to her partner. This exercise can be continued if needed with the full group so that two actors are working in front of the group. After this exercise has taken place with quick exchanges, try the opposite. Actor B reads a line from a text, and Actor A responds without the script but by using his listening skills to determine a response.

Discussion: The group gathers together and discusses the questions. What is hearing? What is listening? How often do you not listen to what you hear? When and why does this happen? How do we get better as listeners? Augusto Boal has a great chapter in *Games for Actors and Non-Actors* (1992) in which he offers a series of exercises designed to cultivate our ability to really listen to what we hear. Consider exploring some of his games and exercises in this area.

Beyond: The next time you find yourself tuning out or letting time, fatigue, or your emotions stop you from really listening, take a deep breath and allow your body posture to come back to neutral and for your eyes to connect with the person you are hearing. Whether this is in a meeting, in the middle of a heated argument, or during a discussion about something you have strong opinions about, ask yourself to relax and to concentrate on what is being communicated. Don't formulate a response while you are listening. Just listen to the communicator and receive the communication.

LESSON ELEVEN: JUMPING INTO THE ROLE YOU WANT TO PLAY
(skills used: vocal, physical, observational, improvisational, characterization)

Purpose: To explore and experience the communication process of a job interview and to gain confidence selling yourself to future employers.

Outcomes: By the end of the lesson you will have developed an increased ability to
- Read your audience (the employer), including verbal and body language, mood, and formality
- Share your talents, ideas, and personality with confidence
- Present yourself in a way that is befitting the job

Opening: Think of jobs as roles we play in our daily lives. What jobs have you held, and how have you needed to present yourself and behave in these places of work? What types of language have you had to use? How did you/do you dress for the job? What jobs do you hope to hold in the future?

Introductory exercise: "Seven Levels of Energy," also called by many other names, is an exercise in which participants explore energy physically. Begin by lying down on the ground, completely exhausted. This is Level 1: Catatonic. Sit up and open your eyes. You are upright, but nothing matters, and there is no tension. This is Level 2: Laid Back. Go ahead and stand up. Neutralize your body, opening it up but allowing only enough tension into your limbs so that they can remain in place. This is Level 3: Economic. Look at things, sit and stand, move around, take everything in. This is Level 4: Curious. Something is going to happen. Allow tension to creep into your body. A crisis is unfolding, and it could come from anywhere—above, behind, or below you. Look at the others with apprehension. This is Level 5: Suspense. Allow yourself to be excited, energetic. Truly enjoy the moment and wait with wonder for the next fabulous thing to occur. Crave connections with others. Delight in your own zeal! This is Level 6: Passion. Fill your entire body with tension and energy until it is about to burst. Take in final breath and hold it until you erupt! This is Level 7: Explode.

Explanation: Every workplace has an attitude, a personality, and an energy. It is important to be able to pick up on the mood of a work environment in an interview and to convince the potential employer that you that you have communication skills and abilities and personal attributes to fit into the workplace. This is not to suggest that the passion or exploding states of energy are appropriate for a job interview, but neither are Levels 1, 2, or 3.

Follow up Exercise: Write out a description of your dream job. Share this description with a small group of three to five others. Ask the group to discuss what broad skills and abilities and what personal attributes they think the position might require. Brainstorm and make a bulleted list.

Skills and Abilities
- 1.
- 2.
- 3.

Personal Attributes
- 1.
- 2.
- 3.

Set up some chairs, one in the center and the others in a horseshoe formation around the central chair. Take turns in the "hot spot" chair. Imagine that the person in the central chair is being interviewed for his dream job. Have the other group members ask the interviewee questions about himself and his abilities and attributes. When you are the interviewee, try to answer in ways that demonstrate and share the skills and abilities and the personal attributes the group listed. Don't think of this as an opportunity to be funny or entertain, but rather as

an opportunity to step into the role of the job you hope to someday hold. Consider the levels of energy explored in the previous exercise. Which level is appropriate for this job? Questions might include "Where are you from?" "What are your hobbies?" "What is the last book you read and loved?" "What was your best educational experience?" "Tell us about an adventure you have had." "What attributes will you bring to the workplace?"

Culminating exercise: Divide into pairs. Each person is handed some basic job descriptions (see below). Decide who will be the interviewer and who will be the interviewee. Without any preparation, the interviewer reads the job summary. The interviewee steps into the role and answers the questions as he or she deems appropriate to the position.

- Why do you think you would be good at this job?
- What are your biggest strengths?
- What do you need to work on?
- Describe your ability to collaborate.
- Why should I hire you?
- Do you have any questions for me?

MARIO'S ITALIAN KITCHEN: Now hiring an evening prep cook. Great pay, will train. Looking for someone who deals with stress well, and is able to multitask. Humor and a laid-back personality are a plus!

PRESCHOOL TEACHER: Are you a child at heart? Busy Bee Preschool is looking to hire an energetic and intelligent teacher. Must have patience and the ability to articulate instructions with clarity and expressiveness.

SENIOR SCIENTIST: Seeking a senior scientist who is efficient and a motivated self-starter. A critical and analytical thinker, applicants must be able to bring closure to work in a timely manner. Easily adaptable to change.

INDEPENDENT SALES EXECUTIVE: Energetic and independent people needed to sell advertisements for fast-growing nutritional drink. Be part of a reputable company before it explodes. Must be willing to work in a fast-paced environment, friendly, and outgoing. Team players only!

CUSTOMER SERVICE REPRESENTATIVE: Detail-oriented person needed to answer calls, direct inquiries, and assist callers with micro problems related to their health insurance claims. We are looking for someone who is persistent and unflappable. Compassion and an ability to be direct with callers are helpful.

TEACHING JOBS IN ASIA: AJC Consulting is seeking English as a Second Language teachers for reputable schools. This job involves teaching conversational English to adults at an English language institute. No teaching experience necessary, but candidates must be professional in demeanor, polite, and well spoken. Reliable and clear.

MANAGEMENT TRAINEE: Company seeking a trainee who is interested in learning on the job! Do you see yourself as a potential manager? Are you capable of overseeing others? Are you philanthropic and invested in your community? Need an ability to direct others without coming across as bossy.

LAW FIRM: A successful Aspen law firm seeks an attorney to join their real estate practice. Candidates must have an excellent academic record, have excellent communication and personal skills, and be able to work under pressure and deadlines. Conflict resolution skills a plus.

Switch roles and interview for other jobs. Create new job descriptions if you want. This is practice for the real interview, and practice will help you improve. If you have time and want to continue, this exercise can be run like a game show. An actor playing the employer comes onstage, with three actors playing potential employees. Let the audience choose the best candidate for the job!

Discussion: What was it like to "speed interview"? What did you learn about the interview process from rehearsing the situation? What did you learn about yourself in these situations? How were you able to articulate yourself and sell yourself for the job? What do you need to work on? How did your energy change depending on the job? Did your body language and voice change as well?

Beyond: The next time you interview for a job, meet a new person in a formal situation, or go on a date (which, early on, is an interview) consider your audience. What are they seeking from you? Do you fit the position? If you seek the job, can you present yourself in such a way that casts you in the role you want?

LESSON TWELVE: FORUM THEATRE (skills used: vocal, physical, observation, imagination, improvisation, characterization)

Purpose: The aim of this lesson is to collaboratively explore potential problem-solving techniques and to cultivate empathy by understanding the perspective of others.

Outcomes: By the end of the lesson you will have developed an increased ability to
- Understand how problems can be discussed through role-play and active participation
- Apply perspective and empathy as you portray a character different from yourself
- Evaluate different options for behaving and responding to the behaviors of others
- Begin to formulate plans for action

Opening: Augusto Boal's forum theatre has been mentioned previously in this book. You might recall that this performance form asks participants, called "spect-actors," to simultaneously observe and act. The goal of forum theatre is to actively discuss potential ways of dealing with conflict and problems. No single answer is sought; rather, it is a way to share ideas and to listen to the observations of others. Forum theatre has been used by communities around the world

to analyze problems and prepare for action. Each forum is conducted by a facilitator, or "joker," as Boal liked to call the person who guides the interactive component.

Introductory exercise: The entire group brainstorms problems and issues that are pertinent to their *own* lives. Rather than share specifics at this early point, the group simply lists the issues by naming them. A facilitator can write these down. Examples might be substance abuse, eating disorders, pollution, poverty, ageism, sexism, sex, pregnancy, individual freedom, depression, physical abuse, and so on. An important aspect of forum theatre is that participants come up with their own list and are not mandated topics to choose from. The issues explored must come from the participants themselves. For example, when I have facilitated forum theatre experiences in India, the caste system was a popular topic for discussion. Working with high school students in Montana, parental pressure often is listed as a topic, and when I work in Sweden, issues revolving around equality tend to top the list. There are no wrong or right issues to choose; the important thing is that the participants have some personal experience with the problem. Once a list is generated, the individuals should vote for two to three topics that they might be interested in working with. The topics with the most votes are the topics that are dealt with in the forum theatre pieces. Sometimes a second vote, or even a third, is needed in order to get the right amount of topics for the group. From here, participants break into groups based on their experience and on which issue they are most interested in exploring. Generally groups should have no less than three or four participants and no more than seven. Each group then finds a space and sits together in a circle. Each individual shares a story from his or her own life that deals with the chosen subject. Each participant takes about two minutes to share his or her story. After all stories have been shared, the group chooses one of the stories to base a forum play on.

Explanation: By brainstorming potential issues, choosing topics, and breaking into groups and sharing stories, participants are defining the problem and naming the central issue at the heart of the problem. The sharing of personal stories allows participants to identify common themes, emotions, and relationships that exist. At this point, depending on the size of the full group, there may be three to ten smaller groups working simultaneously. Each group will be creating a short forum play that showcases the problem and details the central issue or issues.

Follow-up exercise: Once a specific story has been chosen, the group begins to flesh out the storyline. A list of characters is compiled; some are perhaps replicas of characters from the original story, and some might be characters borrowed from another group member's shared story. There should be at least one protagonist and one antagonist and perhaps allies on each side, as well as those who might be caught in the middle of the issue. The teller of the story is likely a character. After characters are listed, actors from the group are cast in the roles. Everyone should have a role, and the person whose story is being told should not play himself or herself. After casting, a script in the form of a list of actions is written. The script is broken down into seven to ten discrete actions that tell the story of the issue but do not resolve the issue. The forum script, rather, should build up to the conflict and end before any resolution takes place. Once the characters and script are finished, the group rehearses the forum piece several times so that it is consistent and plays out the same way each time. Actors learn to understand their characters intimately this way, and thus they know why their characters behave as they do. Each actor might be encouraged to write a monologue in the first person explaining the character's motivation. The person whose story is being focused on can answer questions about characters and actions along the way.

SCRIPT EXAMPLE

FORUM SUBJECT: *Smoking in Public Places*

CHARACTERS
- MONICA: A hardcore smoker who would never consider quitting. Her entire family smokes. It's the first thing she does every morning.
- DAVID: MONICA'S best friend. He is protective of her and watches out for her, and he smokes.
- ARVIND: A classmate of MONICA'S and a nonsmoker. They don't socialize, but ARVIND would like to get to know MONICA better. MONICA is also interested in ARVIND.
- PROFESSOR: Busy and always in a rush. Wants students to like her.

SETTING: *A quiet corner of the nonsmoking university campus.*

ACTION 1: MONICA and DAVID look around to see that no one is watching, and they pull out cigarettes. DAVID lights MONICA'S cigarette. She inhales deeply and sighs a breath of relief. MONICA tells DAVID that she is considering dropping one of her classes because the instructor never gives them a break; she can't stand it.

ACTION 2: They put out their cigarettes. ARVIND walks by, and after seeing MONICA, goes over to her. They flirt, and it is clear they like each other. They talk about the class they have in common, and when ARVIND turns away for a moment, MONICA nudges DAVID, and he moves away to give them some privacy. They trade basic information. ARVIND asks for MONICA'S cell phone number, and she gives it to him.

ACTION 3: DAVID, bored, interrupts and asks MONICA for a cigarette. She gives him one and offers one to ARVIND, who declines. DAVID smokes, and ARVIND begins to cough.

ACTION 4: ARVIND tells them that he has asthma and the smoke is bothering him. MONICA apologizes and puts out her cigarette, but DAVID does not put out his cigarette.

ACTION 5: ARVIND tells DAVID that he is smoking in a non-designated area. DAVID continues to smoke, saying it is a ridiculous rule and unfair. MONICA moves closer to ARVIND, and so does DAVID. ARVIND coughs again and asks DAVID to put out the cigarette. DAVID says no. MONICA is quiet.

ACTION 6: A professor walks by and says hello. She stops to talk to DAVID for a moment but says nothing about the cigarette. She leaves.

ACTION 7: ARVIND and DAVID begin to argue. ARVIND threatens DAVID, and DAVID blows smoke in his face. ARVIND coughs worse, and MONICA tries to help him. ARVIND tells her to leave him alone, and he sits down to try to get a breath. MONICA asks him if he has an inhaler, but he cannot respond. She goes to his bag and looks through it to find the inhaler. DAVID keeps smoking.

END OF PLAY.

Culminating exercise: The individual forum theatre plays are presented to the full group one at a time. After each play is performed, short monologues from each character in the first person may or may not be performed. The joker then asks the audience to identify the protagonist and his or her allies, as well as the antagonist and his or her allies. The group is reminded of the rules of the game:

- In all subsequent showings of the piece, certain characters can be replaced by spect-actors (audience members who have been actively observing), who can attempt to change the course of the action by changing their tactics and actions.
- It is important that the antagonist is not replaced, as replacing the antagonist merely replaces the problem. The goal is to brainstorm ways to deal with the problem, and if there is no problem, there need be no discussion. Rather, the protagonist and his or her allies are the best choice to replace to brainstorm effective change.
- Only one replacement takes place at a time, and in each case the forum is played out until some change occurs.
- The actors who remain onstage and are not replaced are asked to remain true to their characters' behavior and intentions but to allow for the characters and scene to evolve based on the new information.
- Several forums are enacted via improvisations based on the original scenario, characters, and issue.

After the rules have been addressed, the joker asks the play to be performed a second time from the top. At this performance, any spect-actor who can identify a moment in which the protagonist or allies can make a different choice can call out, "Stop!" and take the place of one of the actors in order to explore a different line of action. The actor who has been replaced sits with the other spect-actors and watches. Twenty to sixty minutes to explore and discuss the play via a community, or "forum," should be reserved after each presentation.

Discussion: The discussion of the issues really takes place during the forums, through enacting different tactics and behaviors that lead to different outcomes. However, a verbal group discussion about the issues, the characters, and spect-actor observations or new insights can also be very valuable. Questions to lead such a discussion might include the following: What did you learn about the issue or problem by watching the original play and the subsequent forums? Were there any characters that you recognize from your life? What consequences and changes might the forum ideas lead to in the future? Do you think any of the ideas generated might work in real life? Why or why not? Questions for the group who write the original play or for the person whose actual story served as the base for the play are as follows: What did you learn about this issue and yourself by watching the forums? Which character(s) do you most relate to, and why? What did you learn from the characters in the fictionalized account? What might you do differently in the future with regard to this issue or problem in your life?

Beyond: The next time you come across an issue dealt with in one of the forum plays, reflect back to the ideas that were offered by the spect-actors. Boal often called forum theatre "rehearsal for reality," and perhaps you can see why. How much of the rehearsal can you use in your real life? Alternatively, if you find yourself dealing with a new problem or issue, consider exploring forum theatre as a way to collect information about the subject and the person involved with the problem and to rehearse for possible ways to deal with the issue.

LESSON THIRTEEN: DOCUMENTARIES (skills used: vocal, physical, observation, characterization)

Purpose: The aim of this lesson is to help you learn more about someone and to connect to their life story and perspective in an intimate way.

Outcomes: By the end of the lesson you will have developed an increased ability to
- Learn about others through careful and attentive listening
- Analyze the story of another person to discover clues to emotion, intent, and personality
- Create a new monologue that shares a perspective, a character, and a story

Opening: Many film, television, and theatre performances portray fictional stories. Documentaries, however, show nonfictional events, stories, and people in order to document and share real life. Documentary films are very popular, as are documentary television and radio shows. Reality TV, though staged, might also fall under the domain of documentary. What documentaries have you seen? How did they affect you?

Introductory exercise: Choose a person you have not yet worked with and share with each other a story from your life of an event that experience that changed you. After you have each shared one story with your partner, ask your partner to tell the story back to you as if he or she were you. In other words, you should be telling your partner's story as if you were your partner. As you watch and listen to the story, observe movements, habits, and vocal qualities. When you retell the story, seek to capture the personality, emotions, and verbal and body language of the original storyteller.

Explanation: We can learn about events and experiences that we are unfamiliar with by reading about them and by asking people to share their stories. This allows us to understand such things from our perspective. But by performing the language, movements, and emotions that share such stories, we come closer to authentically understanding the event or experience from the perspective of the storyteller.

Follow-up exercise: Choose someone from your life to interview. Make sure that the person is interested in sharing a personal story from his or her life with you and that he or she is comfortable with the interview being recorded and played back, and with allowing his or her answers to be used to craft a monologue to be shared in an informal performance. Consider conducting this interview over the phone, via Skype or in person. Consider interviewing someone who is different from you, perhaps not your closest friend and confidant, but rather someone you would like to know more about.

Once you have chosen the person to interview and received his or her consent to participate in the interview, begin to formulate interview questions. What is it that you wish to discuss with this person? Is there a specific event that occurred in their life that you want to know more about? Do you want to understand this person's perspective on an issue? If needed, conduct preliminary research using secondary sources—books, articles, documentaries or videos, and websites. Once you know what information you would like to get in the interview, create five to ten open-ended interview questions around the subject. Conduct the interview and make an audio recording of the questions and answers. Transcribe the entire interview verbatim. Once it has been transcribed, read it many times, even reading

it aloud to get a sense of themes and a central story. Choose a portion or portions of the interview to excerpt. Using these excerpts, craft a one- to two-minute monologue that documents a reality of the person you interviewed.

Culminating exercise: Memorize your monologue. Rehearse the monologue. Perform the monologue for a group in character, as if you were the original storyteller. Consider performing it for the person whose story it is, or share it with the interviewee in some other way, such as in written form.

Discussion: What did you learn from the process? What did you learn from the performance? Were your interview questions appropriate? Did they help the guide the storyteller? What was it like to portray someone you know? Did this help you feel empathetic? What was the interviewee's response to the monologue?

Beyond: Consider asking people you know questions about their experiences and the events of their lives. Think about their perspectives rather than your own and see if that helps you understand them even more. What would you share if you were going to be interviewed? How can you tell the stories that make up your life so that people learn more about you and your perspective?

LESSON FOURTEEN: OPEN SCENES (skills used: vocal, physical, observation, imagination, relaxation and concentration, characterization)

Purpose: To aim of this lesson is to explore the interdependency between character and story and to learn how to craft a plot with an arc.

Outcomes: By the end of the lesson you will have developed an increased ability to
- Understand the core components of storytelling
- Evaluate how structure is needed in a scene so that the story builds toward a climax
- Create characters and stories from your imagination

Opening: Open scenes, content-less scenes, or ambiguous scenes are one of the most helpful tools to organize an acting lesson around. Made popular by Robert Cohen, Claire Trevor professor of theatre at UC Irvine, and used by countless teachers, these scenes are open-ended in terms of plot, character, and setting. Because they are typically very short, they offer the actor an opportunity to delve into the techniques of acting without the burden of memorizing a great deal of text, and their brevity allows for exploration through repetition. Teachers and students alike can create open scenes so that there are no copyright issues, and they are a great way to explore all the skills introduced earlier. Typically written as two-person scenes, they can be adapted or written for three or four people and typically make use of letters as names, to keep gender, culture, and story open.

Introductory exercise: Ask everyone to find a spot in the room to relax in. Ask participants to let go of tension and to do a check-in with their body to locate points of stress. Encourage them, through breathing, to let the stress fade away and to come to a relaxed mental state in which they can concentrate. Ask a pair of students to read one of the open scenes at the bottom of this lesson aloud to the full group. Ask them to read the scenes neutrally, without characterization or a specific scenario in mind. Have them read the scene a few times, and each time ask the rest

of the class to imagine what types of characters, settings, actions, and conflicts might be taking place during the dialogue. If desired, have another pair read a second or even a third open scene. Allow the rest of the group to remain in a relaxed and concentrated physical state while listening to the scenes read aloud. After some scenes have been read, ask the group to come join in a circle to discuss their imaginings and the variety and range of options.

Explanation: Open scenes are an excellent way to explore character and plot. Because there is no formal content, problem, or scenario, the actor is free to create these on her own. The script provides the frame: the beginning and the end, and potentially a stimulus for the actor. Everything else must be left to the imagination of the two to four actors who must collaborate to build a story.

Follow-up exercise: Choose one open scene for every pair to work on. This can be an open scene from this book, one found online or in another book, or one written by the group or facilitator. Ask each pair to choose a setting in which they believe the dialogue could be taking place (five-star restaurant, airplane, elevator, beauty parlor, etc.). Ask them to choose a setting that has not already been discussed. Ask each pair to next choose an action that the characters or that each character individually might be doing (having supper, listening to music or trying to sleep, sneaking out of work early, getting a manicure, etc.). Next, have pairs decide on a simple relationship (a new couple, strangers, enemies, parent/child, etc.). Finally, pairs should decide on an inherent conflict that is occurring in the scene because of differing points of view or conflicting objectives. Once the scenario has been decided, ask each pair to rehearse the scene using only the dialogue provided. After fifteen to twenty minutes of rehearsal, show the scenes to the class. All dialogue will be the same, but each story and characters will be completely different.

Culminating exercise: Have everyone choose a new partner for another open scene. Before open scenes are handed out, have each pair choose a new location, action, relationship, and conflict to work with. Ask partners to flesh out the characters and the plot of the story. *After* these have been chosen, each pair is given an open scene. Everyone can have the same open scene, or pairs can have their own open scene. Once the script has been chosen and read out loud by the actors, the script should be analyzed to create a build. Actors can be reminded of the elements of a plot: introduction, inciting incident (the moment the conflict is introduced), rising action, climax, falling action, and resolution. Each pair should choose specific moments in the script when the above elements occur. Pairs should be encouraged to experiment for fifteen to twenty minutes at least to discover the arc of the scene and how the arc drives the story. Actors should be encouraged to delve deeper and to use movement, expression, and emotion to convey arc, character, and plot to their audience. Perform these scenes for the full group.

Discussion: After the scenes have been performed, ask the group how they came up with their ideas for characters and story. Ask how the two might have informed each other. Discuss with the class the moments when character and story worked well together and possible moments that seemed contradictory. Discuss the arc. How did stories build? Why is a build necessary? Have a discussion about the larger question: are we defined by our circumstances and how we respond to them?

Beyond: As you find yourself performing in scenes from both formal scripts and in your daily life, consider the character you are presenting and how your characterization informs the story. Additionally, consider the arc of your scenes, both formally as presented in classes, in videos, or on the stage, and informally in the moments of interaction that occur in your life. Is there conflict in your formal performances? Is there conflict in your daily informal performances? Where is it coming from, and why does it exist? How do your character and story create conflict? Do you want this to happen?

Note on open scenes: I've written them for my students, had students write them themselves, and used single lines drawn from a hat to have students organize into a ten- to twenty-line scene; the possibilities are endless and the results typically very good. There is little pressure with these, perhaps because of their length or perhaps because the open-endedness lends itself to a process-based approach rather than a product. Furthermore, collaborating on such scenes creates a solid pair or group because of the exploratory nature of the work. These scenes are a good way to create, perform, and reflect, a cycle that can be repeated again and again to allow for actors to build on their skills. A quick Google search will offer you many prewritten open scenes, and here are a few short ones I have created, based on ones I have come across over the years.

EXAMPLE 1

A: Hi.
B: Hello.
A: How are you?
B: Fine. And you?
A: Well. Very well.
B: I'm also good.
A: Glad to hear it.
B: Nice weather today.
A: Yes, it is. Beautiful.
B: I'd better be going.
A: Goodbye.

EXAMPLE 2

A: What are you doing?
B: Nothing.
A: Nothing?
B: I said nothing.
A: It doesn't look like nothing.
B: Well what are you doing?
A: I'm not doing anything.
B: Exactly.

EXAMPLE 3

A: Do you want to talk?
B: About what?
A: Whatever.
B: OK. Should I go first?
A: If you want to.
B: No, you start.
A: OK.
B: OK.

EXAMPLE 4

A: What should we do?
B: What do you think we should do?
A: I asked you.
B: But I don't know.
A: I thought you did.
B: I don't.

LESSON FIFTEEN: APPROACHING A CHARACTER THROUGH A SCENE
(skills used: vocal, physical, observation, imagination, concentration and relaxation, improvisation, and characterization)

Purpose: To experience the creative process and formal product of rehearsing for and performing in a text-based scene. To delve deep into character and to work intimately with objectives, obstacles, and tactics.

Outcomes: By the end of the lesson you will have developed an increased ability to
- Approach a text-based story and character confidently
- Work intimately and collaboratively with another person
- Analyze another person though identifying with the given circumstances
- Interpret another person through the use of active imagination
- Perform as a character in a committed and sustained way

Opening: Working on a scene from a published play is one of the best ways to incorporate all of the acting skills you have studied. Working on, and eventually performing in, a scene is the absolute best way to rehearse your acting abilities and blend the skills you've gained. Both the process and product make use of all skills we have discussed in this book and encourage the abilities highlighted at the end of Section 1.

Introductory exercise: Working in pairs is a good way to approach scene work. Pair work enables actors to focus on one other person, rather than several, and engenders close and sustained collaboration. I like to have participants choose their own scenes, because personal interest in the characters and subject matter often facilitates a deeper appreciation of and

commitment to the work. I bring in a multitude of scenes from plays to offer, and students spend twenty to thirty minutes reading through the first page or two of as many scenes as they can. After they have been exposed to a variety of texts, I ask them to consider who might be a suitable partner for their top two scene choices. Scenes are shared with the full group, and partners are chosen based on interest in the text. After scenes and partners have been chosen, pairs sit together so that they are facing each other and in close proximity and read the scene aloud with one another several times.

Explanation: Some groups might have a difficult time finding good scenes completely on their own, so bringing in a variety of scenes from modern and contemporary plays for students to read through and choose from works well. Film scenes can sometimes work, but scenes from published plays are often more multifaceted in terms of content and are typically longer, offering more language and opportunity for a developed arc. Because of the nature of film, such scenes are often shorter and build to a conflict and climax much more quickly, which can make them difficult to work on. In addition, participants are likely to have seen the films that scenes come

Fig. 4.4 (photo: Terry Cyr)—Sarah Jo Wojciechowski-Prill as Catherine in *Proof*.

Fig. 4.5 (photo: Terry Cyr)—Hugh Butterfield as Rod and Eric Montague and Holly Cooper as Nicky in *Avenue Q.*

from and base their performance off the original, leaving less to their imagination, analysis, and interpretation. Negotiating scene and partner choice is all a bit of a dance, but this process generally ensures that students choose scenes based on personal interest and then choose partners based on scene interest rather than simply someone with whom they are comfortable working. Reading the scene aloud with a partner will serve the actor's memory. By speaking the text to their scene partner from the very beginning, the actors will begin to connect the textual language to their character, the situation, and the story, and they will instinctively begin to analyze the characters and the plot.

Follow-up exercise: At this point in the process, actors can benefit from three major exercises:

1. *Initial work*: The pairs analyze and discuss, and make a list of the given circumstances of the scene and the play the scene has been taken from. Using their own imaginations and the given circumstances provided by the playwright, the actors

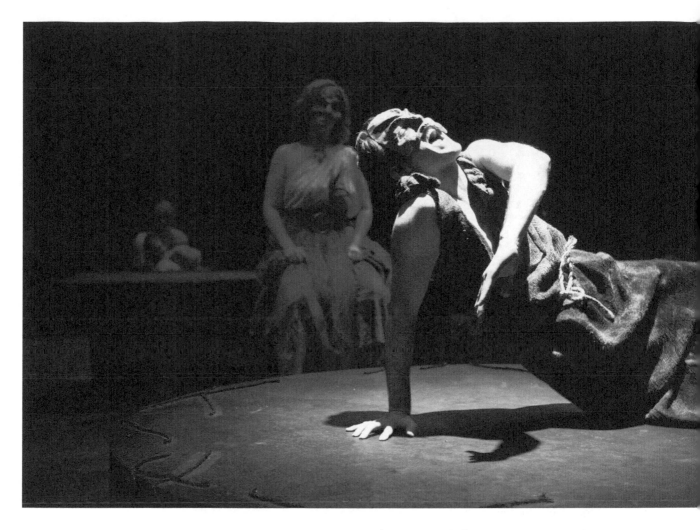

Fig. 4.6 (photo: Terry Cyr)—Raker Wilson in *Medea*.

individually explore the six questions presented in Section 2: Who am I? What are my circumstances? What are my relationships? What do I want? What is in my way? What am I willing to do? It is a good idea to have actors continue to read the scene aloud throughout this process, so that the choices made are linked to the text and tested to see if they work with the lines, overall plot, and characterization. Consider having actors read the scene aloud after each of the six questions have been discussed. In addition, the facilitator can encourage the actors to stand up and begin to move according to the character's personality, relationship, needs, and tactics. Two things will simultaneously occur if participants approach the work in this way: the line memorization will automatically begin to take place, and the blocking will naturally begin to emerge.

2. *Units*: The pairs break the scene up into smaller parts, called "units" or "beats." A *unit* of action is a discrete and smaller part of action within the larger scene. Dividing the script into units helps actors understand that each scene is made up of bits of

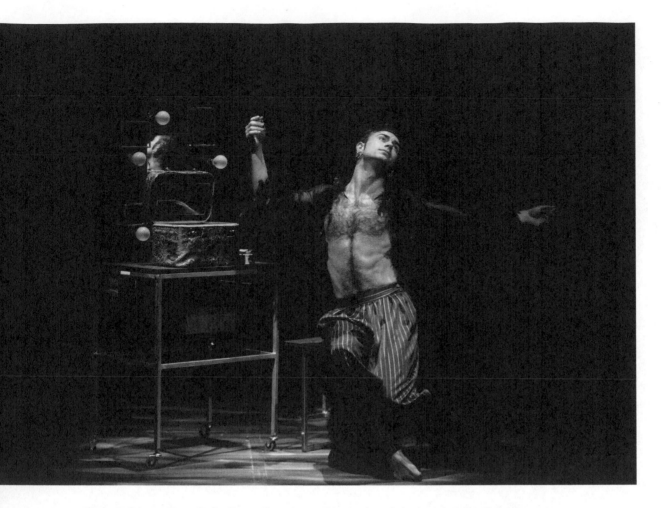

Fig. 4.7 (photo: Terry Cyr)—Trevor Pressler as Prior in *Angels in America, Part I*

action, each with its own objective, tactic, or subject matter. An actor cannot simply pursue the same action throughout the entire scene, because in life we don't do that, and because changes are needed to engage the audience. Breaking down a scene into units, or beats, as Stanislavski called them (he actually called them "bits," but with his strong accent, Americans understood him to be saying "beats"), helps build the plot through moment-to-moment exchanges, which, when assembled together, form an arc for the scene. There is no wrong or right way to mark a unit change. Partners should work together to discuss and discover, via enactment, moments of change in the scene. When both partners agree that a change has occurred, in the form of a change of action, a change of objective, a change of obstacle or tactic, or a change in mood or subject, they draw a line in pencil in their script to indicate the unit. After units have been marked, it is helpful for actors to name the change and to write some descriptive words about the change in the margin of the text. Labeling the unit will help the actor recall when, where, and why the change is being made and to incorporate the change into the blocking and the arc of the scene. Often actors like to rehearse scenes bit by bit, beginning with the first unit and adding the second unit after the first has been grasped.

3. *Exploratory techniques*: Often actors don't know what to do beyond this initial and analytical work. Sometimes they think that once choices have been made and lines have been memorized, the process is complete. This is the point at which opportunities for further exploration must be encouraged. Actors can try any of the options listed below, returning to the text and blocking after each exploration to see if and how the characters and scene have shifted.

Ideas for actors to explore in scene work:

Improvisation: Actors cast the script aside and use their own words to play the character and the scene. Some lines might be the same, but the focus is on personalizing the story and character, and as such, much will change.

Image work: Pairs create a frozen image for each of the different units in the scene. The frozen image should showcase the character, objective, and relationship as it exists in the individual moment. The entire body and face should be used and controlled in this exercise, and the frozen images are then strung together to tell the story through images with no verbal language.

Switching roles: Partners switch roles and either improvise the scene or read through it standing up, playing the other character.

Inner monologue: At the end of each unit, characters speak their inner monologue out loud, stating their feelings, wants, and conflicts. After monologues have been spoken, the scene resumes. Inner monologues express what the character is feeling and thinking but cannot overtly state. This serves to clarify and reinforce the unspoken.

Laban's efforts: Rudolph Laban broke down human movement into what he called the eight basic effort actions: pressing, thrusting, wringing, flicking, slashing, gliding, dabbing, and floating. Laban believed that, "man moves in order to satisfy a need" (Newlove 1993, 11) and he asked actors and dancers to explore the effort actions as ways to guide their movements. For scene work it can be useful to explore the efforts individually for the duration of the scene and then to choose specific efforts to guide individual units or beats within the greater scene. This can be done overtly with full movement and voice or subtly.

Culminating exercise: The focus of the work shifts to the presentation of a product after scenes have been analyzed, explored, and interpreted. It is a nice idea to offer actors more than one performance in order to ease the pressure and to allow for process to influence product. Having actors choose and procure their own costumes allows for yet another deepening of the character and story. At this point they will probably automatically understand what their character would or would not wear in the scene. Actors should perform their scene in costume in front of a group, and they should receive feedback from the facilitator about character, relationship, objectives, obstacles, and tactics. They might also reflect on the scene and offer their own assessment of the

performance. A few more rehearsals should take place between the dress rehearsal and the final performance, and then the scenes are performed a second time.

Discussion: What was it like to follow a specific process as you worked on a scene? What was the most helpful aspect or exercise? If you were to rehearse or perform the scene again, what would you do differently? What did you learn from your character? Were you able to fully immerse yourself in his or her world? How did you let go of the character at the end of the work? What other skills did you use and rely on in rehearsals and performances?

Beyond: Could you ever approach a moment in your life the way you approached this scene? Before you engage in an interaction with another person, can you explore the given circumstances of the situation and answer the questions that led you to understand your actions? Consider taking part in a dress rehearsal before you "perform" in real life. Consider the costume you wear and what it communicates. Consider analyzing scenes from your life before and after they take place.

REFERENCES

Adams, Susan. 2013. "The 10 Skills Employers Most Want In 20-Something Employees." *Forbes Magazine*, October 11. www.forbes.com/sites/susanadams/2013/10/11/the-10-skills-employers-most-want-in-20-something-employees.

Adler, Stella. 2000. *The Art of Acting*. Compiled and edited by Howard Kissel.New York: Applause.

Baker, Beth. 2012. "Arts Education." *CQ Researcher* 22:Ball, William. 1984. *A Sense of Direction*. New York: Drama Publishers.

Bandura, Albert. 1997. *Self-efficacy: the exercise of control*. New York: Worth Publishers.

Benedictus, Leo. 2013. "Top Ten Things Employers Are Looking For." *The Guardian*, April 22. www.theguardian.com/money/2013/apr/22/top-10-things-employers-looking-for.

Bloom, Paul. 2013. "The Baby in the Well." *The New Yorker*, May 20.

Boal, Augusto. 1992 *Games for Actors and Non-Actors*. Translated by Adrian Jackson. London Routledge.

Bogart, Anne. 2001. *A Director Prepares*. London: Routledge.

Bogart, Anne. 2007. And Then You Act. New York and London: Routledge.

Bogart, Anne, and Landau, Tina. 2005. *The Viewpoints Book*. New York Theatre Communications Group.

Brockett, Oscar. 2007. *Theatre History*. 10th ed. Upper Saddle River, New Jersey Pearson.

Brook, Peter. 1968. *The Empty Space*. New York Touchstone.

Brown, Brene. 2012. *Daring Greatly*. New York Gotham.

Chaiken, Joseph. 1991. *The Presence of the Actor*. New York Theatre Communications Group.

Cohen, Robert. 2007. *Acting One*. New York McGraw-Hill.

Courtney, Richard. 1991 "Making Up One's Mind: Aesthetic Questions about Children and Theatre." In *Re-cognizing Richard Courtney: Selected Writings on Drama and Education*, edited by DavidBooth and Alistair Martin-Smith. London: Jessica Knightly Publishers.

Eisner, Eliot. 1968. "Qualitative Intelligence and the Act for Teaching." In *Teaching: Vantage Points of Study*, edited by Ronald T. Hyman. Philadelphia, PA: Lippincott.Ekman, Paul, and Wallace V. Friesen. 2003. *Unmasking the Face*. Los Altos, CA Malor Books.

Elkind, David. 2007. *The Power of Play*. Cambridge, MA Da Capo Press.

Fey, Tina. 2013. *Bossypants*. New York Reagan Arthur Books/Little, Brown and Company.

Frederic, Louis (Ed). 2002. "Kabuki." In *Japan Encyclopedia*. Cambridge, MA: Harvard University Press Reference Library.

Goffman, Erving. 1959. *The Presentation of Self in Everyday Life*. New York Doubleday.

Goodall, Jane. 2008. *Stage Presence*. London and New York Routledge.

Griggs, Tom. 2001. "Teaching as Acting." *Teacher Education Quarterly* Volume 28, Number 223–37.

Hagen, Uta. 1991. *A Challenge for the Actor*. New York: Schribner.

Kuritz, Paul. 1982. *Playing: An Introduction to Acting*. Upper Saddle River, NJ Prentice-Hall.

Lecoq, Jaques. 2001. *The Moving Body*. New York: Routledge.

Linklater, Kristen. 2006. *Freeing the Natural Voice*. Hollywood: Drama Publishers.

McEvenue, Kelly. 2001. *The Actor and the Alexander Technique*. New York Palgrave Macmillian.

Mehrabian, Albert, and Susan R. Ferris. 1967. "Influence of Attitudes from Nonverbal Communication in Two Channels." *Journal of Consulting Psychology* 31:248–52.

Mosbergen, Dominique. 2012. "Facebook has 83 Million 'Fake' or Duplicate Users, About 8.7 Percent of All Active Accounts." *Huffington Post*. March 12, 2012.

Newlove, Jean. 1993. *Laban for Actors and Dancers*. New York: Routledge.

Noice, Helga and Noice, Tony. 2006. "What Actors Can Teach Us About Memory and Learning." *Current Directions in Psychological Science*. Volume 15. Number 1.

Pavis, Patrice. 1998. *Dictionary of the Theatre: Terms, Concepts, and Analysis*. Toronto University of Toronto Press Incorporated.

Pestka, Elizabeth L., Susan M. Bee, and Michele M. Evans. 2010. "Relaxation Therapies." In *Complementary and Alternative Therapies in Nursing*, 6th ed., edited by Mariah Snyder and Ruth Lindquist. New York: Springer Publishing Co.

Piaget, Jean. 2001. *The Psychology of Intelligence*. 2nd ed. London and New York Routledge.

Prynne, William. 1632. *The Histrio-matrix or the Player's Scourge*. London Bookseller Michael Sparke.

Reid, Theresa, ed. 2012. "Art Making and the Arts in Research Universities." *M Arts Engine Interim Report*, March. http://a2ru.org/wp-content/uploads/2012/03/ArtsEngine-National-Strategic-Task-Forces-Interim-Report-March-2012.pdf.

Rodenburg, Patsy. 1992. *The Right to Speak*. London Methuen.

Royall, Janet. 2012. "Notable Opposition: Scrutiny in the Lords." Lecture, House of Lords, London, February 9, 2012.

Schechner, Richard. 2002. *Performance Studies: An Introduction*. London and New York Routledge.

Spolin, Viola. 1999. *Improvisation for the Theatre*. Evanston, IL: Northwestern University Press.

Sports Illustrated/Associated Press. 2013. "Te'o Denies Creating 'Dead' Girlfriend Hoax." *Sports Illustrated*, January 19. http://sportsillustrated.cnn.com/college-football/news/20130119/manti-teo-off-camera-interview-hoax-explanation/index.html.

Stanislavski, Constantin. 1964. *An Actor Prepares*. Translated by Elizabeth Reynolds Hapgood. New York: Theatre Arts Books (Routledge).

Suzuki, Tadashi. 1986. *The Way of Acting*. New York Theatre Communications Group.

Turner, Victor. 1982. *From Ritual to Theatre: The Seriousness of Human Play*. New York PAJ Publications.

Zarelli, Philip B., McConachie, Williams, Gary Jay, and Sorgenfrei, Carol Fisher 2010. Theatre Histories: An Introduction, second edition. New York: Routledge.

RESOURCES

BOOKS FOR OTHER EXERCISES, PHILOSOPHIES, AND APPROACHES

Adler, Stella. 2000. *The Art of Acting*. Compiled and edited by Howard Kessel. New York Applause.

Ball, William. 1984. *A Sense of Direction*. New York: Drama Publishers.

Barton, Robert. 2012 *Acting On Stage and Off*. Boston: Wadsworth.

Barton, Robert, and Rocco Dal Vera. 2003. *Voice On Stage and Off*. Belmont, CA Wadsworth.

Boal, Augusto. 1992. *Games for Actors and Non-Actors*. Translated by Adrian Jackson. London: Routledge

Boal, Augusto. 1985. *Theatre of the Oppressed*. Translated by Charles A. and Maria-Odilia Leal McBride. New York: Theatre Communications Group

Boal, Augusto. 1998. *Legislative Theatre*. Translated by Adrian Jackson. London: Routledge.

Bogart, Anne and Landau, Tina. 2005 *The Viewpoints Book: A Practical Guide to Viewpoints and Composition*. New York: Theatre Communications Group.

Brandon, James. 1992. *Kabuki: Five Classic Plays*. Honolulu, Hawaii University of Hawaii Press.

Callery, Dymphna. 2001. *Through the Body: A Practical Guide to Physical Theatre*. London: Nick Hern Books.

Chekhov, Michael. XXXX. *On the Technique of Acting*. XXXX: XXXX.

Cole, Toby, and Helen Chinoy Krich, eds. 1970. *Actors on Acting*. New York: Three Rivers Press.

Haggard, Ernest A., and Kenneth S. Isaacs. 1966. "Micro-momentary Facial Expressions as Indicators of Ego Mechanisms in Psychotherapy." In *Methods of Research in Psychotherapy*, edited by Louis A. Gottschalk and Arthur H. Auerbach, 154–165. New York: Appleton-Century-Crofts.

Huizinga, Johan. 1955. *Homo Ludens*. Boston: The Beacon Press.

Jory, Jon. 2000. *TIPS: Ideas for Actors*. Lyme, NH: Smith and Kraus Inc.

Johnstone, Keith. 1992. *Improv: Improvisation and the Theatre*. New York: Routledge.

Landy, Robert, J. 1994. *Drama Therapy: Concepts, Theories and Practices*. Springfield, IL: Charles C Thomas Publisher.

Linklater, Kristin. 2006 *Freeing the Natural Voice*. Hollywood: Drama Publishers. XXXX.

Loui, Annie. 2009. *The Physical Actor*. London and New York: Routledge.

McEvenue, Kelly. 2001. *The Actor and the Alexander Technique*. New York: Palgrave Macmillian.

Meisner, Sanford. 1987 *Sanford Meisner on Acting*. New York: Random House, Inc.

Potter, Nicole, ed. 2002. *Movement for Actors*. New York: Allworth Press.

Schechner, Richard. 1985. *Between Theatre and Anthropology*. Philadelphia: University of Pennsylvania Press.

Schutzman, Mady, and Jan Cohen-Cruz. 1994. *Playing Boal*. London and New York: Routledge.

Spolin, Viola. 2013 *Improvisation for the Theatre*. New Albany, IN New Albany Press.

Spolin, Viola. 1986 *Theater Games for the Classroom: A Teacher's Handbook*. Evanston, IL: Northwestern University Press.

Spolin, Viola. 1985 *Theater Games for the Rehearsal: A Director's Handbook*. Evanston, IL: Northwestern University Press. XXXX.

Spolin, Viola. 2001 *Theater Games for the Lone Actor*. Evanston, IL: Northwestern University Press. XXXX.

Stanislavski, Konstantin. 1946. *An Actor Prepares*. Translated by Elizabeth Reynolds Hapgood. New York: Theatre Arts, Inc.XXXX: XXXX.

IDEAS FOR INDIVIDUAL SPEECH WORK

Unlike scenes, which focus on a give and take between characters, speeches are talks or public addresses offered to audiences containing numerous people. Most of us have had to give, or will need to give, a speech to a group at some point. Speaking directly to the audience, with no fourth wall, can often be disconcerting. There is no character to hide behind, and often the performer is less able to control the behavior of the audience. The good news is that you can apply acting skills to any public address to capture and keep the crowd's attention. Some important rules for speech delivery are: rehearse your speech over and over; convey a passion for what you are saying; make a connection with your audience; maintain good posture; seek to look and feel comfortable; use body language; and, reinforce your language with specific vocal choices.

Well-Known Historical Speeches

"The Golden Speech" by Queen Elizabeth I (1601)
"Abolish the Slave Trade" by William Wilberforce (1791)
"The Gettysburg Address" by Abraham Lincoln (1863)
"Quit India Speech" by Mohandas K. Gandhi (1942)
"I Have a Dream" by Martin Luther King, Jr. (1963)

Commencement Speeches

David Foster Wallace, Kenyon College (2005)
Steve Jobs, Stanford University (2005)
Barbara Kingsolver, Duke University (2008)
Oprah Winfrey, Harvard (2013)

Humorous Speeches

Russell Brand, Broadcasting Press Guild Awards (2007)
Ellen DeGeneres, Tulane (2009)
Tina Fey, Kennedy Center (2010)
Steve Carrell, Golden Globes (2010)

Speeches of Personal Conviction

"Strike against War," by Helen Keller, at Carnegie Hall, New York City (1916)
"Farewell to Baseball," by Lou Gehrig, in New York (1939)
"A Whisper of AIDS," by Mary Fisher, in Houston (1992)
 "Free Speech," by Erica Jong, at ACLU Biennial Conference, New York City (1995)

Speeches from Children's Books

"The Little Engine that Could" by Watty Piper (1930)
"I Know an Old Lady Who Swallowed a Fly" by Rose Bonne (1961)
"Oh, the Places You'll Go" by Dr. Seuss (1990)

IDEAS FOR DUO OR TRIO SCENES

Unlike speeches, monologues are typically delivered to one other person, or at least a smaller group. Monologues typically come from plays or films and are spoken by a character performed by an actor. Some actors will find it easier to work with monologues before working with speeches because of the safety they can find behind the characters they are performing. Others will find the opposite to be true and will find it easier to perform a speech because it has taken away the need to embrace a character distinct from themselves. There are numerous monologue books available, and of course one can always find monologues on the Internet, but the best ones come from published plays and screenplays.

Aston, Irene Ziegler, and John Capecci, eds. 2005. *The Ultimate Audition Book: 222 Comedy Monologues, 2 Minutes and Under*. Hanover, NH: Smith and Krauss.

Coen, Stephanie, ed. 2001. *American Theatre Book of Monologues for Women (Vol. 2)*. New York: Theatre Communications Group.

Coen, Stephanie, ed. 2001. *American Theatre Book of Monologues for Men (Vol. 1)*. New York: Theatre Communications Group.

Earley, Michael, and Phillipa Keil, eds. 2013. *The Contemporary Monologue: Women*. New York: Routledge.

Harrington, Laura, ed. 1989. *100 Monologues: An Audition Sourcebook from New Dramatists*. New YorkX: Signet.

Hooks, Ed. 2007. *The Ultimate Scene and Monologue Source Book*. New York: Backstage Books.

Mamet, David. 2011. *Dramatic Sketches and Monologues*. New York: Samuel French Publishers.

McHardy, Leonard, and John Harvey, ed. 2014. *His: Monologues for Men*. Toronto: ECW Press.

Shengold, Nina, and Eric Lane, eds. 1992. *Moving Parts: Monologues from Contemporary Plays*. New York: Penguin Books.

Shengold, Nina and Lane, Eric, eds.2004. *Talk to Me: Monologue Plays*. New York: Vintage.

Shengold, Nina, ed. 1987. *The Actor's Book of Contemporary Stage Monologues: More Than 150 Monologues from More Than 70 Playwrights*. New York: Penguin Books.
Find all the books, read about the author, and more.
See search results for this author
Are you an author? Learn about Author Central

SCENE IDEAS

Performing a scene from a published play or film is an opportunity to bring all of the pieces of the puzzle together. Actors in scene work embrace character, body, voice, emotions, communication, and, at times, improvisation. Scenes require memorization and analysis of story, character, and relationships, and scene work demands imagination and collaboration. As with monologues, it is easy to find a scene from a play or film in one of the many scene books published each year, but finding a scene from a published play will certainly provide a richer script for an actor to work with.

Beard, Jocelyn A., ed. 2000. *102 Scenes for Two Actors*. New York: Smith and Kraus Press.
Dixson, Michael Bigelow, Amy Wegener, and Stephen Moulds, eds. 2001. *30 Ten-Minute Plays for 3 Actors*. New York: Smith and Kraus Press.
Dixson, Michael Bigelow, Amy Wegener, and Stephen Moulds, eds. 2004. *The Best Ten-Minute Plays for 3 or More Actors*. New York: Smith and Kraus Press.
Harbinson, Lawrence, ed. 2013. *The Best Women's Stage Monologues and Scenes*. New York: Smith and Kraus.
Harbinson, Lawrence, ed. 2013. *The Best Men's Stage Monologues and Scenes*. New York: Smith and Kraus.
Jaroff, Rebecca Dunn, Bob Shuman, and Joyce E. Henry, eds. 2009. *Duo!: The Best Scenes for Two for the 21st Century*. New York: Applause Books.
Lane, Eric, and Nina Shengold, eds. 1988. *The Actor's Book of Scenes from New Plays*. New York: Penguin Books.
Miller, Bruce. 2010. *The Scene Study Book: Roadmap to Success*. Milwaukee, WI Hal Leonard Corporation.
Nicholas, Angela, ed. 1999. *99 Film Scenes for Actors*. New York: Avon Books.
Schulman, Michael, and Eva Mekler, eds. 1980. *Contemporary Scenes for Student Actors*. New York: Penguin Books.
Schulman, Michael, and Eva Mekler, eds. 1998. *Great Scenes and Monologues for Actors*. New York: St. Martin's Press.

WEBSITES FOR MORE PERFORMANCE EXERCISES

Creative Drama and Theatre Education Resource Site: www.creativedrama.com
This site offers improvisational games, creative drama ideas, and classroom exercises.
Drama Resource: http://dramaresource.com
The UK's David Farmer is a drama consultant who offers games and other resources on this site.
Drama Toolkit: www.dramatoolkit.co.uk
This is a resource and support website for teachers, facilitators, and practitioners.
Improv Encyclopedia: http://improvencyclopedia.org/games

This site offers improvisational games, including short-form and long-form exercises, workshop information, tips, and more.

Learn Improv: http://learnimprov.com

Devoted to the art of improvisational comedy theatre; this site offers warm-ups and exercises.

Project Gutenberg: www.gutenberg.org

This site offers free downloads of scripts in the public domain.

The Spolin Center: www.spolin.com

The Spolin Center offers improvisation techniques, games, and exercises from Viola Spolin and her son, Paul Stills.

Stagemilk: www.stagemilk.com

This is an Australian theater information site, with excellent games, articles, monologues, and advice.

Theatre Teachers: www.theatreteachers.com

Lessons and ideas from theatre teachers across the world. A login is required.

IMAGE
CREDITS

Section One

1. Copyright © by Terry Cyr. Reprinted with permission.
2. Copyright © Missvain (CC BY-SA 3.0) at http://commons.wikimedia.org/wiki/File:GLAMcamp-Subway-B.jpg.
3. Copyright © JoeInQueens (CC by 2.0) at http://commons.wikimedia.org/wiki/File:DSC_0040_(5747118713).jpg.
4. Source: http://commons.wikimedia.org/wiki/File:MetalStallLHist.JPG. Copyright in the Public Domain.
5. Source: http://commons.wikimedia.org/wiki/File:Classroom_at_a_seconday_school_in_Pendembu_Sierra_Leone.jpg. Copyright in the Public Domain.
6. Copyright © Mohamed Al-Jamry (CC BY-SA 2.0) at http://commons.wikimedia.org/wiki/File:Mohamed_Albuflasa_giving_a_speech_during_the_2010_Bahraini_parliamentary_elections_campaign.jpg.
7. Copyright © Eva Rinaldi (CC BY-SA 2.0) at http://commons.wikimedia.org/wiki/File:Liliya_May_(6811619257).jpg.
8. Source: http://commons.wikimedia.org/wiki/File:Girl_with_computer_emerging_technologies_social_media.jpg. Copyright in the Public Domain.
9. Copyright © Gert Germeraad (CC BY-SA 3.0) at http://commons.wikimedia.org/wiki/File:Portret_van_een_man005.jpg.
10. Source: http://commons.wikimedia.org/wiki/File:John_Reinhard_Weguelin_%E2%80%93_Bacchus_and_the_Choir_of_Nymphs_(1888).jpg. Copyright in the Public Domain.
11. Source: http://commons.wikimedia.org/wiki/File:Okuni_with_cross_dressed_as_a_samurai.jpg. Copyright in the Public Domain.
12. Source: http://commons.wikimedia.org/wiki/File:Nell_Gwynn_engraved_after_portrait_by_Simon_Verelst.jpg. Copyright in the Public Domain.
13. Copyright © by Terry Cyr. Reprinted with permission.

Section Two

14. Copyright © by Terry Cyr. Reprinted with permission.
15. Copyright © Jere Keys (CC by 2.0) at http://commons.wikimedia.org/wiki/File:Tisch_School_of_the_Arts_NYU.jpg.
16. Photo by Mike Fink.
17. Source: http://commons.wikimedia.org/wiki/File:Stanislavski_as_Vershinin.jpg. Copyright in the Public Domain.
18. Source: http://commons.wikimedia.org/wiki/File:Stella_Adler_in_Shadow_of_The_Thin_Man_trailer.jpg. Copyright in the Public Domain.
19. Copyright © Thehero (CC BY-SA 3.0) at http://commons.wikimedia.org/wiki/File:Augusto_Boal_nyc1.jpg.
20. Photo by Mike Fink.
21. Photo by Mike Fink.
22. Photo by Mike Fink.
23. Copyright © by Terry Cyr. Reprinted with permission.
24. Photo by Mike Fink.
25. Copyright © greyloch (CC BY-SA 2.0) at http://commons.wikimedia.org/wiki/File:Marvel_characters.jpg.
26. Photo by Mike Fink.
27. Copyright © Aude Vanlathem / www.audevan.com (CC BY-SA 2.5 CA) at http://commons.wikimedia.org/wiki/File:Ligue_d%27improvisation_montr%C3%A9alaise_(LIM)_20110116-03.jpg.
28. Source: http://commons.wikimedia.org/wiki/File:Robeson_Hagen_Othello.jpg. Copyright in the Public Domain.

Section Three

29. Copyright © Al Jazeera English (CC BY-SA 2.0) at http://commons.wikimedia.org/wiki/File:John_Kerry,_US_senator_-_Flickr_-_Al_Jazeera_English.jpg.
30. Copyright © Keith Allison (CC BY-SA 2.0) at http://commons.wikimedia.org/wiki/File:Doug_Collins_gestures.jpg.
31. Copyright © Heptagon (CC BY-SA 3.0) at http://commons.wikimedia.org/wiki/File:Young_old.jpg.
32. Source: http://commons.wikimedia.org/wiki/File:Gregor_Baci.jpg. Copyright in the Public Domain.
33. Copyright © Thamizhpparithi Maari (CC BY-SA 3.0) at http://commons.wikimedia.org/wiki/File:Bhadrasana.JPG.
34. Copyright © Thehero (CC BY-SA 3.0) at http://commons.wikimedia.org/wiki/File:Theatre_of_the_Oppressed1.jpg.
35. Source: http://commons.wikimedia.org/wiki/File:FEMA_-_13355_-_Photograph_by_Kevin_Galvin_taken_on_01-01-2004_in_Massachusetts.jpg. Copyright in the Public Domain.
36. Copyright © by Terry Cyr. Reprinted with permission.

Section Four

37. Source: http://commons.wikimedia.org/wiki/File:Gray_111_-_Vertebral_column-coloured.png. Copyright in the Public Domain.
38. Photo by Mike Fink.
39. Photo by Mike Fink.
40. Copyright © by Terry Cyr. Reprinted with permission.
41. Copyright © by Terry Cyr. Reprinted with permission.
42. Copyright © by Terry Cyr. Reprinted with permission.
43. Copyright © by Terry Cyr. Reprinted with permission.

CPSIA information can be obtained
at www.ICGtesting.com
Printed in the USA
FSOW03n0800150715
8880FS